FRY PLAYS ONE

CHRISTOPHER FRY was born Arthur Hammond Harris in 1907. After a short stint as a teacher, he renamed himself Christopher Fry – taking his new, Quaker-inflected surname from his mother's side of the family – and during the 1930s worked in a variety of theatrical jobs, including playwright, producer, lyricist, composer, designer, draughtsman and actor. Plays from this time include *Siege* (1936) and *The Boy with a Cart* (1939). After the Second World War he began to make a name for himself as a verse dramatist with the one-act *A Phoenix Too Frequent* and the full-length drama *The Firstborn* (both 1946). However, the major success of his career came with *The Lady's Not for Burning* in 1948, which ran for nine months in the West End and is still frequently revived. Fry followed this up with *Thor, with Angels* (1948), *Venus Observed* (1950), *A Sleep of Prisoners* (1951) and *The Dark is Light Enough* (1954). During this period he also produced much-loved translations of Jean Anouilh's *L'Invitation au château* (*Ring Round the Moon*) and *The Lark*, and went on to translate three plays by Jean Giraudoux: *La Guerre de Troie n'aura pas lieu* (*Tiger at the Gates*), *Pour Lucrèce* (*Duel of Angels*) and *Judith*. From the mid-1950s he began to work on screenplays for Hollywood, most famously *Ben Hur* and *The Bible*. His last two full-length stage plays were *Curtmantle* (1962) and *A Yard of Sun* (1970), still in verse but employing a leaner language than in his earlier work. In the 1970s he produced verse translations of both *Peer Gynt* and *Cyrano de Bergerac*, as well as writing drama for television, including *The Brontës of Haworth*, and essays and autobiographical writings such as *Can You Find Me?* He would go on to write two more one-act plays: *Caedmon Construed* (1986) – also known as *One Thing More* – and *A Ringing of Bells* (2000), written in his nineties for his old school, Bedford Modern. He died in 2005.

Christopher Fry

PLAYS ONE

The Lady's Not for Burning

A Yard of Sun

Siege

OBERON BOOKS
LONDON

First published in this collection in 2007 by Oberon Books Ltd
521 Caledonian Road, London N7 9RH
Tel: 020 7607 3637 / Fax: 020 7607 3629
e-mail: info@oberonbooks.com
www.oberonbooks.com

The Lady's Not for Burning first published by Oxford University Press,
1949; second edition, 1950; reprinted with revisions, 1985

A catalogue record for this book is available from the British Library.

ISBN: 1 84002 771 1 / 978 1 84002 771 6

Printed in Great Britain by Antony Rowe Ltd, Chippenham

Contents

THE LADY'S NOT FOR BURNING

'In the past I wanted to be hung. It was worthwhile being hung to be a hero, seeing that life was not really worth living.'

A convict who confessed falsely to a murder, February 1947

To Alec Clunes

Characters

RICHARD, an orphaned clerk

THOMAS MENDIP, a discharged soldier

ALIZON ELIOT

NICHOLAS DEVIZE

MARGARET DEVIZE, mother of Nicholas

HUMPHREY DEVIZE, brother of Nicholas

HEBBLE TYSON, the Mayor

JENNET JOURDEMAYNE

THE CHAPLAIN

EDWARD TAPPERCOOM, a Justice

MATTHEW SKIPPS

Scene: A room in the house of Hebble Tyson, Mayor of the small market town of Cool Clary

Time: 1400 either more or less or exactly

The Lady's Not for Burning was first performed at the Arts Theatre, London, on 10 March 1948, with the following cast:

RICHARD, Derek Blomfield

THOMAS MENDIP, Alec Clunes

ALIZON ELIOT, Daphne Slater

NICHOLAS DEVIZE, Michael Gough

MARGARET DEVIZE, Henzie Raeburn

HUMPHREY DEVIZE, Gordon Whiting

HEBBLE TYSON, Andrew Leigh

JENNET JOURDEMAYNE, Sheila Manahan

THE CHAPLAIN, Frank Napier

EDWARD TAPPERCOOM, Peter Bull

MATTHEW SKIPPS, Morris Sweden

Directed by Jack Hawkins

It subsequently opened at the Globe Theatre, London, with this cast:

RICHARD, Richard Burton

THOMAS MENDIP, John Gielgud

ALIZON ELIOT, Claire Bloom

NICHOLAS DEVIZE, David Evans

MARGARET DEVIZE, Nora Nicholson

HUMPHREY DEVIZE, Richard Leech

HEBBLE TYSON, Harcourt Williams

JENNET JOURDEMAYNE, Pamela Brown

THE CHAPLAIN, Eliot Makeham

EDWARD TAPPERCOOM, Peter Bull

MATTHEW SKIPPS, Esme Percy

Directed by John Gielgud and Esme Percy

Scenery and costumes for both productions were by Oliver Messel.

ACT ONE

(The Scene (the house of HEBBLE TYSON, the Mayor of the little market town of Cool Clary) and the appearance of the characters are as much fifteenth century as anything. RICHARD, a young copying-clerk, stands working at a desk. THOMAS MENDIP, less young, in his late twenties perhaps, and less respectable, looks in through a great window from the garden.)

THOMAS: Soul!

RICHARD: – and the plasterer, that's fifteen groats –

THOMAS: Hey, soul!

RICHARD: – for stopping the draught in the privy –

THOMAS: Body!
 You calculating piece of clay!

RICHARD: Damnation.

THOMAS: Don't mention it. I've never seen a world
 So festering with damnation. I have left
 Rings of beer on every alehouse table
 From the salt sea-coast across half a dozen counties,
 But each time I thought I was on the way
 To a faintly festive hiccup
 The sight of the damned world sobered me up again.
 Where is the Mayor? I've business with His Worship.

RICHARD: Where have you come from?

THOMAS: Straight from your local.
 Damnation's pretty active there this afternoon,
 Licking her lips over gossip of murder and witchcraft;
 There's mischief brewing for someone. Where's the Mayor?

RICHARD: I'm the Mayor's clerk.

THOMAS: How are you?

RICHARD: Can I have your name?

THOMAS: It's yours.

RICHARD: Now, look –

THOMAS: It's no earthly

Use to me. I travel light; as light,
That is, as a man can travel who will
Still carry his body around because
Of its sentimental value. Flesh
Weighs like a thousand years, and every morning
Wakes heavier for an intake of uproariously
Comical dreams which smell of henbane.
Guts, humours, ventricles, nerves, fibres
And fat – the arterial labyrinth, body's hell.
Still, it was the first thing my mother gave me,
God rest her soul. What were you saying?

RICHARD: Name
And business.

THOMAS: Thomas Mendip. My well-born father,
If birth can ever be said to be well, maintains
A castle as draughty as a tree. At every sunset,
It falls into the river and fish swim through its walls.
They swim into the bosom of my grandmother
Who sits late, watching for the constellation of Orion
Because my dead grandfather, she believes,
Is situated somewhere in the Belt.
That is part of the glory of my childhood.

RICHARD: I like you as much as I've liked anybody.
Perhaps you're a little drunk. But here, I'm afraid,
They may not take to you.

THOMAS: That's what I hope.

RICHARD: Who told you to come here?
You couldn't have chosen a less fortunate afternoon.
They're expecting company – well, a girl. Excuse me,
I must get back to the books.

THOMAS: I'll wait.

RICHARD: He'll not
See anybody; I'm sure of it.

THOMAS: Dear boy,
I only want to be hanged. What possible
Objection can he have to that?

RICHARD: Why, no, I –
 To be – *want* to be hanged? How very drunk you are
 After all. Whoever would want to be hanged?

THOMAS: You don't
 Make any allowance for individuality.
 How do you know that out there, in the day or night
 According to latitude, the entire world
 Isn't wanting to be hanged? Now you, for instance,
 Still damp from your cocoon, you're desperate
 To fly into any noose of the sun that should dangle
 Down from the sky. Life, forbye, is the way
 We fatten for the Michaelmas of our own particular
 Gallows. What a wonderful thing is metaphor.

RICHARD: Was that a knock?

THOMAS: The girl. She knocks. I saw her
 Walking through the garden beside a substantial nun.
 Whsst! Revelation!

 (*Enter ALIZON ELIOT, aged seventeen, talking to herself.*)

ALIZON: Two steps down, she said. One, two,
 The floor. Now I begin to be altogether
 Different – I suppose.

RICHARD: O God, God,
 God, God, God. I can see such trouble!
 Is life sending a flame to nest in my flax?
 For pity's sake!

THOMAS: Sweet pretty noose, nice noose.

RICHARD: Will you step in?

ALIZON: They told me no one was here.

RICHARD: It would be me they meant.

ALIZON: Oh, would it be?
 Coming in from the light, I am all out at the eyes.
 Such white doves were paddling in the sunshine
 And the trees were as bright as a shower of broken glass.
 Out there, in the sparkling air, the sun and the rain
 Clash together like the cymbals clashing
 When David did his dance. I've an April blindness.

You're hidden in a cloud of crimson catherine-wheels.

RICHARD: It doesn't really matter. Sit in the shadow.

THOMAS: There are plenty to choose from.

ALIZON: Oh, there are three of us!
 Forgive me.

RICHARD: He's waiting – he wants – he says –

THOMAS: I breathe,
 I spit, I am. But take no further notice.
 I'll just nod in at the window like a rose;
 I'm a black and frosted rosebud whom the good God
 Has preserved since last October. Take no notice.

ALIZON: Men, to me, are a world to themselves.

RICHARD: Do you think so?

ALIZON: I am going to be married to one of them, almost at once.
 I have met him already.

RICHARD: Humphrey.

ALIZON: Are you his brother?

RICHARD: No. All I can claim as my flesh and blood
 Is what I stand up in. I wasn't born,
 I was come-across. In the dusk of one Septuagesima
 A priest found an infant, about ten inches long,
 Crammed into the poor-box. The money had all
 Been taken. Nothing was there except myself,
 I was the baby, as it turned out. The priest,
 Thinking I might have eaten the money, held me
 Upside down and shook me, which encouraged me
 To live, I suppose, and I lived.

ALIZON: No father or mother?

RICHARD: Not noticeably.

ALIZON: You mustn't let it make you
 Conceited. Pride is one of the deadly sins.

THOMAS: And it's better to go for the lively ones.

ALIZON: Which ones
 Do you mean?

THOMAS: Pay no heed. I was nodding in.

ALIZON: I am quite usual, with five elder sisters. My birth
 Was a great surprise to my parents, I think. There had been
 A misunderstanding and I appeared overnight
 As mushrooms do. My father thought
 He would never be able to find enough husbands
 For six of us, and so he made up his mind
 To simplify matters and let me marry God.
 He gave me to a convent.

RICHARD: What showing did he think he would make as God's
 Father-in-law?

ALIZON: He let his beard grow longer.
 But he found that husbands fell into my sisters' laps.
 So then he stopped thinking of God as eligible –
 No prospects, he thought. And so he looked round and
 found me
 Humphrey Devize. Do you think he will do?

RICHARD: Maybe.
 He isn't God, of course.

ALIZON: No, he isn't.
 He's very nearly black.

RICHARD: Swart.

ALIZON: Is that it?
 When he dies it may be hard to picture him
 Agreeable to the utter white of heaven.
 Now you, you are –

RICHARD: Purgatory-colour.

ALIZON: It's on the way to grace. Who are you?

RICHARD: Richard,
 The Mayor's copying-clerk.

ALIZON: The Mayor is Humphrey's
 Uncle. Humphrey's mother is the Mayor's sister.
 And then, again, there's Nicholas, Humphrey's brother.
 Is he sensible?

RICHARD: He knows his way about.

THOMAS: O enviable Nick.

RICHARD: He's nodding in.

ALIZON: I'll tell you a strange thing. Humphrey Devize
 Came to the convent to see me, bringing a present
 For his almost immediate wife, he said, which is me,
 Of barley-sugar and a cross of seed-pearls. Next day
 Nicholas came, with a little cold pie, to say
 He had a message from Humphrey. And then he sat
 And stared and said nothing until he got up to go.
 I asked him for the message, but by then
 It had gone out of his head. Quite gone, you see.
 It was curious. – Now you're not speaking either.

RICHARD: Yes, of course; of course it was curious.

ALIZON: Men are strange. It's almost unexpected
 To find they speak English. Do you think so too?

RICHARD: Things happen to them.

ALIZON: What things?

RICHARD: Machinations of nature;
 As April does to the earth.

ALIZON: I wish it were true!
 Show me daffodils happening to a man!

RICHARD: Very easily.

THOMAS: And thistles as well, and ladies'
 Bedstraw and deadly nightshade and the need
 For rhubarb.

ALIZON: Is it a riddle?

RICHARD: Very likely.
 Certainly a considerable complication.
 (*Enter NICHOLAS DEVIZE, muddy, dishevelled.*)

NICHOLAS: Where are you, Alizon? Alizon, what do you think?
 I've won you from him! I've destroyed my brother!
 It's me you're going to marry. What do you think
 Of that?

RICHARD: You have mud in your mouth.

NICHOLAS: You canter off.

ALIZON: No, Nicholas. That's untrue. I have to be
 The wife of Humphrey.

NICHOLAS: Heaven says no. Heaven
And all the nodding angels say
Alizon for Nicholas, Nicholas for Alizon.
You must come to know me; not so much now, because now
I'm excited, but I have at least three virtues.
How many have you got?

RICHARD: Are you mad? Why don't you
Go and clean yourself up?

NICHOLAS: What shall I do
With this nattering wheygoose, Alizon?
Shall I knock him down?

ALIZON: His name is Richard, he says;
And I think he might knock you down.

THOMAS: Nicholas,
He might. There you have a might, for once,
That's right. Forgive me; an unwarranted interruption.

NICHOLAS: Come in, come in. – Alizon, dear, this Richard
Is all very well. But I was conceived the night
The church was struck by lightning
And born in the great gale. I apologise
For boasting, but once you know my qualities
I can drop back into a quite brilliant
Humility. God have mercy upon me,
You have such little hands. I knew I should love you.

RICHARD: Just tell me: am I to knock him down? You have only
To say so.

ALIZON: No, oh no. We only have
To be patient and unweave him. He is mixed,
Aren't you, Nicholas?

NICHOLAS: Compounded of explosives
Like the world's inside. I'm the recipe God followed
In the creation. It took the roof off his oven.
How long will it be before you love me, Alizon?
Let's go.

(*He picks her up in his arms. Enter MARGARET DEVIZE.*)

MARGARET: Where are you taking Alizon, Nicholas?

NICHOLAS: Out into the air, mother.

MARGARET: Unnecessary.
　　She's in the air already. This room is full of it.
　　Put her down, Nicholas. You look
　　As though you had come straight out of a wheelbarrow;
　　And not even straight out.

NICHOLAS: I have to tell you
　　I've just been reborn.

MARGARET: Nicholas, you always think
　　You can do things better than your mother. You can be sure
　　You were born quite adequately on the first occasion.
　　There is someone here I don't know. Who is it, Alizon?
　　Did he come with you?

ALIZON: Oh, no. A rosebud, he says,
　　He budded in October.

MARGARET: He's not speaking the truth. – Tch! more rain!
　　This is properly April. – And you're eager to see
　　Your handsome Humphrey. Nicholas will fetch him.
　　They're inseparable, really twin natures, utterly
　　Brothers, like the two ends of the same thought. –
　　Nicholas, dear, call Humphrey.

NICHOLAS: I can't. I've killed him.

MARGARET: Fetch Humphrey, Nicholas dear.

NICHOLAS: I've killed him, dearest
　　Mother.

MARGARET: Well, never mind. Call Humphrey, dear.

THOMAS: Is that the other end of this happy thought,
　　There, prone in the flower-bed?

RICHARD: Yes, it's Humphrey
　　Lying in the rain.

MARGARET: One day I shall burst my bud
　　Of calm, and blossom into hysteria.
　　Tell him to get up. What on earth is he doing
　　Lying in the rain?

THOMAS: All flesh is grass.

ALIZON: Have you really killed Humphrey?

MARGARET: Nicholas,
 Your smile is no pleasure to me.

NICHOLAS: We fought for possession
 Of Alizon Eliot. What could be more natural?
 What he loves, I love. And if existence will
 Disturb a man with beauty, how can he help
 Trying to impose on her the boundary
 Of his two bare arms? – Pandemonium, what a fight!
 What a fight! Humphrey went hurtling
 Like Lucifer into the daffodils.
 When Babylon fell there wasn't a better thump.

MARGARET: Are you standing there letting your brother be
 rained on?
 Haven't you any love for him?

NICHOLAS: Yes, mother,
 But wet as well as dry.

MARGARET: Can Richard carry him
 Single-handed?

NICHOLAS: Why can't he use both hands?
 And how did I know it was going to rain?
 (*Exit NICHOLAS with RICHARD.*)

MARGARET: I would rather have to plait the tails of unbroken
 Ponies than try to understand Nicholas.
 Oh! it's bell-ringing practice. Their ding-dong rocks me
 Till my head feels like the belfry, and makes blisters
 All along my nerves. Dear God, a cuckoo
 As well!

THOMAS: By God, a cuckoo! Grief and God,
 A canting cuckoo, that laugh with no smile!
 A world unable to die sits on and on
 In spring sunlight, hatching egg after egg,
 Hoping against hope that out of one of them
 Will come the reason for it all; and always
 Out pops the arid chuckle and centuries
 Of cuckoo-spit.

MARGARET: I don't really think we need
 To let that worry us now. I don't know why you're waiting,
 Or who brought you, or whether I could even
 Begin to like you, but I know it would be agreeable
 If you left us. There's enough going on already.

THOMAS: There is certainly enough going on.
 Madam, watch Hell come
 As a gleam into the eye of the wholesome cat
 When philip-sparrow flips his wing.
 I see a gleam of Hell in *you,* madam.
 You understand those bells perfectly.
 I understand them, too.
 What is it that, out there in the mellow street,
 The soft rain is raining on?
 Is it only on the little sour grass, madam?

MARGARET: Out in the street? What could it be?

THOMAS: It could be,
 And it is, a witch-hunt.

MARGARET: Oh! – dear; another?

THOMAS: Your innocence is on at such a rakish angle
 It gives you quite an air of iniquity.
 Hadn't you better answer that bell? With a mere
 Clouding of your unoccupied eyes, madam,
 Or a twitch of the neck: what better use can we put
 Our faces to than to have them express kindness
 While we're thinking of something else? Oh, be disturbed,
 Be disturbed, madam, to the extent of a tut
 And I will thank God for civilisation.
 This is my last throw, my last poor gamble
 On the human heart.

MARGARET: If I knew who you were
 I should ask you to sit down. But while you're on
 Your feet, would you be kind enough to see
 How Humphrey is doing?

THOMAS: If we listened, we could hear
 How the hunters, having washed the dinner things,

Are now toiling up and down the blind alleys
Which they think are their immortal souls,
To scour themselves in the blood of a grandmother.
They, of course, will feel all the better for it.
But she? Grandma? Is it possible
She may be wishing she had died yesterday,
The wicked sobbing old body of a woman?

MARGARET: At the moment, as you know,
I'm trying hard to be patient with my sons.
You really mustn't expect me to be Christian
In two directions at once.

THOMAS: What, after all,
Is a halo? It's only one more thing to keep clean.
Richard and Nicholas
Have been trying to persuade the body to stand up.

ALIZON: Why, yes, he isn't dead. He's lying on his back
Picking the daffodils. And now they are trying
To lift him.

MARGARET: Let me look over your shoulder.
They mustn't see me taking an interest.
Oh, the poor boy looks like a shock
Of bedraggled oats. – But you will see, Alizon,
What a nice boy he can be when he wears a clean shirt.
I more than once lost my heart to clean linen
When I was a young creature, even to linen
That hung on the hedges without a man inside it.
Do I seem composed, sufficiently placid and unmotherly?

ALIZON: Altogether, except that your earring
Trembles a little.

MARGARET: It's always our touches of vanity
That manage to betray us.

THOMAS: When shall I see the Mayor?
I've had enough of the horror beating in the belfry.
Where is the Mayor?

*(Re-enter RICHARD and NICHOLAS carrying HUMPHREY who
has a bunch of daffodils in his hand.)*

NICHOLAS: Here's Humphrey. Where would you like him?

MARGARET: Humphrey, why do you have to be carried?

HUMPHREY: My dear
　　Mother, I didn't knock myself down. Why
　　Should I pick myself up? – Daffodils
　　For my future wife.

NICHOLAS: You swindling half-cock alderman!
　　Do I have to kill you a second time?
　　I've proved my right to have her.

HUMPHREY: Nothing of the sort. Officially
　　Alizon is mine. What is official
　　Is incontestable. – Without disrespect either
　　To you, mother, or to my officially
　　Dear one, I shall lie down. – Who is playing the viol?

MARGARET: The Chaplain is tuning his G string by the bells.
　　It must be time for prayers. It must be time
　　For something. You're both transfigured with dirt.

THOMAS: Where in thunder is the Mayor? Are you deaf to
　　　the baying
　　Of those human bloodhounds out in the street?
　　I want to be hanged.

NICHOLAS: (*To HUMPHREY.*) You dismal coprolite!
　　It's in my stars I should have her. Wait
　　Till it's dark, and go out if you dare
　　Bareheaded under the flash of my star Mercury.
　　Ignore the universe if you can. Go on,
　　Ignore it! – Alizon, who's going to marry you?

MARGARET: He deserves no answer.

RICHARD: Can you tell us, Alizon?

ALIZON: I am not very used to things happening rapidly.
　　The nuns, you see, were very quiet, especially
　　In the afternoon. They say I shall marry Humphrey.

MARGARET: Certainly so. Now, Nicholas, go and get clean.

NICHOLAS: She never shall!

THOMAS: Will someone fetch the Mayor?
　　Will no one make the least effort to let me

Out of the world?

NICHOLAS: Let Humphrey go and officially
Bury himself. She's not for him.
What does love understand about hereinafter-
Called-the-bride-contracted?
An April anarchy, she is, with a dragon's breath,
An angel on a tiger,
The jaws and maw of a kind of heaven, though hell
Sleeps there with one open eye; an onslaught
Unpredictable made by a benefactor
Armed to the teeth –

THOMAS: Who benefits, before God,
By this collision of the sexes,
This paroxysm of the flesh? Let me get out!
I'll find the Mayor myself
And let you go on with your psalm of love.
(*He makes for the door.*)

HUMPHREY: Who the hell's that?

RICHARD: The man about the gallows.
(*Enter HEBBLE TYSON the Mayor, afflicted with office.*)

MARGARET: Now here's your uncle. Do, for the sake of calm,
Go and sweeten yourselves.

THOMAS: Is this the man
I long for?

TYSON: Pest, who has stolen my handkerchief?

MARGARET: Use this one, Hebble. – Go and get under the pump.
(*Exit HUMPHREY and NICHOLAS.*)

TYSON: (*Blowing his nose.*) Noses, noses.

THOMAS: Mr Mayor, it's a joy to see you.
You're about to become my gateway to eternal
Rest.

TYSON: Dear sir, I haven't yet been notified
Of your existence. As far as I'm concerned
You don't exist. Therefore you are not entitled
To any rest at all, eternal or temporary,

And I would be obliged if you'd sit down.

MARGARET: Here is Alizon Eliot, Humphrey's bride
 To be.

THOMAS: I have come to be hanged, do you hear?

TYSON: Have you filled in the necessary forms? –
 So this is the young lady? Very nice, very charming. –
 And a very pretty dress.
 Splendid material, a florin a yard
 If a groat. I'm only sorry you had to come
 On a troubled evening such as this promises
 To be. The bells, you know. Richard, my boy,
 What is it this importunate fellow wants?

RICHARD: He says he wants to be hanged, sir.

TYSON: Out of the question.
 It's a most immodest suggestion; which I know
 Of no precedent for. Cannot be entertained.
 I suspect an element of mockery
 Directed at the ordinary decencies
 Of life. – Tiresome catarrh. – A sense of humour
 Incompatible with good citizenship
 And I wish you a good evening. Are we all
 Assembled together for evening prayers?

THOMAS: Oh no!
 You can't postpone me. Since opening-time I've been
 Propped up at the bar of heaven and earth, between
 The wall-eye of the moon and the brandy-cask of the sun,
 Growling thick songs about jolly good fellows
 In a mumping pub where the ceiling drips humanity,
 Until I've drunk myself sick, and now, by Christ,
 I mean to sleep it off in a stupor of dust
 Till the morning after the day of judgement.
 So put me on the waiting-list for your gallows
 With a note recommending preferential treatment.

TYSON: Go away; you're an unappetising young man
 With a tongue too big for your brains. I'm not at all sure
 It would be amiss to suppose you to be a vagrant,

In which case an unfortunate experience
At the cart's tail –

THOMAS: Unacceptable.
Hanging or nothing.

TYSON: Get this man away from here!
Good gracious, do you imagine the gallows to be
A charitable institution? Very mad,
Wishes to draw attention to himself;
The brain a delicate mechanism; Almighty
God more precise than a clockmaker;
Grant us all a steady pendulum.

ALL: Amen.

THOMAS: Listen! The wild music of the spheres:
Tick-tock.

RICHARD: Come on; you've got to go.

THOMAS: Does Justice with her sweet, impartial sword
Never come to this place? Do you mean
There's no recognition given to murder here?

MARGARET: Murder – ?

TYSON: Now what is it?

THOMAS: I'm not a fool.
I didn't suppose you would do me a favour for nothing.
No crime, no hanging; I quite understand the rules.
But I've made that all right. I managed to do-in
A rag-and-bone merchant at the bottom of Leapfrog Lane.

TYSON: (*Staring.*) Utterly unhinged.

MARGARET: Hebble, they're all
In the same April fit of exasperating nonsense.
Nicholas, too. He said he had killed Humphrey
But of course he hadn't. If he had I should have told you.

THOMAS: It was such a monotonous cry, that 'Rag-a-boa!'
Like the damned cuckoo. It was more than time
He should see something of another world.
But, poor old man, he wasn't anxious to go.
He picked on his rags and his bones as love

Picks upon hearts, he with an eye to profit
And love with an eye to pain.

RICHARD: *Sanctus fumus!*

TYSON: Get a complete denial of everything
He has said. I don't want to be bothered with you.
You don't belong to this parish. I'm perfectly satisfied
He hasn't killed a man.

THOMAS: I've killed two men
If you want me to be exact.
The other I thought scarcely worth mentioning:
A quite unprepossessing pig-man with a birthmark.
He couldn't have had any affection for himself.
So I pulped him first and knocked him into the river
Where the water gives those girlish giggles around
The ford, and held him under with my foot
Until he was safely in Abram's bosom, birthmark
And all. You see, it still isn't properly dry.

TYSON: What a confounded thing! Who do people
Think they are, coming here without
Identity, and putting us to considerable
Trouble and expense to have them punished?
You don't deserve to be listened to.

THOMAS: It's habit.
I've been unidentifiably
Floundering in Flanders for the past seven years,
Prising open ribs to let men go
On the indefinite leave which needs no pass.
And now all roads are uncommonly flat, and all hair
Stands on end.

(*Enter NICHOLAS.*)

NICHOLAS: I'm sorry to interrupt
But there's a witch to see you, uncle.

TYSON: To see me?
A witch to see me? I will not be the toy
Of irresponsible events. Is that clear
To you all?

NICHOLAS: Yes. But she's here.

TYSON: A witch to see me!
Do I have to tell you what to do with her?

NICHOLAS: Don't tell me. My eyes do that only too well.
She is the one, of witches she's the one
Who most of all disturbs Hell's heart. Jimminy!
How she must make Torment sigh
To have her to add to its torment! How the flames
Must burn to lay their tongues about her.
If evil has a soul it's here outside,
The flower of sin, Satan's latest
Button-hole. Shall I ask her in?

THOMAS: She's young,
O God, she's young.

TYSON: I stare at you, Nicholas,
With no word of condemnation. I stare,
Astonished at your behaviour.

MARGARET: Ask her in?
In here? Nicholas –

NICHOLAS: She's the glorious
Undercoat of this painted world –
(*JENNET JOURDEMAYNE stands in the doorway.*)
– You see:
It comes through, however much of our whiteness
We paint over it.

TYSON: What is the meaning of this?
What is the meaning of this?

THOMAS: That's the most relevant
Question in the world.

JENNET: Will someone say
Come in? And understand that I don't every day
Break in on the quiet circle of a family
At prayers? Not quite so unceremoniously,
Or so shamefully near a flood of tears,
Or looking as unruly as I surely do. Will you
Forgive me?

TYSON: You'll find I can't be disarmed
 With pretty talk, young woman. You have no business
 At all in this house.

JENNET: Do you know how many walls
 There are between the garden of the Magpie,
 Past Lazer's field, Slink Alley and Poorsoul Pond
 To the gate of your paddock?

TYSON: I'm not to be seduced.
 I'm not attending.

JENNET: Eight. I've come over them all.

MARGARET: How could she have done?

THOMAS: Her broomstick's in the hall.

MARGARET. Come over to this side of the room, Nicholas.

NICHOLAS: Don't worry, mother, I have my fingers crossed.

TYSON: Never before in the whole term of my office
 Have I met such extraordinary ignorance
 Of what is permitted –

JENNET: Indeed, I was ignorant.
 They were hooting and howling for me, as though echoes
 Could kill me. So I started to run. Thank God
 I only passed one small girl in a ditch
 Telling the beads of her daisy-chain.
 And a rumpled idiot-boy who smiled at me.
 They say I have turned a man into a dog.

TYSON: This will all be gone into
 At the proper time –

JENNET: But it isn't a dog at all,
 It's a bitch; a rather appealing brindle bitch
 With many fleas. Are you a gentleman
 Full of ripe, friendly wisdom?

TYSON: This
 Will all be gone into at the proper –

JENNET: If so
 I will sit at your feet. I will sit anyway;
 I am tired. Eight walls are enough.

MARGARET: What do we do?
 I can almost feel the rustling-in of some
 Kind of enchantment already.

TYSON: She will have
 To be put in charge.

ALIZON: Oh, must she, must she?

THOMAS: He can see she's a girl of property,
 And the property goes to the town if she's a witch;
 She couldn't have been more timely.

NICHOLAS: Curious, crooked
 Beauty of the earth. Fascinating.

TYSON: (*To JENNET.*) Get up at once, you undisciplined girl. Have
 you never
 Heard of law and order?

NICHOLAS: Won't you use
 This chair?

JENNET: Thank you. Oh, this is the reasonable
 World again! I promise not to leave behind me
 Any flymarks of black magic, or any familiars
 Such as mice or beetles which might preach
 Demonology in your skirting-board.
 It's unbelievable, the quite fantastic
 Tales they tell!

TYSON: This will be discussed
 At the proper time –

THOMAS: When we have finished talking
 About my murders.

MARGARET: Are they both asking to be punished? Has death
 Become the fashionable way to live?
 Nothing would surprise me in their generation.

JENNET: Asking to be punished? Why, no, I have come
 Here to have the protection of your laughter.
 They accuse me of such a brainstorm of absurdities
 That all my fear dissolves in the humour of it.
 If I could perform what they say I *can* perform

 I should have got safely away from here
 As fast as you bat your eyelid.

TYSON: Oh, indeed;
 Could you indeed?

JENNET: They say I have only
 To crack a twig, and over the springtime weathercocks
 Cloudburst, hail and gale, whatever you will,
 Come leaping fury-foremost.

TYSON: The report
 May be exaggerated, of course, but where there's smoke…

JENNET: They also say that I bring back the past;
 For instance, Helen comes,
 Brushing the maggots from her eyes,
 And, clearing her throat of several thousand years,
 She says 'I loved…'; but cannot any longer
 Remember names. Sad Helen. Or Alexander, wearing
 His imperial cobwebs and breastplate of shining worms
 Wakens and looks for his glasses, to find the empire
 Which he knows he put beside his bed.

TYSON: Whatever you say will be taken down in evidence
 Against you; am I making myself clear?

JENNET: They tell one tale, that once, when the moon
 Was gibbous and in a high dazed state
 Of nimbus love, I shook a jonquil's dew
 Onto a pearl and let a cricket chirp
 Three times, thinking of pale Peter:
 And there Titania was, vexed by a cloud
 Of pollen, using the sting of a bee to clean
 Her nails and singing, as drearily as a gnat,
 'Why try to keep clean?'

THOMAS: 'The earth is all of earth' –
 So sang the queen:
 So the queen sung,
 Crumbling her crownet into clods of dung.

JENNET: You heard her, too, Captain? Bravo. Is that
 A world you've got there, hidden under your hat?

THOMAS: Bedlam, ma'am, and the battlefield
 Uncle Adam died on. He was shot
 To bits with the core of an apple
 Which some fool of a serpent in the artillery
 Had shoved into God's cannon.

TYSON: That's enough!
 Terrible frivolity, terrible blasphemy,
 Awful unorthodoxy. I can't understand
 Anything that is being said. Fetch a constable.
 The woman's tongue clearly knows the flavour
 Of *spiritu maligno.* The man must be
 Drummed out of the town.

THOMAS: Oh, *must* he be?

RICHARD: Are you certain, sir? The constable? The lady
 Was laughing. She laughed at the very idea
 Of being a witch, sir.

TYSON: Yes, just it, just it.
 Giving us a rigmarole of her dreams:
 Probably dreams: but intentionally
 Recollected, intentionally consented to,
 Intentionally delighted in. And so
 As dangerous as the act. Fetch the constable.

NICHOLAS: Sad, how things always are. We get one gulp
 Of dubious air from our hellmost origins
 And we have to bung up the draught with a constable.
 It's a terribly decontaminating life.

TYSON: I'll not have any frivolity.
 The town goes in terror.
 I have told you, Richard, twice, what to do.
 Are you going about it?

RICHARD: No, sir. Not yet.

TYSON: Did you speak to me? Now be careful how you answer.

JENNET: Can you be serious? I am Jennet Jourdemayne
 And I believe in the human mind. Why play with me
 And make me afraid of you, as you did for a moment,
 I confess it. You can't believe – oh, surely, not

When the centuries of the world are piled so high –
You'll not believe what, in their innocence,
Those old credulous children in the street
Imagine of me?

THOMAS: Innocence! Dear girl,
Before the world was, innocence
Was beaten by a lion all round the town.
And liked it.

JENNET: What, does everyone still knuckle
And suckle at the big breast of irrational fears?
Do they really think I charm a sweat from Tagus,
Or lure an Amazonian gnat to fasten
On William Brown and shake him till he rattles?
Can they think and then think like this?

TYSON: Will be
Gone into at the proper time. Disturbing
The peace. In every way. Have to arrest you.

JENNET: No!

THOMAS: You bubble-mouthing, fog-blathering,
Chin-chuntering, chap-flapping, liturgical,
Turgidical, base old man! What about my murders?
And what goes round in *your* head,
What funny little murders and fornications
Chatting up and down in three-four time
Afraid to come out? What bliss to sin by proxy
And do penance by way of someone else!
But we'll not talk about you. It will make the outlook
So dark. Neither about this exquisitely
Mad young woman. Nor about this congenital
Generator, your nephew here;
Nor about anyone but me. I'm due
To be hanged. Good Lord, aren't two murders enough
To win me the medals of damnation? Must I put
Half a dozen children on a spit
And toast them at the flame that comes out of my mouth?

You let the fairies fox you while the devil
Does you. Concentrate on me.

TYSON: I'll not
Have it – I'll – I'll –

THOMAS: Power of Job!
Must I wait for a stammer? Your life, sir, is propelled
By a dream of the fear of having nightmares; your love
Is the fear of being alone; your world's history
The fear of a possible leap by a possible antagonist
Out of a possible shadow, or a not-improbable
Skeleton out of your dead-certain cupboard.
But here am I, the true phenomenon
Of acknowledged guilt, steaming with the blood
Of the pig-man and the rag-and-bone man, Crime
Transparent. What the hell are we waiting for?

TYSON: Will you attend to me? Will you be silent?

JENNET: Are you doing this to save me?

THOMAS: You flatter my powers,
My sweet; you're too much a woman. But if you wish
You can go down to the dinner of damnation
On my arm.

JENNET: I dine elsewhere.

TYSON: Am I invisible?
Am I inaudible? Do I merely festoon
The room with my presence? Richard, wretched boy,
If you don't wish to incur considerable punishment
Do yourself the kindness to fetch the constable.
I don't care for these unexpurgated persons.
I shall lose my patience.

MARGARET: I shall lose my faith
In the good-breeding of providence. Wouldn't this happen
Now: today: within an hour or two
Of everyone coming to congratulate
Humphrey and Alizon. Arrangements were made
A month ago, long before this gentleman's
Murders were even thought of.

TYSON: They don't exist,
 I say —
 (*Enter HUMPHREY.*)

HUMPHREY: Uncle, there's a sizeable rumpus,
 Without exaggeration a how-do-you-do
 Taking place in the street. I thought you should know.

TYSON: Rumpus?

HUMPHREY: Perhaps rumpus isn't the word.
 A minor kind of bloody revolution.
 It's this damned rascal, this half-pay half-wit.
 I should say he's certifiable. It seems
 He's been spreading all around the town some tale
 About drowning a pig-man and murdering old Skipps
 The rag-and-bone man.

THOMAS: Ah, old Skipps, old Skipps,
 What a surplus of bones you'll have where you've gone to now!

JENNET: Old Skipps? But he's the man —

TYSON: Will you both be silent?
 I won't have every Tom, Dick and Harry
 Laying information against himself before
 He's got written authority from me.

HUMPHREY: Quite right.
 As it is, the town is hell's delight. They've looked
 For the drowned pig-man and they've looked for Skipps
 And they've looked in the places where he says he left them
 And they can't find either.

NICHOLAS: Can't find either?

HUMPHREY: Can't find either.

MARGARET: Of course they can't. When he first
 Mentioned murders I knew he had got hold
 Of a quite wrong end of the stick.

HUMPHREY: They say he's the Devil.

MARGARET: I can imagine who started *that* story.

HUMPHREY: But are we so sure he isn't? Outside in the street
 They're convinced he's the Devil. And none of us ever having

 Seen the Devil, how can we know? They say
 He killed the old men and spirited them into the Limbo.
 We can't search there. I don't even know where it is.

THOMAS: Sir, it's between me and the deep blue sea.
 The wind of conscience blows straight from its plains.

HUMPHREY: Shut up. – If you're the Devil I beg your pardon. –
 They also have the idea
 He's got a girl in his toils, a witch called –

JENNET: Jennet.
 I am she.

HUMPHREY: God.

TYSON: Well, Humphrey, well?
 Is that the end of your information?

NICHOLAS: Humphrey,
 Have you spoken to your little future wife
 Lately?

THOMAS: Tinder, easy tinder.

HUMPHREY: In fact –
 In fact –

NICHOLAS: In fact it's all a bloody revolution.

TYSON: I'm being played with, I'm sure of it; something tells me
 There is irresponsibility somewhere. Richard,
 You'll not get out of this lightly. Where's the constable?
 Why isn't he standing before me?

RICHARD: I can see
 No need for the constable, sir.

TYSON: No need? No need?

 (Enter the CHAPLAIN with his viol.)

CHAPLAIN: I am late for prayers, I know; I know you think me
 A broken reed, and my instrument too, my better half,
 You lacked it, I'm afraid. But life has such
 Diversity, I sometimes remarkably lose
 Eternity in the passing moment. Just now
 In the street there's a certain boisterous interest
 In a spiritual matter. They say –

TYSON: I know what they say.

CHAPLAIN: Ah yes; you know. Sin, as well as God,
Moves in a most mysterious way. It is hard to imagine
Why the poor girl should turn Skipps into a dog.

NICHOLAS: Skipps? Skipps into a dog?

HUMPHREY: But Skipps –

THOMAS: Skipps trundles in another place, calling
His raga-boa in gutters without end,
Transfigured by the spatial light
Of Garbage Indestructible. And I
Ought to know since I sent him there. A dog?
Come, come; don't let's be fanciful.

TYSON: They say one thing and another thing and both at once;
I don't know. It will all have to be gone into
At the proper time –

HUMPHREY: But this is a contradiction –

CHAPLAIN: Ah, isn't that life all over? And is this
The young assassin? If he is the doer of the damage
Can it be she also? My flock are employing
Fisticuffs over this very question.

HUMPHREY: But if he could be the Devil –

THOMAS: Good boy! Shall I set
Your minds at rest and give you proof? Come here.
(*He whispers in HUMPHREY's ear.*)

HUMPHREY: That's not funny.

THOMAS: Not funny for the goats.

HUMPHREY: I've heard it before. He says the Day of Judgement
Is fixed for tonight.

MARGARET: Oh no. I have always been sure
That when it comes it will come in the autumn.
Heaven, I am quite sure, wouldn't disappoint
The bulbs.

THOMAS: Consider: vastness lusted, mother;
A huge heaving desire, overwhelming solitude,
And the mountain belly of Time laboured

And brought forth man, the mouse. The spheres churned on,
Hoping to charm our ears
With sufficient organ-music, sadly sent out
On the wrong wave of sound; but still they roll
Fabulous and fine, a roundabout
Of doomed and golden notes. And on beyond,
Profound with thunder of oceanic power,
Lie the morose dynamics of our dumb friend
Jehovah.
Why should these omnipotent bombinations
Go on with the deadly human anecdote, which
From the first was never more than remotely funny?
No; the time has come for tombs to tip
Their refuse; for the involving ivy, the briar,
The convolutions of convolvulus,
To disentangle and make way
For the last great ascendancy of dust,
Sucked into judgement by a cosmic yawn
Of boredom. The Last Trump
Is timed for twenty-two forty hours precisely.

TYSON: This will all be gone into at the proper –

THOMAS: Time
Will soon be most improper. Why not hang me
Before it's too late?

MARGARET: I shall go and change my dress;
Then I shall both be ready for our guests
And whatever else may come upon the world.

HUMPHREY: I'm sure he's mad.

CHAPLAIN: And his information, of course,
Is in opposition to what we are plainly told
In the Scriptures: that the hour will come –

NICHOLAS: Do you think
He means it? I've an idea he's up to something
None of us knows about, not one of us.

ALIZON: (*Who has found her way to RICHARD.*) Quiet Richard, son
of nobody.

RICHARD: (*Whispering.*) It isn't always like this, I promise it isn't.

JENNET: May I, Jennet Jourdemayne, the daughter
 Of a man who believed the universe was governed
 By certain laws, be allowed to speak?
 Here is such a storm of superstition
 And humbug and curious passions, where will you start
 To look for the truth? Am I in fact
 An enchantress bemused into collaboration
 With the enemy of man? Is this the enemy,
 This eccentric young gentleman never seen by me
 Before? I say I am not. He says perhaps
 He is. You say I am. You say he is not.
 And now the eccentric young gentleman threatens us all
 With imminent cataclysm. If, as a living creature,
 I wish in ail good faith to continue living,
 Where do you suggest I should lodge my application?

TYSON: That is perfectly clear. You are both under arrest.

THOMAS: Into Pandora's box with all the ills.
 But not if that little hell-cat Hope's
 Already in possession. I've hoped enough.
 I gave the best years of my life to that girl,
 But I'm walking out with Damnation now, and she's
 A flame who's got finality.

JENNET: Do you want no hope for me either? No compassion
 To lift suspicion off me?

THOMAS: Lift? Compassion
 Has a rupture, lady. To hell with lifting.

JENNET: Listen, please listen to me!

THOMAS: Let the world
 Go, lady; it isn't worth the candle.

TYSON: Take her, Richard; down to the cellars.

THOMAS: You see?
 He has the key to every perplexity.
 Kiss your illusions for me before they go.

JENNET: But what will happen?

THOMAS: That's something even old nosedrip doesn't know.

(*RICHARD leads JENNET away.*)

TYSON. Take him away!

THOMAS: Mr Mayor, hang me for pity's sake,
For God's sake hang me, before I love that woman!

(*Curtain on Act One.*)

ACT TWO

(The same room, about an hour later. The CHAPLAIN in a chair, sleeping. TYSON surrounded with papers. EDWARD TAPPERCOOM, the town's Justice, mountainously rolling up and down the room.)

TAPPERCOOM: Well, it's poss-ss-ible, it's poss-ss-ible.
 I *may* have been putting the Devil to the torture.
 But can you smell scorching? – not a singe
 For my sins – that's from yesterday: I leaned
 Across a candle. For all practical purposes
 I feel as unblasted as on the day I was born.
 And God knows I'm a target. Cupid scarcely
 Needs to aim, and no devil could miss me.

TYSON: But his action may be delayed. We really must
 Feel our way. We don't want to put ourselves wrong
 With anything as positive as evil.

TAPPERCOOM: We have put him to the merest thumbscrew,
 Tyson,
 Courteously and impartially, the purest
 Cajolery to coax him to deny
 These cock-and-bull murders for which there isn't a scrap
 Of evidence.

TYSON: Ah; ah. How does he take it?
 Has he denied them?

TAPPERCOOM: On the contrary.
 He says he has also committed petty larceny,
 Abaction, peculation and incendiarism.
 As for the woman Jourdemayne –

TYSON: Ah, yes,
 Jourdemayne; what are we to make of her?
 Wealthy, they tell me. But on the other hand
 Quite affectingly handsome. Sad, you know.
 We see where the eye can't come, eh, Tappercoom?
 And all's not glorious within; no use

Saying it is. – I had a handkerchief.
Ah yes; buried amongst all this evidence.

TAPPERCOOM: Now, no poetics, Tyson. Blow your nose
And avoid lechery. Keep your eye on the evidence
Against her; there's plenty of it there. Religion
Has made an honest woman of the supernatural
And we won't have it kicking over the traces again,
Will we, Chaplain? – In the Land of Nod.
Admirable man.

TYSON: Humanity,
That's all, Tappercoom; it's perfectly proper.
No one is going to let it interfere
With anything serious. I use it with great
Discretion, I assure you. – Has she confessed?

TAPPERCOOM: Not at all. Though we administer persuasion
With great patience, she admits nothing. And the man
Won't stop admitting. It really makes one lose
All faith in human nature.

(*Enter MARGARET, without her placidity.*)

MARGARET: Who has the tongs?
The tongs, Hebble, the tongs, dear! Sweet
Elijah, we shall all go up in flames!

TYSON: Flames? Did you hear that, Tappercoom? Flames!
My sister said flames!

MARGARET: A log the size of a cheese
Has fallen off the fire! Well, where are they?
What men of action! Tongs, I said! – Chaplain,
They're under your feet. Very simple you'd look
As a pile of ashes.

(*Exit.*)

TYSON: Oh. I beg your pardon,
Tappercoom. A blazing log.

CHAPLAIN: Would there be something
I could do? I was asleep, you know.

TYSON: All this evidence from the witchfinder…

TAPPERCOOM: The advent of a woman cannot be
 Too gradual. I am not a nervous man
 But I like to be predisposed to an order of events.
CHAPLAIN: It was very interesting: I was dreaming I stood
 On Jacob's ladder, waiting for the Gates to open.
 And the ladder was made entirely of diminished sevenths.
 I was surprised but not put out. Nothing
 Is altogether what we suppose it to be.
TAPPERCOOM: As for the Day of Judgement, we can be sure
 It's not due yet. What are we told the world
 Will be like? 'Boasters, blasphemers, without natural
 Affection, traitors, trucebreakers', and the rest of it.
 Come, we've still a lot of backsliding ahead of us.
TYSON: Are you uneasy, Tappercoom?
TAPPERCOOM: No, Tyson.
 The whole thing's a lot of amphigourious
 Stultiloquential fiddle-faddle.

 (Re-enter MARGARET, head-first.)

MARGARET: Hebble!

TAPPERCOOM: For God's sake!

TYSON: What is it now? What is it?

MARGARET: The street's gone mad. They've seen a shooting star!

TYSON: They? Who? What of it?

MARGARET: I'm sure I'm sorry,
 But the number of people gone mad in the street
 Is particularly excessive. They were shaking
 Our gate, and knocking off each other's hats
 And six fights simultaneously, and some
 Were singing psalm a hundred and forty – I think
 It's a hundred and forty – and the rest of them shouting
 'The Devil's in there!' (pointing at this house)
 'Safety from Satan!' and 'Where's the woman? Where's
 The witch? Send her out!'; and using words
 That are only fit for the Bible. And I'm sure
 There was blood in the gutter from somebody's head
 Or else it was the sunset in a puddle,

But Jobby Pinnock was prising up cobblestones,
Roaring like the north wind, and you know
What he is in church when he starts on the responses.
And that old Habbakuk Brown using our wall
As it was never meant to be used. And then
They saw the star fall over our roof somewhere
And followed its course with a downrush of whistling
And Ohs and Ahs and groans and screams; and Jobby
Pinnock dropped a stone on his own foot
And roared 'Almighty God, it's a sign!' and some
Went down on their knees and others fell over them
And they've started to fight again, and the hundred and fortieth
Psalm has begun again louder and faster than ever.
Hebble dear, isn't it time they went home?

TYSON: All right, yes, all right, all right. Now why
Can't people mind their own business? This shooting star
Has got nothing to do with us, I am quite happy
In my mind about that. It probably went past
Perfectly preoccupied with some astral anxiety or other
Without giving us a second thought. Eh, Tappercoom?
One of those quaint astrological holus-boluses,
Quite all right.

TAPPERCOOM: Quite. An excess of phlegm
In the solar system. It was on its way
To a heavenly spittoon. How is that,
How is that? On its way —

TYSON: I consider it unwise
To tempt providence with humour, Tappercoom.

MARGARET: And on the one evening when we expect company!
What company is going to venture to get here
Through all that heathen hullabaloo in the road?
Except the glorious company of the Apostles,
And we haven't enough glasses for all that number.

TAPPERCOOM: Doomsday or not, we must keep our integrity.
We cannot set up dangerous precedents
Of speed. We shall sincerely hope, of course,

 That Doomsday will refrain from precipitous action;
 But the way we have gone must be the way we arrive.

CHAPLAIN: I wish I were a thinking man, very much.
 Of course I feel a good deal, but that's no help to you.

TYSON: I'm not bewildered, I assure you I'm not
 Bewildered. As a matter of fact a plan
 Is almost certainly forming itself in my head
 At this very moment. It may even be adequate.

CHAPLAIN: Where did I put my better half? I laid it
 Aside. I could take it down to the gate and perhaps
 Disperse them with a skirmish or two of the bow.
 Orpheus, you know, was very successful in that way,
 But of course I haven't his talent, not nearly his talent.

TYSON: If you would allow me to follow my train of thought –

TAPPERCOOM: It's my belief the woman Jourdemayne
 Got hold of the male prisoner by unlawful
 Supernatural soliciting
 And bewitched him into a confession of murder
 To draw attention away from herself. But the more
 We coax him to withdraw his confession, the more
 Crimes he confesses to.

CHAPLAIN: I know I am not
 A practical person; legal matters and so forth
 Are Greek to me, except, of course,
 That I understand Greek. And what may seem nonsensical
 To men of affairs like yourselves might not seem so
 To me, since everything astonishes me,
 Myself most of all. When I think of myself
 I can scarcely believe my senses. But there it is,
 All my friends tell me I actually exist
 And by an act of faith I have come to believe them.
 But this fellow who is being such a trouble to us,
 He, on the contrary, is so convinced
 He *is* that he wishes he was NOT. Now why
 Should that be?

TAPPERCOOM: I believe you mean to tell us,
 Chaplain.

MARGARET: I might as well sit down, for all
 The good that standing up does.

CHAPLAIN: I imagine
 He finds the world not entirely salubrious.
 If he cannot be stayed with flagons, or comforted
 With apples – I quote, of course – or the light, the ocean,
 The ever-changing… I mean and stars, extraordinary
 How many, or some instrument or other – I am afraid
 I appear rhapsodical – but perhaps the addition
 Of your thumbscrew will not succeed either. The point
 I'm attempting to make is this one: he might be wooed
 From his aptitude for death by being happier;
 And what I was going to suggest, quite irresponsibly,
 Is that he might be invited to partake
 Of our festivities this evening. No,
 I see it astonishes you.

MARGARET: Do you mean ask him –

TYSON: I have heard very little of what you have said, Chaplain,
 Being concerned, as I am, with a certain Thought,
 But am I to believe that you recommend our inviting
 This undesirable character to rub shoulders
 With my sister?

CHAPLAIN: Ah; rubbing shoulders. I hadn't exactly
 Anticipated that. It was really in relation to the soul
 That the possibility crossed my mind.

TAPPERCOOM: As a criminal the boy is a liability.
 I doubt very much if he could supply a farthing
 Towards the cost of his execution. So
 You suggest, Chaplain, we let him bibulate
 From glass to glass this evening, help him to
 A denial of his guilt and get him off our hands
 Before daybreak gets the town on its feet again?

MARGARET: I wish I could like the look of the immediate
 Future, but I don't.

TYSON: I'm glad to tell you
 An idea has formed in my mind, a possible solution.
 (*Enter RICHARD.*)
RICHARD: Sir, if you please –
TYSON: Well, Richard?
RICHARD: I should like to admit
 That I've drunk some of the wine put out for the guests.
TYSON: Well, that's a pretty thing, I must say.
RICHARD: I was feeling
 Low; abominably; about the prisoners,
 And the row in the street that's getting out of hand –
 And certain inner things. And I saw the wine
 And I thought Well, here goes, and I drank
 Three glassesful.
TYSON: I trust you feel better for it.
RICHARD: I feel much worse. Those two, sir, the prisoners,
 What are you doing with them? I don't know why
 I keep calling you Sir. I'm not feeling respectful.
 If only inflicted pain could be as contagious
 As a plague, you might use it more sparingly.
TAPPERCOOM: Who's this cub of a boy?
MARGARET: Richard, be sensible.
 He's a dear boy but a green boy, and I'm sure
 He'll apologise in a minute or two.
TYSON: The boy
 Is a silly boy, he's a silly boy; and I'm going
 To punish him.
MARGARET: Where are Humphrey and Nicholas?
TYSON: Now, Margaret –
RICHARD: They were where the prisoners are,
 Down in the cellars.
MARGARET: Not talking to that witch?
RICHARD: There isn't a witch. They were sitting about on barrels.
 It seemed that neither would speak while the other was there

And neither would go away. Half an hour ago.
They may be there still.

TYSON: I must remind you, Margaret,
I was speaking to this very stupid boy.
He is going to scrub the floor. Yes, scrub it.
Scrub this floor this evening before our guests
Put in an appearance. Mulish tasks for a mulish
Fellow. I haven't forgotten his refusal
To fetch the constable.

RICHARD: Has Alizon Eliot
Been left sitting alone?

MARGARET: Alizon Eliot
Is not for you to be concerned with, Richard.

TYSON: Am I supposed to be merely exercising my tongue
Or am I being listened to? Do you hear me?

RICHARD: Yes; scrub the floor. – No, she is not;
I know that.

TYSON: Furthermore, you'll relegate
Yourself to the kitchen tonight, fetching and carrying.
If you wish to be a mule you shall be a mule.

(*He hands RICHARD a note.*)

And take this to whatever splendid fellow's
On duty. You will return with the prisoners
And tell them to remain in this room till I send for them.
– Tactics, Tappercoom: the idea that came to me.
You'll think it very good. – You may go, Richard.

(*Exit RICHARD.*)

TAPPERCOOM: I am nothing but the Justice here, of course,
But, perhaps, even allowing for that, you could tell me
What the devil you're up to.

(*Enter NICHOLAS with a gash on his forehead, followed more
slowly by HUMPHREY.*)

NICHOLAS: Look, Chaplain: blood.
Fee, fi, fo, fum. Can you smell it?

MARGARET: Now what have you been doing?

NICHOLAS: Isn't it beautiful?
 A splash from the cherry-red river that drives my mill!

CHAPLAIN: Well, yes, it has a cheerful appearance,
 But isn't it painful?

MARGARET: I am sure it's painful.
 How did you –

HUMPHREY: Mother, I make it known publicly:
 I'm tired of my little brother. Will you please
 Give him to some charity?

NICHOLAS: Give me to faith
 And hope and the revolution of our native town.
 I've been hit on the head by two-thirds of a brick.

HUMPHREY: The young fool climbed on the wall and addressed
 the crowd.

NICHOLAS: They were getting discouraged. I told them how
 happy it made me
 To see them interested in world affairs
 And how the conquest of evil was being openly
 Discussed in this house at that very moment
 And then unfortunately I was hit by a brick.

MARGARET: What in the world have world affairs
 To do with anything? But we won't argue.

TYSON: I believe that brick to have been divinely delivered,
 And richly deserved. And am I to understand
 You boys have also attempted conversation
 With the prisoners?

HUMPHREY: Now surely, uncle,
 As one of the Town Council I should be allowed
 To get a grasp of whatever concerns the welfare
 Of the population? Nicholas, I agree,
 Had no business on earth to be down there.

NICHOLAS: I was on
 Business of the soul, my sweetheart, business
 Of the soul.

MARGARET: You may use that word once too often,
 Nicholas. Heaven or someone will take you seriously

And then you *would* look foolish. Come with me
And have your forehead seen to.

NICHOLAS: But my big brother
Was on business of the flesh, by all the fires
Of Venus, weren't you, Humphrey?

HUMPHREY: What the hell
Do you mean by that, you little death-watch beetle?

MARGARET: Nicholas, will you come?

NICHOLAS: Certainly, mother.

(*Exit MARGARET and NICHOLAS.*)

TYSON: How very remarkably insufferable
Young fellows can sometimes be. One would expect them
To care to model themselves on riper minds
Such as our own, Tappercoom. But really
We might as well have not existed, you know.

TAPPERCOOM: Am I to hear your plan, Tyson, or am I
Just to look quietly forward to old age?

TYSON: My plan, ah, yes. Conclusive and humane.
The two are brought together into this room. –
How does that strike you?

TAPPERCOOM: It makes a complete sentence:
Subject: they. Predicate: are brought together –

TYSON: Ah, you will say 'with what object?' I'll tell you. We,
That is: ourselves, the Chaplain, and my elder nephew –
Will remain unobserved in the adjoining room
With the communicating door ajar. – And how
Does that strike you?

TAPPERCOOM: With a dull thud, Tyson,
If I may say so.

TYSON: I see the idea has eluded you.
A hypothetical Devil, Tappercoom,
Brought into conversation with a witch.
A dialogue of Hell, perhaps, and conclusive.
Or one or other by their exchange of words
Will prove to be innocent, or we shall have proof
Positive of guilt. Does that seem good?

TAPPERCOOM: Good is as good results.

HUMPHREY: I should never have thought
You would have done anything so undignified
As to stoop to keyholes, uncle.

TYSON: No, no, no.
The door will be ajar, my boy.

HUMPHREY: Ah yes,
That will make us upright. – I can hear them coming.

TYSON: (*Going.*) Come along, come along.

CHAPLAIN: 'The ears of them that hear
Shall hearken.' The prophet Isaiah.

TYSON: Come along, Chaplain.

TAPPERCOOM: (*Following.*) A drink, Tyson. I wish to slake
the dryness
Of my disbelief.

(*They go in. The CHAPLAIN returns.*)

CHAPLAIN: I musn't leave my mistress.
Where are you, angel? Just where chucklehead left her.

(*Enter RICHARD with JENNET and THOMAS.*)

RICHARD: He wants you to wait here till he sends for you.
If in some way – I wish –! I must fetch the scrubbers.

(*Exit RICHARD.*)

CHAPLAIN: Ah…ah… I'm not really here. I came
For my angel, a foolish way to speak of it,
This instrument. May I say, a happy issue
Out of all your afflictions? I hope so. – Well,
I'm away now.

THOMAS: God bless you, in case you sneeze.

CHAPLAIN: Yes; thank you. I may. And God bless you.

(*Exit CHAPLAIN.*)

THOMAS: (*At the window.*) You would think by the holy scent of it
our friend
Had been baptising the garden. But it's only
The heathen rainfall.

JENNET: Do you think he knows
 What has been happening to us?

THOMAS: Old angel-scraper?
 He knows all right. But he's subdued
 To the cloth he works in.

JENNET: How tired I am.

THOMAS: And palingenesis has come again
 With a hey and a ho. The indomitable
 Perseverance of Persephone
 Became ludicrous long ago.

JENNET: What can you see
 Out there?

THOMAS: Out here? Out here is a sky so gentle
 Five stars are ventured on it. I can see
 The sky's pale belly glowing and growing big,
 Soon to deliver the moon. And I can see
 A glittering smear, the snail-trail of the sun
 Where it crawled with its golden shell into the hills.
 A darkening land sunken into prayer
 Lucidly in dewdrops of one syllable,
 Nunc dimittis. I see twilight, madam.

JENNET: But what can you hear?

THOMAS: The howl of human jackals.

 (Enter RICHARD with pail and scrubbing-brush.)

RICHARD: Do you mind? I have to scrub the floor.

THOMAS: A good old custom. Always fornicate
 Between clean sheets and spit on a well-scrubbed floor.

JENNET: Twilight, double, treble, in and out!
 If I try to find my way I bark my brain
 On shadows sharp as rocks where half a day
 Ago was a soft world, a world of warm
 Straw, whispering every now and then
 With rats, but possible, possible, not this,
 This where I'm lost. The morning came, and left
 The sunlight on my step like any normal
 Tradesman. But now every spark

Of likelihood has gone. The light draws off
As easily as though no one could die
Tomorrow.

THOMAS: Are you going to be so serious
About such a mean allowance of breath as life is?
We'll suppose ourselves to be caddis-flies
Who live one day. Do we waste the evening
Commiserating with each other about
The unhygienic condition of our worm-cases?
For God's sake, shall we laugh?

JENNET: For what reason?

THOMAS: For the reason of laughter, since laughter is surely
The surest touch of genius in creation.
Would *you* ever have thought of it, I ask you,
If you had been making man, stuffing him full
Of such hopping greeds and passions that he has
To blow himself to pieces as often as he
Conveniently can manage it – would it also
Have occurred to you to make him burst himself
With such a phenomenon as cachinnation?
That same laughter, madam, is an irrelevancy
Which almost amounts to revelation.

JENNET: I laughed
Earlier this evening, and where am I now?

THOMAS: Between
The past and the future which is where you were
Before.

JENNET: Was it for laughter's sake you told them
You were the Devil? Or why did you?

THOMAS: Honesty,
Madam, common honesty.

JENNET: Honesty common
With the Devil?

THOMAS: Gloriously common. It's Evil, for once
Not travelling incognito. It is what it is,
The Great Unspurious.

JENNET: Thank you for that.
You speak of the world I thought I was waking to
This morning. But horror is walking round me here
Because nothing is as it appears to be.
That's the deep water my childhood had to swim in.
My father was drowned in it.

THOMAS: He was drowned in what?
In hypocrisy?

JENNET: In the pursuit of alchemy.
In refusing to accept your dictum 'It is
What it is'. Poor father. In the end he walked
In Science like the densest night. And yet
He was greatly gifted.
When he was born he gave an algebraic
Cry; at one glance measured the cubic content
Of that ivory cone his mother's breast
And multiplied his appetite by five.
So he matured by a progression, gained
Experience by correlation, expanded
Into a marriage by contraction, and by
Certain physical dynamics
Formulated me. And on he went
Still deeper into the calculating twilight
Under the twinkling of five-pointed figures
Till Truth became for him the sum of sums
And Death the long division. My poor father.
What years and powers he wasted.
He thought he could change the matter of the world
From the poles to the simultaneous equator
By strange experiment and by describing
Numerical parabolas.

THOMAS: To change
The matter of the world! Magnificent
Intention. And so he died deluded.

JENNET: As a matter of fact, it wasn't a delusion.
As a matter of fact, after his death
When I was dusting the laboratory

I knocked over a crucible which knocked
Over another which rocked a third, and they poured
And spattered over some copper coins which two days later
By impregnation had turned into solid gold.

THOMAS: Tell that to some sailor on a horse!
If you had such a secret, I
And all my fiendish flock, my incubi,
Succubi, imps and cacodemons, would have leapt
Out of our bath of brimming brimstone, crying
Eureka, cherchez la femme! – Emperors
Would be colonising you, their mistresses
Patronising you, ministers of state
Governmentalising you. And you
Would be eulogised, lionised, probably
Canonised for your divine mishap.

JENNET: But I never had such a secret. It's a secret
Still. What it was I spilt, or to what extent,
Or in what proportion; whether the atmosphere
Was hot, cold, moist or dry, I've never known.
And someone else can discolour their fingers, tease
Their brains and spoil their eyesight to discover it.
My father broke on the wheel of a dream; he was lost
In a search. And so, for me, the actual!
What I touch, what I see, what I know; the essential fact.

THOMAS: In other words, the bare untruth.

JENNET: And, if I may say it
Without appearing rude, absolutely
No devils.

THOMAS: How in the miserable world, in that case,
Do you come to be here, pursued by the local consignment
Of fear and guilt? What possible cause –

JENNET: Your thumbs.
I'm sure they're giving you pain.

THOMAS: Listen! by both
My cloven hooves! if you put us to the rack

Of an exchange of sympathy, I'll fell you to the ground.
Answer my question.

JENNET: Why do they call me a witch?
Remember my father was an alchemist.
I live alone, preferring loneliness
To the companionable suffocation of an aunt.
I still amuse myself with simple experiments
In my father's laboratory. Also I speak
French to my poodle. Then you must know
I have a peacock which on Sundays
Dines with me indoors. Not long ago
A new little serving maid carrying the food
Heard its cry, dropped everything and ran,
Never to come back, and told all whom she met
That the Devil was dining with me.

THOMAS: It really is
Beyond the limit of respectable superstition
To confuse my voice with a peacock's. Don't they know
I sing solo bass in Hell's Madrigal Club?
– And as for you, you with no eyes, no ears,
No senses, you the most superstitious
Of all – (for what greater superstition
Is there than the mumbo-jumbo of believing
In reality?) – you should be swallowed whole by Time
In the way that you swallow appearances.
Horns, what a waste of effort it has been
To give you Creation's vast and exquisite
Dilemma! where altercation thrums
In every granule of the Milky Way,
Persisting still in the dead-sleep of the moon,
And heckling itself hoarse in that hot-head
The sun. And as for here, each acorn drops
Arguing to earth, and pollen's all polemic. –
We have given you a world as contradictory
As a female, as cabbalistic as the male,
A conscienceless hermaphrodite who plays
Heaven off against hell, hell off against heaven,

Revolving in the ballroom of the skies
Glittering with conflict as with diamonds:
We have wasted paradox and mystery on you
When all you ask us for, is cause and effect! –
A copy of your birth-certificate was all you needed
To make you at peace with Creation. How uneconomical
The whole thing's been.

JENNET: This is a fine time
To scold me for keeping myself to myself and out
Of the clutch of chaos. I was already
In a poor way of perplexity and now
You leave me no escape except
Out on a stream of tears.

THOMAS: (*Falling over RICHARD scrubbing.*) Now, none of that! –
Hell!

RICHARD: I beg your pardon.

THOMAS: Now that I'm down
On my knees I may as well stay here. In the name
Of all who ever were drowned at sea, don't weep!
I never learnt to swim. May God keep you
From being my Hellespont.

JENNET: What I do
With my own tears is for me to decide.

THOMAS: That's all very well. You get rid of them.
But on whose defenceless head are they going to fall?

JENNET: I had no idea you were so afraid of water.
I'll put them away.

THOMAS: O Pete, I don't know which
Is worse; to have you crying or to have you behaving
Like Catharine of Aix, who never wept
Until after she had been beheaded, and then
The accumulation of the tears of a long lifetime
Burst from her eyes with such force, they practic'ly winded
Three onlookers and floated the parish priest
Two hundred yards into the entrance-hall
Of a brothel.

JENNET: Poor Catharine!

THOMAS: Not at all.
 It made her life in retrospect infinitely
 More tolerable, and when she got to Purgatory
 She was laughing so much they had to give her a sedative.

JENNET: Why should you want to be hanged?

THOMAS: Madam,
 I owe it to myself. But I can leave it
 Until the last moment. It will keep
 While the light still lasts.

JENNET: What can we see in this light?
 Nothing, I think, except flakes of drifting fear,
 The promise of oblivion.

THOMAS: Nothing can be seen
 In the thistle-down, but the rough-head thistle comes.
 Rest in that riddle. I can pass to you
 Generations of roses in this wrinkled berry.
 There: now you hold in your hand a race
 Of summer gardens, it lies under centuries
 Of petals. What is not, you have in your palm.
 Rest in the riddle, rest; why not? This evening
 Is a ridiculous wisp of down
 Blowing in the air as disconsolately as dust.
 And you have your own damnable mystery too,
 Which at this moment I could well do without.

JENNET: I know of none. I'm an unhappy fact
 Fearing death. This is a strange moment
 To feel my life increasing, when this moment
 And a little more may be for both of us
 The end of time. You've cast your fishing-net
 Of eccentricity,
 Caught me when I was already lost
 And landed me with despairing gills on your own
 Strange beach. That's too inhuman of you.

THOMAS: Inhuman?
 If I dared to know what you meant it would sound disastrous!

JENNET: It means I care whether you live or die.

THOMAS: Will you stop frightening me to death?
 Do you want our spirits to hobble out of their graves
 Enduring twinges of hopeless human affection
 As long as death shall last? Still to suffer
 Pain in the amputated limb! To feel
 Passion *in vacuo*! That is the sort of thing
 That causes sun-spots, and the Lord knows what
 Infirmities in the firmament. I tell you
 The heart is worthless,
 Nothing more than a pomander's perfume
 In the sewerage. And a nosegay of private emotion
 Won't distract me from the stench of the plague-pit,
 You needn't think it will. – Excuse me, Richard. –
 Don't entertain the mildest interest in me
 Or you'll have me die screaming.

JENNET: Why should that be?
 If you're afraid of your shadow falling across
 Another life, shine less brightly upon yourself,
 Step back into the rank and file of men,
 Instead of preserving the magnetism of mystery
 And your curious passion for death. You are making yourself
 A breeding-ground for love and must take the consequences.
 But what are you afraid of, since in a little
 While neither of us may exist? Either or both
 May be altogether transmuted into memory,
 And then the heart's obscure indeed. – Richard,
 There's a tear rolling out of your eye. What is it?

RICHARD: Oh, that? I don't really know. I have things on
 my mind.

JENNET: Not us?

RICHARD: Not only.

THOMAS: If it's a woman, Richard,
 Apply yourself to the scrubbing-brush. It's all
 A trick of the light.

JENNET: The light of a fire.

THOMAS: And, Richard,
 Make this woman understand that I
 Am a figure of vice and crime –
JENNET: Guilty of –
THOMAS: Guilty
 Of mankind. I have perpetrated human nature.
 My father and mother were accessories before the fact,
 But there'll be no accessories after the fact,
 By my virility there won't! Just see me
 As I am, me like a perambulating
 Vegetable, patched with inconsequential
 Hair, looking out of two small jellies for the means
 Of life, balanced on folding bones, my sex
 No beauty but a blemish to be hidden
 Behind judicious rags, driven and scorched
 By boomerang rages and lunacies which never
 Touch the accommodating artichoke
 Or the seraphic strawberry beaming in its bed:
 I defend myself against pain and death by pain
 And death, and make the world go round, they tell me,
 By one of my less lethal appetites:
 Half this grotesque life I spend in a state
 Of slow decomposition, using
 The name of unconsidered God as a pedestal
 On which I stand and bray that I'm best
 Of beasts, until under some patient
 Moon or other I fall to pieces, like
 A cake of dung. Is there a slut would hold
 This in her arms and put her lips against it?
JENNET: Sluts are only human. By a quirk
 Of unastonished nature, your obscene
 Decaying figure of vegetable fun
 Can drag upon a woman's heart, as though
 Heaven were dragging up the roots of hell.
 What is to be done? Something compels us into
 The terrible fallacy that man is desirable
 And there's no escaping into truth. The crimes

And cruelties leave us longing, and campaigning
Love still pitches his tent of light among
The suns and moons. You may be decay and a platitude
Of flesh, but I have no other such memory of life.
You may be corrupt as ancient apples, well then
Corruption is what I most willingly harvest.
You are Evil, Hell, the Father of Lies; if so
Hell is my home and my days of good were a holiday:
Hell is my hill and the world slopes away from it
Into insignificance. I have come suddenly
Upon my heart and where it is I see no help for.

THOMAS: We're lost, both irretrievably lost –

(*Enter TYSON, TAPPERCOOM, HUMPHREY, and the
CHAPLAIN.*)

TAPPERCOOM: Certainly.
The woman has confessed. *Spargere auras
Per vulgum ambiguas.* The town can go to bed.

TYSON: It was a happy idea, eh, Tappercoom? This will be
A great relief to my sister, and everybody
Concerned. A very nice confession, my dear.

THOMAS: What is this popping-noise? Now what's the matter?

JENNET: Do they think I've confessed to witchcraft?

TAPPERCOOM: Admirably.

CHAPLAIN: (*To JENNET.*) Bother such sadness. You understand,
 I'm sure:
Those in authority over us. I should like
To have been a musician but others decreed otherwise.
And sin, whatever we might prefer, cannot
Go altogether unregarded.

TAPPERCOOM: Now,
Now, Chaplain, don't get out of hand.
Pieties come later. – Young Devize
Had better go and calm the populace.
Tell them faggots will be lit tomorrow at noon.

HUMPHREY: Have a heart, Mr Tappercoom; they're hurling
 bricks.

JENNET: What do they mean? Am I at noon to go
 To the fire? Oh, for pity! Why must they brand
 Themselves with me?

THOMAS: She has bribed you to procure
 Her death! Graft! Graft! Oh, the corruption
 Of this town when only the rich can get to kingdom
 Come and a poor man is left to groan
 In the full possession of his powers. And she's
 Not even guilty! I demand fair play
 For the criminal classes!

TYSON: Terrible state of mind.
 Humphrey, go at once to the gate –

HUMPHREY: Ah well, I can
 But try to dodge.

THOMAS: (*Knocking him down.*) You didn't try soon enough.
 Who else is going to cheat me out of my death?
 Whee, ecclesiastic, let me brain you
 With your wife!

 (*He snatches the CHAPLAIN's viol and offers to hit him on the head.*)

CHAPLAIN: No, no! With something else – oh, please
 Hit me with something else.

THOMAS: Exchange it
 For a harp and hurry off to heaven. – Am I dangerous?
 Will you give me the gallows? – Now, *now,* Mr Mayor!
 Richard, I'll drown him in your bucket.

 (*JENNET faints.*)

RICHARD: (*Running to support her.*) Look, she has fallen!

CHAPLAIN: Air! Air!

TYSON: Water!

THOMAS: But no fire, do you hear? No fire! – How is she,
 Richard?
 Oh, the delicate mistiming of women! She has carefully
 Snapped in half my jawbone of an ass.

RICHARD: Life is coming back.

THOMAS: Importunate life.
 It should have something better to do
 Than to hang about at a chronic street-corner
 In dirty weather and worse company.

TAPPERCOOM: It is my duty as Justice to deliver
 Sentence on you as well.

THOMAS: Ah!

TAPPERCOOM: Found guilty
 Of jaundice, misanthropy, suicidal tendencies
 And spreading gloom and despondency. You will spend
 The evening joyously, sociably, taking part
 In the pleasures of your fellow men.

THOMAS: Not
 Until you've hanged me. I'll be amenable then.

JENNET: Have I come back to consciousness to hear
 That still? – Richard, help me to stand. – You see,
 Preacher to the caddis-fly, I return
 To live my allotted span of insect hours.
 But if you batter my wings with talk of death
 I'll drop to the ground again.

THOMAS: Ah! One
 Concession to your courage and then no more.
 Gentlemen, I'll accept your most inhuman
 Sentence. I'll not disturb the indolence
 Of your gallows yet. But on one condition:
 That this lady shall take her share tonight
 Of awful festivity. She shall suffer too.

TYSON: Out of the question, quite out of the question,
 Absolutely out of the question. What, what?

TAPPERCOOM: What?

THOMAS: Then you shall spend your night in searching
 For the bodies of my victims, or else the Lord
 Chief Justice of England shall know you let a murderer
 Go free. I'll raise the country.

JENNET: Do you think
 I can go in gaiety tonight

Under the threat of tomorrow? If I could sleep –

THOMAS: That is the heaven to come.
We should be like stars now that it's dark:
Use ourselves up to the last bright dregs
And vanish in the morning. Shall we not
Suffer as wittily as we can? Now, come,
Don't purse your lips like a little prude at the humour
Of annihilation. It is somewhat broad
I admit, but we're not children.

JENNET: I am such
A girl of habit. I had got into the way
Of being alive. I will live as well as I can
This evening.

THOMAS: And I'll live too, if it kills me.

HUMPHREY: Well, uncle? If you're going to let this clumsy-
Fisted cut-throat loose on the house tonight,
Why not the witch-girl, too?

CHAPLAIN: Foolishly
I can't help saying it, I should like
To see them dancing.

TYSON: We have reached a decision.
The circumstances compel us to agree
To your most unorthodox request.

THOMAS: Wisdom
At last. But listen, woman: after this evening
I have no further interest in the world.

JENNET: My interest also will not be great, I imagine,
After this evening.

(*Curtain on Act Two.*)

ACT THREE

(*Later the same night. The same room, by torchlight and moonlight.*
HUMPHREY at the window. Enter THOMAS, who talks to himself
until he notices HUMPHREY.)

THOMAS: O tedium, tedium, tedium. The frenzied
 Ceremonial drumming of the humdrum!
 Where in this small-talking world can I find
 A longitude with no platitude? – I must
 Apologise. That was no joke to be heard
 Making to myself in the full face of the moon.
 If only I had been born flame, a flame
 Poised, say, on the flighty head of a candle,
 I could have stood in this draught and gone out,
 Whip, through the door of my exasperation.
 But I remain, like the possibility
 Of water in a desert.

HUMPHREY: I'm sure nobody
 Keeps you here. There's a road outside if you want it.

THOMAS: What on earth should I do with a road, that furrow
 On the forehead of imbecility, a road?
 I would as soon be up there, walking in the moon's
 White unmolared gums. I'll sit on the world
 And rotate with you till we roll into the morning.

HUMPHREY: You're a pestering parasite. If I had my way
 You'd be got rid of. You're mad and you're violent,
 And I strongly resent finding you slightly pleasant.

THOMAS: O God, yes, so do I.

 (*Enter NICHOLAS.*)

NICHOLAS: As things turn out
 I want to commit an offence.

THOMAS: Does something prevent you?

NICHOLAS: I don't know what offence to commit.

THOMAS: What abysmal
 Poverty of mind!

NICHOLAS: This is a night
 Of the most asphyxiating enjoyment that ever
 Sapped my youth.

HUMPHREY: I think I remember
 The stars gave you certain rights and interest
 In a little blonde religious. How is she, Nicholas?

NICHOLAS: Your future wife, Humphrey, if that is who
 You mean, is pale, tearful, and nibbling a walnut.
 I loved her once – earlier today –
 Loved her with a passionate misapprehension.
 I thought you wanted her, and I'm always deeply
 Devoted to your affairs. But now I'm bored,
 As bored as the face of a fish,
 In spite of the sunlit barley of her hair.

HUMPHREY: Aren't I ready to marry her? I thought that was why
 We were mooning around celebrating. What more
 Can I do to make you take her off my hands?
 And I'm more than ready for the Last Trump as well.
 It will stop old Mrs Cartwright talking.

NICHOLAS: Never.
 She's doom itself. She could talk a tombstone off anybody.
 (*Enter MARGARET.*)

MARGARET: Oh, there you are. Whatever's wrong? You both
 Go wandering off, as though our guests could be gay
 Of their own accord (the few who could bring themselves
 To bring themselves, practically in the teeth
 Of the recording angel). They're very nervous
 And need considerable jollying. Goose liver,
 Cold larks, cranberry tarts and sucking pig,
 And now everyone looks as though they only
 Wanted to eat each other, which might in the circumstances
 Be the best possible thing. Your uncle sent me
 To find you. I can tell he's put out; he's as vexed
 As a hen's hind feathers in a wind. And for that
 Matter so am I. Go back inside
 And be jolly like anyone else's children.

NICHOLAS: Mother,
I'd as soon kiss the bottom of a Barbary ape.
The faces of our friends may be enchantment
To some, but they wrap my spirits in a shroud. —
For the sake of my unborn children, I have to avoid them.
Oh now, be brave, mother. They'll go in the course of nature.

MARGARET: It's unfortunate, considering the wide
Choice of living matter on this globe,
That I should have managed to be a mother. I can't
Imagine what I was thinking of. Your uncle
Has made me shake out the lavender
From one of my first gowns which has hung in the wardrobe
Four-and-twenty unencouraging years,
To lend to this Jennet girl, who in my opinion
Should not be here. And I said to her flatly
'The course of events is incredible. Make free
With my jewel box.' Where is she now?

THOMAS: No doubt
Still making free. Off she has gone,
Away to the melting moody horizons of opal,
Moonstone, bloodstone; now moving in lazy
Amber, now sheltering in the shade
Of jade from a brief rainfall of diamonds.
Able to think tomorrow has an even
Brighter air, a glitter less moderate,
A quite unparalleled freedom in the fire:
A death, no bounds to it. Where is she now?
She is dressing, I imagine.

MARGARET: Yes, I suppose so.
I don't like to think of her. And as for you
I should like to think of you as someone I knew
Many years ago, and, alas, wouldn't see again.
That would be charming. I beg you to come,
Humphrey. Give your brother a good example.

HUMPHREY: Mother, I'm unwell.

MARGARET: Oh, Humphrey!

NICHOLAS: Mother,
 He is officially sick and actually bored.
 The two together are as bad as a dropsy.

MARGARET: I must keep my mind as concentrated as possible
 On such pleasant things as the summer I spent at Stoke
 D'Abernon. Your uncle must do what he will.
 I've done what I can.
 (*Exit MARGARET.*)

NICHOLAS: Our mother isn't
 Pleased.

HUMPHREY: She has never learnt to yawn
 And so she hasn't the smallest comprehension
 Of those who can.

THOMAS: Benighted brothers in boredom,
 Let us unite ourselves in a toast of ennui.
 I give you a yawn: to this evening, especially remembering
 Mrs Cartwright. (*They all yawn.*) To mortal life, women,
 All government, wars, art, science, ambitions,
 And the entire fallacy of human emotions!
 (*As they painfully yawn again, enter JENNET, bright with jewels,*
 and twenty years exquisitely out of fashion.)

JENNET: And wake us in the morning with an ambrosial
 Breakfast, amen, amen.

NICHOLAS: Humphrey, poppin,
 Draw back the curtains. I have a sense of daylight.

HUMPHREY: It seems we're facing east.

THOMAS: You've come too late.
 Romulus, Remus and I have just buried the world
 Under a heavy snowfall of disinterest.
 There's nothing left of life but cranberry tarts,
 Goose's liver, sucking pig, cold larks,
 And Mrs Cartwright.

JENNET: That's riches running mad.
 What about the have-not moon? Not a goose, not a pig,
 And yet she manages to be the wit

Of heaven, and roused the envious Queen of Sheba
To wash in mercury so that the Sheban fountains
Should splash deliriously in the light of her breast.
But she died, poor Queen, shining less
Than the milk of her thousand shorthorn cows.

THOMAS: What's this?
Where has the girl I spoke to this evening gone
With her Essential Fact? Surely she knows,
If she is true to herself, the moon is nothing
But a circumambulating aphrodisiac
Divinely subsidised to provoke the world
Into a rising birth-rate – a veneer
Of sheerest Venus on the planks of Time
Which may fool the ocean but which fools not me.

JENNET: So no moon.

THOMAS: No moon.

NICHOLAS: Let her have the last quarter.

JENNET: No;
If he says no moon then of course there can be no moon.
Otherwise we destroy his system of thought
And confuse the quest for truth.

THOMAS: You see, Nicholas?

JENNET: I've only one small silver night to spend
So show me no luxuries. It will be enough
If you spare me a spider, and when it spins I'll see
The six days of Creation in a web
And a fly caught on the seventh. And if the dew
Should rise in the web, I may well die a Christian.

THOMAS: I must shorten my sail. We're into a strange wind.
This evening you insisted on what you see,
What you touch, what you know. Where did this weather blow
 from?

JENNET: Off the moors of mortality: that might
Be so. Or there's that inland sea, the heart –
But you mustn't hinder me, not now. I come
Of a long-lived family, and I have

Some sixty years to use up almost immediately.
I shall join the sucking pig.

NICHOLAS: Please take my arm.
I'll guide you there.

HUMPHREY: He shall do no such thing.
Who's the host here?

THOMAS: They have impeccable manners
When they reach a certain temperature.

HUMPHREY: A word
More from you, and you go out of this house.

THOMAS: Like the heart going out of me, by which it avoids
Having to break.

JENNET: Be quiet for a moment. I hear
A gay modulating anguish, rather like music.

NICHOLAS: It's the Chaplain, extorting lightness of heart
From the guts of his viol, to the greater glory of God.
(*Enter HEBBLE TYSON.*)

TYSON: What I hear from your mother isn't agreeable to me
In the smallest – a draught, quite noticeable.
I'm a victim to air. – I expect members of my family –

THOMAS: Is this courtesy, Mr Mayor, to turn your back
On a guest?

JENNET: Why should I be welcome? I am wearing
His days gone by. I rustle with his memories!
I, the little heretic as he thinks,
The all unhallows Eve to his poor Adam;
And nearly stubbing my toes against my grave
In his sister's shoes, the grave he has ordered for me.
Don't ask impossibilities of the gentleman.

TYSON: Humphrey, will you explain yourself?

HUMPHREY: Uncle,
I came to cool my brow. I was on my way back.

NICHOLAS: Don't keep us talking. I need to plunge again
Into that ice-cap of pleasure in the next room.
I repeat, my arm.

HUMPHREY: I repeat that I'm the host.
　　I have the right –
JENNET: He has the right, Nicholas.
　　Let me commit no solecism so near
　　To eternity. Please open the door for us.
　　We must go in as smoothly as old friends.
　　(*Exeunt JENNET, HUMPHREY and NICHOLAS.*)
THOMAS: Well, does your blood run deep enough to run
　　Cold, or have you none?
TYSON: That's enough. Get away.
THOMAS: Are you going to cry-off the burning?
TYSON: Worthless creatures,
　　Both; I call you clutter. The standard soul
　　Must mercilessly be maintained. No
　　Two ways of life. One God, one point of view.
　　A general acquiescence to the mean.
THOMAS: And God knows when you say the mean, you mean
　　The mean. You'd be surprised to see the number
　　Of cloven hoof-marks in the yellow snow of your soul.
　　And so you'll kill her.
　　Time would have done it for her too, of course,
　　But more cautiously, and with a pretence of charm.
　　Am I allowed on bail into your garden?
TYSON: Tiresome catarrh. I haven't any wish to see you,
　　Not in the slightest degree: go where you like.
THOMAS: That's nowhere in this world. But still maybe
　　I can make myself useful and catch mice for an owl.
　　(*Exit THOMAS. Enter TAPPERCOOM.*)
TAPPERCOOM: The young lunatic slipping off, is he?
　　Cheered up and gone? So much the less trouble for us.
　　Very jolly evening, Tyson. Are you sober?
TYSON: Yes, yes, yes.
TAPPERCOOM: You shouldn't say that, you know.
　　You're in tears, Tyson. I know tears when I see them,
　　My wife has them. You've drunk too deep, my boy.

Now I'm sober as a judge, perhaps a judge
A little on circuit, but still sober. Tyson,
You're in tears, old fellow, two little wandering
Jews of tears getting 'emselves embrangled
In your beard.

TYSON: I won't stand it, Tappercoom:
I won't have it, I won't have evil things
Looking so distinguished. I'm no longer
Young, and I should be given protection.

TAPPERCOOM: What
Do you want protecting from now?

TYSON: We must burn her,
Before she destroys our reason. Damnable glitter.
Tappercoom, we musn't become bewildered
At our time of life. Too unusual
Not to be corrupt. Must be burnt
Immediately, burnt, burnt, Tappercoom,
Immediately.

TAPPERCOOM: Are you trying to get rid of temptation,
Tyson? A belated visit of the wanton flesh
After all these years? You've got to be dispassionate.
Calm and civilised. I am civilised.
I know, frinstance, that Beauty is not an Absolute.
Beauty is a Condition. As you might say
Hey nonny no or Hey nonny yes.
But the Law's about as absolute an Absolute –
Hello, feeling dicky, Chaplain?

(*The CHAPLAIN has entered, crying.*)

CHAPLAIN: It would be
So kind if you didn't notice me. I have
Upset myself. I have no right to exist,
Not in any form, I think.

TAPPERCOOM: I hope you won't
Think me unsociable if I don't cry myself.
What's the matter? Here's the pair of you
Dripping, like newly weighed anchors.

Let the butterflies come to you, Chaplain,
Or you'll never be pollinated into a Bishop.
CHAPLAIN: No, it's right and it's just I should be cast down.
I've treated her with an abomination
That maketh desolate: – the words, the words
Are from Daniel –
TAPPERCOOM: Hey, what's this? The young woman again?
CHAPLAIN: My patient instrument. I made my viol
Commit such sins of sound – and I didn't mind:
No, I laughed. I was trying to play a dance.
I'm too unaccomplished to play with any jollity.
I shouldn't venture beyond religious pieces.
TYSON: There's no question of jollity. We've got
To burn her, for our peace of mind.
TAPPERCOOM: You must wait
Until tomorrow, like a reasonable chap.
And tomorrow, remember, you'll have her property
Instead of your present longing for impropriety.
And her house, now I come to think of it,
Will suit me nicely.
A large mug of small beer for both of you.
Leave it to me.
CHAPLAIN: No, no, no,
I should become delighted again. I wish
For repentance –
(Enter RICHARD.)
TAPPERCOOM: You shall have it. I'll pour it out
Myself. You'll see: it shall bring you to your knees.
CHAPLAIN: I'm too unaccomplished. I haven't the talent,
But I hoped I should see them dancing. And after all
They didn't dance –
TAPPERCOOM: They shall, dear saint, they shall.
(Exit TAPPERCOOM and the CHAPLAIN.)
RICHARD: I was to tell you, Mr Tyson –
TYSON: I'm not
To be found. I'm fully occupied elsewhere.

If you wish to find me I shall be in my study.
You can knock, but I shall give you no reply.
I wish to be alone with my own convictions.
Good-night.

(*Exit TYSON. THOMAS looks through the window. Enter ALIZON.*)

THOMAS: (*To RICHARD.*) The Great Bear is looking so
 geometrical
One would think that something or other could be proved.
Are you sad, Richard?

RICHARD: Certainly.

THOMAS: I also.
I've been cast adrift on a raft of melancholy.
The night-wind passed me, like a sail across
A blind man's eye. There it is,
The interminable tumbling of the great grey
Main of moonlight, washing over
The little oyster-shell of this month of April:
Among the raven-quills of the shadows
And on the white pillows of men asleep:
The night's a boundless pastureland of peace,
And something condones the world, incorrigibly.
But what, in fact, *is* this vaporous charm?
We're softened by a nice conglomeration
Of the earth's uneven surface, refraction of light,
Obstruction of light, condensation, distance,
And that sappy upshot of self-centred vegetablism
The trees of the garden. How is it we come
To see this as a heaven in the eye?
Why should we hawk and spit out ecstasy
As though we were nightingales, and call these quite
Casual degrees and differences
Beauty? What guile recommends the world
And gives our eyes the special sense to be
Deluded, above all animals? – Stone me, Richard!
I've begun to talk like that soulless girl, and she

73

May at this moment be talking like me! I shall go
Back into the garden, and choke myself with the seven
Sobs I managed to bring with me from the wreck.

RICHARD: To hear her you would think her feet had almost
Left the ground. The evening which began
So blackly, now, as though it were a kettle
Set over her flame, has started to sing. And all
The time I find myself praying under my breath
That something will save her.

THOMAS: You might do worse.
Tides turn with a similar sort of whisper.

ALIZON: Richard.

RICHARD: Alizon!

ALIZON: I've come to be with you.

RICHARD: Not with me. I'm the to-and-fro fellow
Tonight. You have to be with Humphrey.

ALIZON: I think
I have never met Humphrey. I have met him less
And less the more I have seen him.

THOMAS: You will forgive me.
I was mousing for a small Dutch owl.
If it has said towoo t-wice it has said it
A thousand times.

(*He disappears into the garden.*)

RICHARD: Hey! Thomas –! Ah well. –
The crickets are singing well with their legs tonight.

ALIZON: It sounds as though the night-air is riding
On a creaking saddle.

RICHARD: You must go back to the others.

ALIZON: Let me stay. I'm not able to love them.
Have you forgotten what they mean to do
Tomorrow?

RICHARD: How could I forget? But there are laws
And if someone fails them –

ALIZON: I shall run
 Away from laws if laws can't live in the heart.
 I shall be gone tomorrow.
RICHARD: You make the room
 Suddenly cold. Where will you go?
ALIZON: Where
 Will you come to find me?
RICHARD: Look, you've pulled the thread
 In your sleeve. Is it honest for me to believe
 You would be unhappy?
ALIZON: When?
RICHARD: If you marry Humphrey?
ALIZON: Humphrey's a winter in my head.
 But whenever my thoughts are cold and I lay them
 Against Richard's name, they seem to rest
 On the warm ground where summer sits
 As golden as a humblebee.
 So I did very little but think of you
 Until I ran out of the room.
RICHARD: Do you come to me
 Because you can never love the others?
ALIZON: Our father
 God moved many lives to show you to me.
 I think that is the way it must have happened.
 It was complicated, but very kind.
RICHARD: If I asked you
 If you could ever love me, I should know
 For certain that I was no longer rational.
ALIZON: I love you quite as much as I love St Anthony
 And rather more than I love St John Chrysostom.
RICHARD: But putting haloes on one side, as a man
 Could you love me, Alizon?
ALIZON: I have become
 A woman, Richard, because I love you. I know
 I was a child three hours ago. And yet

 I love you as deeply as many years could make me,
 But less deeply than many years will make me.

RICHARD: I think I may never speak steadily again.
 What have I done or said to make it possible
 That you should love me?

ALIZON: Everything I loved
 Before has come to one meeting place in you
 And you have gone out into everything I love.

RICHARD: Happiness seems to be weeping in me, as
 I suppose it should, being newly born.

ALIZON: We must never leave each other now, or else
 We should perplex the kindness of God.

RICHARD: The kindness
 Of God in itself is not a little perplexing.
 What do we do?

ALIZON: We cleave to each other, Richard.
 That is what is proper for us to do.

RICHARD: But you were promised to Humphrey, Alizon.
 And I'm hardly more than a servant here
 Tied to my own apron-strings. They'll never
 Let us love each other.

ALIZON: Then they will have
 To outwit all that ever went to create us.

RICHARD: So they will. I believe it. Let them storm.
 We're lovers in a deep and safe place
 And never lonely any more. – Alizon,
 Shall we make the future, however much it roars,
 Lie down with our happiness? Are you ready
 To forgo custom and escape with me?

ALIZON: Shall we go now, before anyone prevents us?

RICHARD: I'll take you to the old priest who first found me.
 He is as near to being my father
 As putting his hand into a poor-box could make him.
 He'll help us. Oh, Alizon, I so
 Love you. Let yourself quietly out and wait for me

Somewhere near the gate but in a shadow.

I must fetch my savings. Are you afraid?

ALIZON: In some

Part of me, not all; and while I wait

I can have a word with the saints Theresa and Christopher:

They may have some suggestions.

RICHARD: Yes, do that.

Now: like a mouse.

(*When she has gone he goes to the window.*)

 Only let me spell

No disillusion for her, safety, peace,

And a good world, as good as she has made it!

(*RICHARD starts to fetch his money. Enter MARGARET.*)

MARGARET: Now, Richard: have you found Mr Tyson?

RICHARD: Yes;

He's busy with his convictions.

MARGARET: He has no business

To be busy now. How am I to prevent

This girl, condemned as a heretic, from charming us

With gentleness, consideration and gaiety?

It makes orthodoxy seem almost irrelevant.

But I expect they would tell us the soul can be as lost

In loving-kindness as in anything else.

Well, well; we must scramble for grace as best we can.

Where is Alizon?

RICHARD: I must – I must –

MARGARET: The poor child has gone away to cry.

See if you can find her, will you, Richard?

RICHARD: I have to – have to –

MARGARET: Very well. I will go

In search of the sad little soul myself.

Oh dear, I could do with a splendid holiday

In a complete vacuum.

(*Exit MARGARET one way, RICHARD, hastily, another. Enter JENNET. She seems for a moment exhausted, but crosses to the window. Enter NICHOLAS and HUMPHREY.*)

NICHOLAS: Are you tired of us?

HUMPHREY: Why on earth
Can't you stop following her?

NICHOLAS: Stop following me.

JENNET: I am troubled to find Thomas Mendip.

NICHOLAS: He's far gone –
As mad as the nature of man.

HUMPHREY: As rude and crude
As an act of God. He'll burn your house.

JENNET: So he has. –
Are you kind to mention burning?

HUMPHREY: I beg your pardon.

NICHOLAS: Couldn't you tomorrow by some elementary spell
Reverse the direction of the flames and make them burn
downwards?
It would save you unpleasantness and increase at the same
Time the heat below, which would please
Equally heaven and hell.
I feel such a tenderness for you, not only because
I think you've bewitched my brother, which would be
A most salutary thing, but because, even more
Than other women, you carry a sense of that cavernous
Night folded in night, where Creation sleeps
And dreams of men. If only we loved each other
Down the pitshaft of love I could go
To the motive mysteries under the soul's floor.
Well drenched in damnation I should be as pure
As a limewashed wall.

HUMPHREY: Get out!

JENNET: He does no harm. –
Is it possible he still might make for death
Even on this open-hearted night?

HUMPHREY: Who might?

JENNET: Thomas Mendip. He's sick of the world, but the world
Has a right to him.

HUMPHREY: Damn Thomas Mendip.

NICHOLAS: Nothing
 Easier.
 (*Enter RICHARD, upset to see his escape cut off.*)
 You're just the fellow, Richard:
 We need some more Canary, say five bottles
 More. And before we go in, we'll drink here, privately,
 To beauty and the sombre sultry waters
 Where beauty haunts.

RICHARD: I have to find – to find –

NICHOLAS: Five bottles of Canary. I'll come to the cellars
 And help you bring them. Quick, before our mother
 Calls us back to evaporate into duty.
 (*Exit NICHOLAS, taking RICHARD with him.*)

HUMPHREY: He's right. You have bewitched me. But not
 by brews
 And incantations. For all I know
 You may have had some traffic with the Devil
 And made some sinister agreement with him
 To your soul's cost. If so, you will agree
 The fire is fair, as fair goes:
 You have to burn.

JENNET: It's hard enough to live
 These last few hours as the earth deserves.
 Do you have to remind me how soon the night
 Will leave me unprotected, at the daylight's mercy?
 I'm tired, trying to fight those thoughts away.

HUMPHREY: But need you? These few hours of the night
 Might be lived in a way which wouldn't end
 In fire. It would be insufferable
 If you were burned before I could know you.
 I should never sit at ease in my body again.

JENNET: Must we talk of this? All there is
 To be said has been said, and all in a heavy sentence.
 There's nothing to add, except a grave silence.

HUMPHREY: Listen, will you listen? There is more to say.
 I'm able to save you, since all official action

Can be given official hesitation. I happen
To be on the Council, and a dozen reasons
Can be found to postpone the moment of execution:
Legal reasons, monetary reasons –
They've confiscated your property, and I can question
Whether your affairs may not be too disordered.
And once postponed, a great congestion of quibbles
Can be let loose over the Council table –

JENNET: Hope can break the heart, Humphrey. Hope
Can be too strong.

HUMPHREY: But this is true: actual
As my body is. And as for that – now, impartially,
Look what I risk. If in fact you have
Done anything to undermine our fairly
Workable righteousness, and they say you have,
Then my status in both this town and the after-life
Will be gone if either suspect me of having helped you.
I have to be given a considerable reason
For risking that.

JENNET: I fondly hope I'm beginning
To misconstrue you.

HUMPHREY: Later on tonight
When they're all bedded-down in their beauty-sleep
I'll procure the key and come to your cell. Is that
Agreeable?

JENNET: Is it so to you?
Aren't you building your castles in foul air?

HUMPHREY: Foul? No; it's give and take, the basis
Of all understanding.

JENNET: You mean you give me a choice:
To sleep with you, or tomorrow to sleep with my fathers.
And if I value the gift of life,
Which, dear heaven, I do, I can scarcely refuse.

HUMPHREY: Isn't that sense?

JENNET: Admirable sense.
Oh, why, why am I not sensible?

Oddly enough, I hesitate. Can I
So dislike being cornered by a young lecher
That I should rather die? That would be
The maniac pitch of pride. Indeed, it might
Even be sin. Can I believe my ears?
I seem to be considering heaven. And heaven,
From this angle, seems considerable.

HUMPHREY: Now, please, we're not going to confuse the soul and
the body.
This, speaking bodily, is merely an exchange
Of compliments.

JENNET: And surely throwing away
My life for the sake of pride would seem to heaven
A bodily blasphemy, a suicide?

HUMPHREY: Even if heaven were interested. Or even
If you cared for heaven. Am I unattractive to you?

JENNET: Except that you have the manners of a sparrowhawk,
With less reason, no, you are not. But even so
I no more run to your arms than I wish to run
To death. I ask myself why. Surely I'm not
Mesmerised by some snake of chastity?

HUMPHREY: This isn't the time –

JENNET: Don't speak, contemptible boy,
I'll tell you: I am not. We have
To look elsewhere – for instance, into my heart
Where recently I heard begin
A bell of longing which calls no one to church.
But need that, ringing anyway in vain,
Drown the milkmaid singing in my blood
And freeze into the tolling of my knell?
That would be pretty, indeed, but unproductive.
No, it's not that.

HUMPHREY: Jennet, before they come
And interrupt us –

JENNET: I am interested
In my feelings. I seem to wish to have some importance

In the play of time. If not,
Then sad was my mother's pain, my breath, my bones,
My web of nerves, my wondering brain,
To be shaped and quickened with such anticipation
Only to feed the swamp of space.
What is deep, as love is deep, I'll have
Deeply. What is good, as love is good,
I'll have well. Then if time and space
Have any purpose, I shall belong to it.
If not, if all is a pretty fiction
To distract the cherubim and seraphim
Who so continually do cry, the least
I can do is to fill the curled shell of the world
With human deep-sea sound, and hold it to
The ear of God, until he has appetite
To taste our salt sorrow on his lips.
And so you see it might be better to die.
Though, on the other hand, I admit it might
Be immensely foolish. – Listen! What
Can all that thundering from the cellars be?

HUMPHREY: I don't know at all. You're simply playing for time.
Why can't you answer me, before I'm thrown
By the bucking of my pulse, before Nicholas
Interrupts us? Will it be all right?

JENNET: Doesn't my plight seem pitiable to you?

HUMPHREY: Pitiable, yes. It makes me long for you
Intolerably. Now, be a saint, and tell me
I may come to your cell.

JENNET: I wish I could believe
My freedom was not in the flames. O God, I wish
The ground would open.

(*THOMAS climbs in through the window.*)

THOMAS: Allow me to open it for you.
Admit I was right. Man's a mistake.
Lug-worms, the lot of us.

HUMPHREY: Wipe your filthy boots
 Before you start trespassing.
THOMAS: And as for you
 I'll make you the climax to my murders.
 You can die a martyr to the cause
 Of bureaucratic pollution.
JENNET: Oh dear,
 Is this lug-worms at war? And by what right, will you tell me,
 Do you come moralising in, dictating
 What I should do?
THOMAS: Woman, what are you saying?
 Are you trying to tell me you'd even consider –
JENNET: I might prefer the dragon to St George.
HUMPHREY: If he wants to fight me, let him. Come out into
 the garden.
 If he kills me
 Remember I thought you unfairly beautiful
 And, to balance your sins, you should be encouraged
 To spend your beauty in a proper way,
 On someone who knows its worth.
THOMAS: Sound the trumpets!
JENNET: Yes, why not? And a roll
 Of drums. You, if you remember, failed
 Even to give me a choice. You have only said
 'Die, woman, and look as though you liked it.'
 So you'll agree this can hardly be said to concern you.
THOMAS: All right! You've done your worst. You force me to
 tell you
 The disastrous truth. I love you. A misadventure
 So intolerable, hell could not do more.
 Nothing in the world could touch me
 And you have to come and be the damnable
 Exception. I was nicely tucked up for the night
 Of eternity, and, like a restless dream
 Of a fool's paradise, you, with a rainbow where
 Your face is and an *ignis fatuus*

Worn like a rose in your girdle, come pursued
By fire, and presto! the bedclothes are on the floor
And I, the tomfool, love you. Don't say again
That this doesn't concern me, or I shall say
That you needn't concern yourself with tomorrow's burning.
(*Enter NICHOLAS.*)

NICHOLAS: Do you know what that little bastard Richard did?
He locked me in the cellars.

THOMAS: Don't complicate
The situation. – I love you, perfectly knowing
You're nothing but a word out of the mouth
Of that same planet of almighty blemish
Which I long to leave. But the word so sings
With an empty promise. – I shall lie in my grave
With my hands clapped over my ears, to stop your music
From riddling me as much as the meddling worms.
Still, that's beside the point. We have to settle
This other matter –

NICHOLAS: Yes, I was telling you.
I went into the cellars to get the wine,
And the door swung after me, and that little son
Of a crossbow turned the key –

THOMAS: (*To JENNET.*) Can we find somewhere
To talk where there isn't quite so much insect life?

NICHOLAS: And there I was, in cobwebs up to my armpits,
Hammering the door and yelling like a slaughter-house,
Until the cook came and let me out. Where is he?

JENNET: What should we talk of? You mean to be hanged.
Am I to understand that your tongue-tied dust
Will slip a ring on the finger of my ashes
And we'll both die happily ever after? Surely
The other suggestion, though more conventional,
Has fewer flaws?

THOMAS: But you said, like a ray of truth
Itself, that you'd rather burn.

JENNET: My heart, my mind

 Would rather burn. But may not the casting vote
 Be with my body? And is the body necessarily
 Always ill-advised?

NICHOLAS: Something has happened
 Since I made the descent into those hellish cobwebs.
 I'm adrift. What is it?

THOMAS: Let me speak to her.
 You've destroyed my defences, the laborious contrivance
 Of hours, the precious pair of you. O Jennet,
 Jennet, you should have let me go, before
 I confessed a word of this damned word love. I'll not
 Reconcile myself to a dark world
 For the sake of five-feet six of wavering light,
 For the sake of a woman who goes no higher
 Than my bottom lip.

NICHOLAS: I'll strip and fly my shirt
 At the masthead unless someone picks me up.
 What has been going on?

THOMAS: Ask that neighing
 Horse-box-kicker there, your matchless brother.

NICHOLAS: Ah, Humphrey darling, have there been
 Some official natural instincts?

HUMPHREY: I've had enough.
 The whole thing's become unrecognisable.

JENNET: (*To THOMAS.*) Have I a too uncertain virtue to keep you
 On the earth?

THOMAS: I ask nothing, nothing. Stop
 Barracking my heart. Save yourself
 His way if you must. There will always be
 Your moment of hesitation, which I shall chalk
 All over the walls of purgatory. Never mind
 That, loving you, I've trodden the garden threadbare
 Completing a way to save you.

JENNET: If you saved me
 Without wishing to save yourself, you might have saved
 Your trouble.

NICHOLAS: I imagine it's all over with us, Humphrey.
 I shall go and lie with my own thoughts
 And conceive reciprocity. Come on, you boy of gloom.
 The high seas for us.

HUMPHREY: Oh go and drown yourself
 And me with you.

NICHOLAS: There's no need to drown.
 We'll take the tails off mermaids.
 (Enter MARGARET.)

MARGARET: Have any of you
 Seen that poor child Alizon? I think
 She must be lost.

NICHOLAS: Who isn't? The best
 Thing we can do is to make wherever we're lost in
 Look as much like home as we can. Now don't
 Be worried. She can't be more lost than she was with us.

HUMPHREY: I can't marry her, mother. Could you think
 Of something else to do with her?
 I'm going to bed.

NICHOLAS: I think Humphrey has been
 Improperly making a proper suggestion, mother.
 He wishes to be drowned.

MARGARET: *(To THOMAS.)* They find it impossible
 To concentrate. Have you seen the little
 Fair-haired girl?

NICHOLAS: He wishes to be hanged.

MARGARET: *(To JENNET.)* Have you hidden the child?

NICHOLAS: She wishes to be burned
 Rather than sleep with my brother.

MARGARET: She should be thankful
 She can sleep at all. For years I have woken up
 Every quarter of an hour. I must sit down.
 I'm too tired to know what anyone's saying.

JENNET: I think none of us knows where to look for Alizon.
 Or for anything else. But shall we, while we wait
 For news of her, as two dispirited women

Ask this man to admit he did no murders?

THOMAS: You think not?

JENNET: I know. There was a soldier,
Discharged and centreless, with a towering pride
In his sensibility, and an endearing
Disposition to be a hero, who wanted
To make an example of himself to all
Erring mankind, and falling in with a witch-hunt
His good heart took the opportunity
Of providing a diversion. O Thomas,
It was very theatrical of you to choose the gallows.

THOMAS: Mother, we won't listen to this girl.
She is jealous, because of my intimate relations
With damnation. But damnation knows
I love her.

RICHARD: (*Appearing in the doorway.*) We have come back.

NICHOLAS: I want to talk to you. Who locked me in the cellars?

MARGARET: (*As ALIZON enters.*) Alizon, where have you been?

ALIZON: We had to come back.

MARGARET: Back? From where?

RICHARD: We came across old Skipps.

ALIZON: We were running away. We wanted to be happy.

NICHOLAS: Skipps?

HUMPHREY: The body of old Skipps? We'd better
Find Tappercoom.
(*Exit HUMPHREY.*)

MARGARET: Alizon, what do you mean,
Running away?

RICHARD: He is rather drunk. Shall I bring him
In? He had been to see his daughter.

JENNET: (*To THOMAS.*) Who
Will trouble to hang you now?
(*She goes up the stairs.*)

THOMAS: (*Calling after her.*) He couldn't lie quiet
Among so many bones. He had to come back

To fetch his barrow.

TAPPERCOOM: (*Entering with HUMPHREY.*) What's all this
 I'm told?
 I was hoping to hang on my bough for the rest of the evening
 Ripe and undisturbed. What is it? Murder
 Not such a fabrication after all?

ALIZON: We had to come back, you see, because nobody now
 Will be able to burn her.

RICHARD: Nobody now will be able
 To say she turned him into a dog. Come in,
 Mr Skipps.

 (*Enter SKIPPS, unsteady.*)

TAPPERCOOM: It looks uncommonly to me
 As though someone has been tampering with the evidence.
 Where's Tyson? I'm too amiable tonight
 To controvert any course of events whatsoever.

SKIPPS: Your young gentleman says Come in, so I comes in.
 Youse only has to say muck off, and I goes, wivout argument.

TAPPERCOOM: Splendid, of course. Are you the rag-and-bone
 merchant of this town, name of Matthew Skipps?

SKIPPS: Who give me that name? My granfathers and
 granmothers and all in authorority undrim. Baptised I
 blaming was, and I says to youse, baptised I am, and I says
 to youse, baptised I will be, wiv holy weeping and washing
 of teeth. And immersion upon us miserable offenders.
 Miserable offenders all – no offence meant. And if any
 of youse is not a miserable offender, as he's told to be by
 almighty and mercerable God, then I says to him Hands off
 my daughter, you bloody-minded heathen.

TAPPERCOOM: All right, all right –

SKIPPS: And I'm not quarrelling, mind; I'm not quarrelling.
 Peace on earth and good tall women. And give us our
 trespassers as trespassers will be prosecuted for us. I'm not
 perfect, mind. But I'm as good a miserable offender as any
 man here present, ladies excepted.

THOMAS: Here now, Matt, aren't you forgetting yourself?
 You're dead: you've been dead for hours.

SKIPPS: Dead, am I? I has the respect to ask you to give me coabberation of that. I says mucking liar to nobody. But I seen my daughter three hours back, and she'd have said fair and to my face Dad, you're dead. She don't stand for no nonsense.

NICHOLAS: The whole town knows it, Skipps, old man. You've been dead since this morning.

SKIPPS: Dead. Well, you take my breaf away. Do I begin to stink, then?

HUMPHREY: You do.

SKIPPS: Fair enough. That's coabberation. I'm among the blessed saints.

TAPPERCOOM: He floats in the heaven of the grape. Someone take him home to his hovel.

SKIPPS: (*Roaring.*) Alleluia! Alleluia! Alleluia!

TAPPERCOOM: Now, stop that, Skipps. Keep your hosannas for the cold light of morning or we shall lock you up.

SKIPPS: Alleluia!

TAPPERCOOM: He'll wake your guests and spoil their pleasure. They're all sitting half sunk in a reef of collars. Even the dear good Chaplain has taken so many glasseful of repentance he's almost unconscious of the existence of sin.

SKIPPS: Glory, amen! Glory, glory, amen, amen!

MARGARET: Richard will take this old man home. Richard – Where is Richard? Where is Alizon?
Have they gone again?

NICHOLAS: Yes; Humphrey's future wife,
Blown clean away.

MARGARET: Yes; that's all very well;
But she mustn't think she can let herself be blown
Away whenever she likes.

THOMAS: What better time
Than when she likes?

SKIPPS: As it was in the beginning,
Ever and ever, amen, al-leluia!

MARGARET: Take the old man to his home. Now that you've
 made him
 Think he's dead we shall never have any peace.

HUMPHREY: Nor shall we when he's gone.

NICHOLAS: Spread your wings, Matthew; we're going to teach
 you to fly.

SKIPPS: I has the respect to ask to sit down. Youse blessed saints
 Don't realise: it takes it out of you, this life everlasting. Alleluia!

NICHOLAS: Come on.
 Your second wind can blow where no one listens.

 (*Exeunt HUMPHREY, NICHOLAS, and SKIPPS.*)

TAPPERCOOM: That's more pleasant.
 What was the thread, now, which the rascal broke?
 Do I have to collect my thoughts any further?

MARGARET: Yes:
 Or I must. That poor child Alizon
 Is too young to go throwing herself under the wheels
 Of happiness. She should have wrapped up warmly first.
 Hebble must know, in any case. I must tell him,
 Though he's locked himself in, and only blows his nose
 When I knock.

TAPPERCOOM: Yes, get him onto a horse;
 It will do him good.

MARGARET: Hebble on a horse is a man
 Delivered neck and crop to the will of God.
 But he'll have to do it.

 (*Exit MARGARET.*)

TAPPERCOOM: Ah yes, he'll have to do it.
 He's a dear little man. – What's to be the end of you?
 I take it the male prisoner is sufficiently
 Deflated not to plague us with his person
 Any longer?

THOMAS: Deflated? I'm overblown
 With the knowledge of my villainy.

TAPPERCOOM: Your guilt, my boy,
 Is a confounded bore.

THOMAS: Then let it bore me to extinction.

(*JENNET returns, wearing her own dress.*)

TAPPERCOOM: The woman prisoner may notice, without
 My mentioning it, that there's a certain mildness
 In the night, a kind of somnolent inattention.
 If she wishes to return to her cell, no one
 Can object. On the other hand – How very empty
 The streets must be just now. – You will forgive
 A yawn in an overworked and elderly man. –
 The moon is full, of course. To leave the town
 Unobserved, one would have to use caution. As for me
 I shall go and be a burden to my bed.
 Good night.

JENNET: Good night.

THOMAS: Good night.

(*Exit TAPPERCOOM.*)

 So much for me.

JENNET: Thomas, only another
 Fifty years or so and then I promise
 To let you go.

THOMAS: Do you see those roofs and spires?
 There sleep hypocrisy, porcous pomposity, greed,
 Lust, vulgarity, cruelty, trickery, sham
 And all possible nitwittery – are you suggesting fifty
 Years of that?

JENNET: I was only suggesting fifty
 Years of me.

THOMAS: Girl, you haven't changed the world.
 Glimmer as you will, the world's not changed.
 I love you, but the world's not changed. Perhaps
 I could draw you up over my eyes for a time
 But the world sickens me still.

JENNET: And do you think
 Your gesture of death is going to change it? Except
 For me.

THOMAS: Oh, the unholy mantrap of love!

JENNET: I have put on my own gown again,
>But otherwise everything that is familiar,
>My house, my poodle, peacock, and possessions,
>I have to leave. The world is looking frozen
>And forbidding under the moon; but I must be
>Out of this town before daylight comes, and somewhere,
>Who knows where, begin again.

THOMAS: Brilliant!
>So you fall back on the darkness to defeat me.
>You gamble on the possibility
>That I was well-brought-up. And, of course, you're right.
>I have to see you home, though neither of us
>Knows where on earth it is.

JENNET: Thomas, can you mean to let
>The world go on?

THOMAS: I know my limitations.
>When the landscape goes to seed, the wind is obsessed
>By tomorrow.

JENNET: I shall have to hurry.
>That was the pickaxe voice of a cock, beginning
>To break up the night. Am I an inconvenience
>To you?

THOMAS: As inevitably as original sin.
>And I shall be loath to forgo one day of you,
>Even for the sake of my ultimate friendly death.

JENNET: I am friendly too.

THOMAS: Then let me wish us both
>Good morning. – And God have mercy on our souls.
>
>(*The curtain falls.*)

A YARD OF SUN

To Tam and Vreli
with love

Characters

ANGELINO BRUNO

ROBERTO, his son

LUIGI, his son

EDMONDO, his son

GIOSETTA SCAPARE

GRAZIA, her daughter

ALFIO, a jockey from Naples

ANA-CLARA, Edmondo's wife

CESARE SCAPARE, Giosetta's husband

PIERO MARTINI, a photographer

FRANCO, a water carrier

ETTORE, Edmondo's chauffeur

Place: The courtyard of the Palazzo del Traguardo, Siena

Time: July 1946

A Yard of Sun was first performed at the Nottingham Playhouse on 10 August 1970, with the following cast:

ANGELINO BRUNO, Frank Middlemass

ROBERTO, John Shrapnel

LUIGI, Michael Burrell

EDMONDO, Robert East

GIOSETTA SCAPARE, Eithne Dunne

GRAZIA, Lucy Fleming

ALFIO, Nickolas Grace

ANA-CLARA, Cherith Mellor

CESARE SCAPARE, Haydn Jones

PIERO MARTINI, Geoffrey Bateman

FRANCO, Jeremy Chandler

ETTORE, Alec Sabin

SERVANTS, NEIGHBOURS, etc, Helen Lloyd, Evadne Sefton, Geoffrey Drew, Peter Draycott, Douglas Whitlock

Director Stuart Burge

Designer Robin Archer

Lighting designer Nick Chelton

Stage manager Kevin Hubbard

Musical arranger Stephen Hancock

ACT ONE

(July 1946. The courtyard of the Palazzo del Traguardo. A gateway to the street. A handsome doorway to the grand apartment. A smaller door to an apartment partly used as an Osteria; and, across the yard, the door to a third apartment. ANGELINO BRUNO, a stocky, bushy-browed man of middle-age, is sweeping from the porter's room to the street outside. ROBERTO BRUNO, his son, wearing an old outgrown dressing gown, enters from the Osteria.)

ROBERTO: Don't you know it's a dirty world, father?
> And every day is as dirty as another.
> That's why we have to wash.

ANGELINO: It's only nine.
> I thought you'd lie with the day a bit.
> What sinful hour was it when you got to bed?

ROBERTO: Five o'clock. And then it was too hot to sleep.
> I need a bath. There's no water in the taps.

ANGELINO: It's been turned off at the mains.

ROBERTO: Damn.

ANGELINO: There was a storm last night. But there you are,
> What's a collision in the atmosphere to you
> Once you all start singing at one of your reunions?
> You think you're the thunder and the lot. At half past eleven
> The heavens emptied their pots, I can tell you.

ROBERTO: Yes, I know. Rosa Levanti came
> And fetched me to her father about midnight.
> The old man didn't want to die till the weather improved.

ANGELINO: Did you keep him alive?

ROBERTO: Yes, while the storm lasted.
> Then he seemed to notice the silence: put out his hand
> As though he'd been sheltering in a doorway,
> Looked up, and made off. Just before daylight.

ANGELINO: Still,
> You did your best, poor old Giovanni. So you knew
> The streets were flooded. It overflowed the sewers.

ROBERTO: We have no water when there's a drought, and then
 We have no water when there's a flood. You see
 The hopeless way this town is organised!

ANGELINO: What do you want?
 Everyone with snow white necks and typhoid?

ROBERTO: I want an efficient water supply, and not
 A hackneyed parable of modern life.
 I want a shave, and a coffee, and a blessed bath.
 I don't expect to have to start the day
 On a bottle of beer.

(*He goes into the Osteria. ANGELINO raises his voice.*)

ANGELINO: It isn't believable!
 You call yourself a doctor? What a fantasy!
 I've said the floodwater floated the sewers!
 Why don't you listen? That's an Act of God
 Not a political manifesto. A doctor!
 You ought to be saying seven Hail Marys
 For not having to wade up to your gorge
 Through an epidemic. Always the same thing:
 You have a Reunion, and that's perfectly right,
 You are all fine fellows, I say it to God,
 The Partisans were all fine courageous fellows.
 You deserve to shout the night down, once a month.
 But next morning you have to come back to earth
 And, each time you do, the earth isn't good enough for you.

(*ROBERTO emerges, grinning, with a glass and bottle.*)

ROBERTO: Is it good enough for you?

ANGELINO: (*With a shrug.*) What is good enough?
 You are not good enough for me, your brother
 Luigi isn't good enough for me, I
 Am not good enough for me. But I don't blame that
 On the city fathers.

ROBERTO: Why not? They made our environment.
 They're the ones who made us in the gutter's image.

ANGELINO: And a fine assorted lot we've turned out to be.
 I couldn't love us more dearly

If we were twenty-four carat. As for environment,
The environment is in for a transformation.
I'm opening up the Palazzo again. What
A delight! I can't help patting myself on the back –
Like you when the stamina of one of your patients
Pulls him through a crisis.
I've been told to expect the new owners today.

ROBERTO: Have you? Who are they?

ANGELINO: I don't know. They must be
High quality of some kind or other.
Like God, they only reveal themselves through an agent.

ROBERTO: So we're enemy-occupied territory again;
That's a cheerful prospect.

ANGELINO: You behave yourself!
Roberto, give me your word you'll behave decently!
If you try and start a class vendetta
Just where I'm paid to keep the floor clear of bodies
You can move into lodgings. I'm not having it!
Fidget with your Luger in another district.

ROBERTO: Look, I was only –

ANGELINO: Haven't I been a good father?

ROBERTO: Yes, you have been a very –

ANGELINO: Don't perjure yourself.
I don't know what I've been. You're always saying
I've got no rules of conduct. Maybe that is
What I haven't got. I'm bound to admit
I like things to have a shine to them –
And I know the sun can lure larks with bits of tin
And pheasants with a mirror, and all that macaroni.
I won't say you're not right. But anyway
I spent all I'd got on you and Luigi
To get you where you are, and that's no further
Than a two-year-old could push you with its left hand.
Look at you, working for nothing because you refuse
To attend anybody who can afford to pay you.
I don't call that the top of the ladder. And now

You haven't enough money to treat them properly.
I suppose you think that makes you a philanthropist.
I invested my money in you because I thought
You had brains, and would make my future, you and Luigi.
But I'm farther off from a future than I ever was
So don't make trouble when things take a lucky turn.
What do we get out of the Osteria
Except good friends drinking at our expense?
And being caretaker of this Palazzo
Doesn't take care of anything. But now
We have rich cows coming to be milked,
And they'll introduce us to other rewarding udders,
And, before you know, we have the most profitable
Restaurant in Siena. But none of this
Will happen if I've got you sniping at their haunches
From behind every shutter in the building.
Do I make you understand?

ROBERTO: We'll have to see
How they behave.

ANGELINO: You make me so anxious.

ROBERTO: Why?
Don't cross your bridge till you see it collapsing.
We don't know yet that I'm going to have to shoot them.
(*A man's voice is heard singing down the street.*)
That voice could only be my brother Luigi's.

ANGELINO: Yes. I can feel it in my neck muscles.
Some people have time on their hands, but I haven't
 this morning.
(*He goes in through the great doorway. The singing ends as LUIGI
turns into the courtyard from the street.*)

LUIGI: Good morning, Bobo.

ROBERTO: Why do you have to exercise
That mongrel tenor in a public thoroughfare?

LUIGI: It's my part in the song of praise. If we're not equipped
To give thanks, we shouldn't give up trying. What's
The matter with you? You look like one of your patients.

A pity on the first day of a better world.

ROBERTO: A what?

LUIGI: I remembered it as soon as it was light.
 I swallowed the last black morsel of what I was dreaming
 And said Here it is, we're all new men
 In a new world. I stood at the window, like Adam
 Looking out on the first garden.

ROBERTO: I remember the view:
 Over the knacker's back yard.

LUIGI: Bobo, the trouble with you is
 You only see life through a rifle sight
 And only hear it through a stethoscope.
 You're always either killing or curing. You won't
 Allow that life ever knows her own business.
 But nevertheless there are times when she manages
 To fight her way out of our raping clutches
 And today is one of them. Not quite a virgin,
 We all know that, but at least confessed and absolved.
 I'm overjoyed to take her back.

ROBERTO: Lucky
 Life. What do you find so parthenogenetic
 About this morning?

LUIGI: Where's your vision of life?
 You know it's the first practice run for the Palio –
 And you know this parish has got the best horse
 It has ever had, and the best jockey too.
 Doesn't it lift your heart to think we're behaving
 Like old times? The Palio! The first
 Since we cleared the war off our premises!

ROBERTO: So it's 'we' who did it? That's the new story?
 Have you forgotten already which side you were on?

LUIGI: No, not yet. But we were a help. We had
 The sense to lose. That deserves some credit.

ROBERTO: Does it?

LUIGI: Yes, I think so.

ROBERTO: You won't get it from me, then.

I still suffer from girds of nausea
Whenever I think of the way you used to strut
In your black shirt.

LUIGI: Well, I strut in any shirt;
I know I strut. When I was small – perhaps
You've forgotten – the teacher always used to think
I'd fouled my breeches.

ROBERTO: When I let myself think
Of the money father wasted, entertaining
Those arm-shooting gangsters and assassins
Because you fancied yourself as a politician –
Careful money he'd taken all his life to earn –
Until he had to sell up the business,
I've so much useless anger, I could crack apart.

LUIGI: Or smash me against the wall. I wish you would.
I'm sick of watching you master the temptation.
Then we might forget it. I've admitted,
Until I'm hoarse, it was a false start.
But I was the one set back by it.

ROBERTO: Just you?
I set out to be a healer, not a killer.
It was what you tried to stand for made me lethal.

LUIGI: Yes, well; we're out of it now. No good pining.
Where's daddo? Eh? Where is he?

ROBERTO: Opening up
The Palazzo.

LUIGI: Has somebody taken it?
Yes? There, you see, what did I tell you?
It's the day of bright beginnings. Just as I said.
(*ANGELINO throws open an upper window. LUIGI shouts up
to him.*)
That's right, daddo! Open the doors and windows!
Let the sun decontaminate the place,
Let the air get rid of that fug of requisitioning.
Who are they, these people?

ROBERTO: He doesn't know.

The children of Mammon come back for their broken toys.
The first of the swarm. That's what it sounds like.

LUIGI: They're going to think they're in the black bear country.
If they see much of you.

ROBERTO: Somebody's got to protect him.
The more he's exploited, the more he glows with pride.
You made the most of that. And if you thought
There was anything left you'd be fastening on him again
To launch you on your Christian Democrat cruise.
That mine's worked out.

LUIGI: You are an unforgiving
Unfair bastard! Why am I supposed
To be the particularly guilty one?
Because eight years ago I put on a dirty shirt? –
He spent no more on me than he spent on you.
And if our brother Edmondo hadn't imagined
He could take on the world alone with his bare wits
He would have had *his* share as well.

(*ANGELINO enters from the great doorway.*)

ANGELINO: Enough,
That's enough, Luigi! I won't have his name mentioned,
You know that.

LUIGI: Yes, I know, but I was only
Standing up for myself against slander and calumny.
I was saying that if Edmondo had wanted –

ANGELINO: Luigi!
Will you keep quiet when I tell you that's enough?
There's no such name in our family. I don't remember him.
Where is Grazia this morning?

ROBERTO: That's the way!
Don't let memory interfere with your pleasures,
Either of you. Ignore the uncomfortable.

ANGELINO: Luigi, why did you have to pick this morning
To argue with him? He's had no bath or coffee.
And last night was a Partisan Reunion.
Even the sunlight scratches him.

LUIGI: Argue? Me?
 I came here dispensing drops of light
 Like a wet retriever. If it's water he wants
 They're coming along the road with it now. I saw them
 Dumping it off in churns.

 (*ANGELINO shouts up to an opposite window.*)

ANGELINO: Grazia Scapare!
 Grazia! – I wish someone would teach her that time
 Promises far more than it lives up to.
 She thinks eternal life is one of the basic
 Human rights, a kind of public swimming bath.
 But I wouldn't lose her an hour of those few years
 When we seem to be living forever.

LUIGI: (*To ROBERTO.*) You've made me thirsty,
 You tup, sweating to defend myself.

 (*He goes into the Osteria as GIOSETTA, GRAZIA's mother, comes out of her apartment and hangs rugs on a line.*)

GIOSETTA: Good morning. What's all the shouting for?

ANGELINO: Your daughter,
 Where's your daughter?

GIOSETTA: I sent her to buy some bread,
 But that was an hour ago at least. I'm sure
 I can't tell you what she has done with herself.

ANGELINO: She was going to help me get the Palazzo ready.

ROBERTO: Don't you know, Giosetta? – we're supposed to have
 Our tongues at the ready to lick the boots of the great ones.

GIOSETTA: The shame of it.

ROBERTO: (*Shrugging.*) We're all well used to blushing.

 (*LUIGI returns, opening a bottle of beer.*)

LUIGI: Though not all of us blush so red. Here's Grazia.

 (*GRAZIA has appeared in the street outside, with ALFIO, a young man pushing a Vespa. He props it against a wall within the archway.*)

GIOSETTA: Here she is.

ANGELINO: Ah, here she is!

GRAZIA: Good morning.
 Why are you all saying I am here? Has something
 Happened?

ANGELINO: Who said she was going to come over early
 And make the place glisten?

GRAZIA: (*Making for the door.*) Oh goodness, I did!

GIOSETTA: Did you get me the bread?

GRAZIA: (*Returning.*) I did, I did!

ROBERTO: Would you say there's anything else you've forgotten?

GRAZIA: I haven't said good morning to Roberto.

ROBERTO: It's just as well. I'm only half human as yet.

GRAZIA: Here's half a kiss, then, for the human part.

GIOSETTA: What have you been doing all this time?

GRAZIA: Watching the preparations down in the square.
 They've laid the sand for the racetrack. Now the stalls
 And the seats are going up. And I've seen our horse!
 It's right he should be called Midnight Pride,
 He shines like a black star. Some flags are flying,
 And they've begun draping the balconies.
 Everyone I spoke to was a shade off balance
 As though he had decided to go up in a balloon.
 It was terribly hard to come away
 And I forgot all about what I'd promised to do.
 I'll get the things now.

ANGELINO: (*Going into the Palazzo.*) No matter, little pony.
 I've taken them already.

GRAZIA: (*Starting to follow.*) Oh, thank you.

ALFIO: (*To LUIGI.*) Excuse me, sir.

LUIGI: You know, we're the only two, Grazia,
 Who seem to recognise what today stands for.
 The happy times are coming out of their shelter.
 They'll be a bit pale at first until the light
 Gets to the skin; but there's a taste in the air
 Of what it was like when we were boys, in a way.

GRAZIA: Is that what it is?

ROBERTO: So he likes to imagine.

ALFIO: (*To ROBERTO.*) Excuse me.

ROBERTO: Quite all right. – But please God, it's not,
When you think of what that time was breeding.

GIOSETTA: Grazia,
Who is this boy who came with you?

GRAZIA: I don't know.
He was asking the way. He said he wanted to get here
So I brought him.

(*She goes in through the big door. Exit GIOSETTA to apartment.*)

LUIGI: (*To ALFIO.*) Are you looking for someone?

ALFIO: Yes,
Yes, I am. I wonder if you can tell me –

LUIGI: Now *you're* an impartial observer. Suppose you judge
The issue between my brother and me.
Is a man never to be allowed to grow
Out of the compost of his own mistakes
And be accepted on his present showing?
What good is served by treading ancient ordure
Into a new carpet? Kindly give us
Your oracular opinion.

ALFIO: I was wanting to ask –

ROBERTO: You haven't convinced me that anything has altered.
You seem to think every change of wind
That crosses your mind is a kind of baptism.
Why don't you ask this chap what he's looking for?

LUIGI: He doesn't seem to have a thought in his head.
All right, what's he looking for?

ALFIO: Someone who can give me
News of my father.

LUIGI: I've never heard of him.

ROBERTO: Who *are* you if we had?

ALFIO: I'm a jockey from Naples.
The Dragon district have hired me to ride for them.

LUIGI: Then; if I were you, I'd give this part of the town

A wide berth. Wouldn't you, Roberto?
I wouldn't take the responsibility
Of seeing you through these streets
Once it got about who you are. The Dragons
Are our oldest rivals. I'm not at all sure
It's not our duty to kidnap him. What do you think?

ROBERTO: I don't see that we've any alternative.

ALFIO: (*Backing away.*) Be serious, will you? I want some help.

LUIGI: He thinks
We're not serious. Don't you know, Neapolitan numbskull,
The race is more serious than matrimony.
Many's the wife goes home to her own district:
My wife, for instance – gone home to her mother
In a desperate state of divided loyalty.

ROBERTO: So you see there's no doubt we should quietly get rid
of you.
What's your father to *us*?

ALFIO: I don't know,
But I met a man very early in the war
Who said my father lives here, or at any rate
Lived here then. I've kept the address he gave me:
I'm afraid it's worn a bit thin down where the folds are,
But you see: Palazzo Traguardo, Via delle Stazioni.

ROBERTO: Right address.

ALFIO: If I'd known the young woman lived here –

ROBERTO: But no redundant fathers.

LUIGI: Unless – I say,
What about it, Roberto? What has daddo
Been doing while you and I were struggling to learn
To read and write?

ROBERTO: Very funny!

LUIGI: Eh? Why not?
Suppose we have here our little brother!
(*He shouts up to the Palazzo.*)
DAD-DO!

ROBERTO: Stop it! You've irritated him once already.

LUIGI: What's your name, brother?

ALFIO: Alfio Scapare.

ROBERTO: Scapare!

LUIGI: (*After a pause.*) Aie! Aie! Aie!

ROBERTO: Is your father
 Cesare Scapare?

ALFIO: Yes. Is he living here?

ROBERTO: Not now.

ALFIO: Where has he gone? Do you know?

LUIGI: Look, I think you'd better talk to my father, (*Shouts.*)
 Dad-do! – He'll tell you.

ALFIO: What do you find so difficult?
 You don't have to mind telling me the truth.
 Is he dead?
 (*ANGELINO looks out of a window.*)

ANGELINO: Were you calling me?

LUIGI: We've someone here
 Who says he's Cesare Scapare's son.

ROBERTO: Don't let all the street hear you.

LUIGI: (*To his father.*) So we thought
 You should come and talk to him.

ROBERTO: (*To ALFIO.*) We can't tell you
 Whether he's dead or not.
 (*ANGELINO stares down at ALFIO without speaking. He withdraws
 from the window. GIOSETTA comes out and regards ALFIO. As
 ANGELINO comes into the courtyard she goes indoors.*)

ALFIO: Why did your father look at me so strangely?

LUIGI: How else would he look at a stranger?

ALFIO: I don't know,
 But, between you, you've made me as jumpy as a cat.
 What's the matter with all of you? Wasn't I asking
 A simple enough question?

ROBERTO: It's the simple questions
 That take the most answering.
 What you *should* know is, he has another family here –

A woman not your mother – a woman known
In these parts as his wife.

(*ANGELINO enters. GRAZIA can be seen at the window looking
at ALFIO.*)

ANGELINO: I thought the storm last night
Would open up a crack in the fabric somewhere.

LUIGI: This is Alfio Scapare.

ANGELINO: And it has, sure enough.

ALFIO: Good morning.

LUIGI: He comes from Naples. And I'd say
He made a name for himself riding winners
When the war rolled on up north. At any rate
The Dragons have got him for their jockey.

ANGELINO: Quiet! You don't want that to get about
In this part of the town. He'll be in trouble.

LUIGI: We've told him that.

ALFIO: Surely no one can object
To a man looking for his father?

ANGELINO: Though, of course,
With the greatest respect, you're no threat to us at all;
We don't have to worry about *you.* We've got Cambriccio.
By some extraordinary stroke of luck –
Really we don't know how it came about –
We've got Cambriccio – and Cambriccio
As every living baby knows
Is an immortal centaur of a man.
Listen, he can lift a mare between his knees
And make her forget the ground weighs anything at all.
Until he drops her at the post
Three lengths ahead of the field.
His riding is like holy love in a world
Given over to bed-bouncing. Don't imagine
I'm trying to undermine your confidence.
You may say you've got youth on your side, but, sweet jakes,
What's youth to genius?

ALFIO: What about my father?

ANGELINO: No man in his senses would want to talk about
 Your father when he can talk about Cambriccio.

ROBERTO: This man would. Tell him as much as we know.
 Tell him why we feel guilty when he's mentioned.

ALFIO: I think you'd better.

ANGELINO: Cesare Scapare,
 You say he's your father. Well, well.
 Yes, he lived here. You were shown the way
 By his daughter.

LUIGI: Your half-sister, you might say.

ALFIO: My sister?

LUIGI: According to you.

ROBERTO: Come on, it's time
 We stopped dancing all round the ring. The history
 Of your father, up to the time we lost him,
 Is simply this: in nineteen forty-three
 He was in the 'M' division at Bracciano.
 And from there he deserted and made his way back home.

ALFIO: I have a half-sister?

ROBERTO: Are you listening?

ALFIO: It's odd, isn't it, that I should have asked the way
 From her, of all people?

LUIGI: My brother is taking
 A lot of painful trouble to answer your question.
 If you want to know, sit down, and keep your mind on it.

ALFIO: I'm sorry. Go on.

ROBERTO: Did you hear me say he deserted?
 No sin. It was virtuous then to be a rat.
 Besides, Giosetta was ill. (You saw her just now,
 Grazia's mother.) There was no man to be got
 To work their olive grove, and that was the whole
 Of their livelihood. My father lent a hand
 Whenever he could. But it was Grazia –
 She was only sixteen – who was cook and nurse,
 Housekeeper and labourer, getting no sleep
 Till she fell into it. So Cesare made for home.

 They hid him in the house during the day;

 At night he went out and worked among the olives.

ALFIO: And what then? What happened? They caught him,
 did they?

ROBERTO: (*His eyes resting on LUIGI.*) They did. Some Fascist big-
 mouth among us betrayed him.

ALFIO: Did they shoot him?

ROBERTO: He sank out of sight; we know nothing
 More than that.

ANGELINO: It was when he was leaving the house

 Late one night to go up into the fields.

 It was a night like the bottom of a pit, no moon.

 I was asleep, but I woke to hear

 Cesare shout, three slams, and a jeep move off.

 Then nothing, the bloody night sitting on my head

 For a long minute, until Giosetta came

 Crying across to me.

ROBERTO: Now you can see why

 We smile here with a gap in our front teeth.

 (*A pause.*)

ALFIO: I'd give something to know who gave him away. Who
 was it?

 Have you any suspicion?

ANGELINO: Suspicion? Suspicion

 Was like a local sirocco blowing grit

 Into all our eyes, until even saints would look shifty.

ALFIO: What was he like, my father?

 I mean, how did he speak? How did he walk?

 Can you see anything of him in me?

ANGELINO: Can we,

 Roberto? What do you think?

ROBERTO: Stand up. Walk.

LUIGI: Grow two inches taller.

ANGELINO: Something, perhaps,

 In the way he's been slung together. Eh? A kind

Of falling back on an old design
For want of a new basic principle.
I wouldn't say more.

ALFIO: Did you like him?

ANGELINO: Cesare? Yes,
Yes, he was one of the family here. Oh yes,
I liked him. Three weeks out of the four
You could get on well with him, and then for a bit
He would drink himself into a puppet-man.
But never an explanation of what was grilling him –
As though he stuck his own legs in the stocks
And was hitting himself on the eyes with cabbage stalks.
You don't have to mourn over a lost hero, son.
It doesn't seem he gave much thought to you
Over the years.

(*GIOSETTA has come out of her door. She turns sharply on
ANGELINO. As the speech goes on she occasionally gives a rug a
whack with a stick.*)

GIOSETTA: How do you know what he thought?
Does a man have to flay the skin off his body
And hang it on your door, you old leather-merchant,
Before you can speak any good of him? Don't imagine
That Cesare kept his boy a secret from me,
I know all about him. Fancy, Angelino Bruno
Judging his neighbours! We can very soon
Have the three black gypsies you call sons
Put up on show, the way you've done to Cesare.
Let me just tell you.
This fine judge of men you see here, Alfio,
Said to his boys as each one came to leave school:
'I've saved a poor man's fortune from the leather shop
And I'll set you up in any profession you name.'

ANGELINO: Giosetta!

GIOSETTA: That one, hefting his eyebrow at me,
Roberto, he said he would be a doctor,
And as far as it goes I suppose he is a doctor,

But his real ambition is to see us all
Peppered with bullets at the barricades
And carried off on stretchers to the casualty station.

(*LUIGI laughs.*)

As for this one, Luigi, he was to be the politician.
He has the biggest mouth in the family.
No other profession could keep it in the style
It was used to – but all that's come of it
Is reporting football matches in the local paper
As though they were grand opera.

ANGELINO: Now, now, Giosetta, don't let's have any more –

GIOSETTA: As for the other one, the third bright product,
The one that we're not allowed to mention –

(*ANGELINO groans and sits down.*)

He looked straight into his father's eyes and said
'Give me enough to get going and I promise
I'll be as good a thief as any in the business.
That's my ambition, I want to be a thief.'
Well, at least he knew where his talents lay
Which is more than can be said of his brothers.
But poor Angelino, he couldn't understand
Such honest self-appreciation.
So the boy went straight off to Giovanni Levanti
Who worked in the shop in those days, and borrowed
The whole of his savings. That was his word for it: 'borrowed'.
He knew something about Giovanni and didn't
Leave him any choice, and then departed the country.
He started off as he meant to go on. That's all
About him. Now you know what family it is
That doesn't know how to speak well of Cesare.

ANGELINO: Do you mean we still exist? What have I said
To deserve such a terrible beating, Giosetta?
I was only trying to ease the boy's mind, and you've made
All my old wounds ache.

ALFIO: Please excuse me;
I didn't know I was going to cause so much trouble.

LUIGI: You'll see how well we survive. Her curse is never
Altogether fatal. We still limp on.

(*GIOSETTA blows her nose and wipes away the tears of excitement.*)

GIOSETTA: You dare to be hurt by what I say, Angelino!
You've sinned quite enough making me angry,
Don't sin worse by making me sorry I was,
Don't you dare.

ROBERTO: Giovanni Levanti died
Last night, Giosetta.

GIOSETTA: (*Crossing herself.*) Rest his soul. I guessed
It would come. He was smelling the ground all this last year.
I hope the next world enjoys him as much as we did.
Let's be friends, Angelino.

ANGELINO: Well, I should think so.

(*She kisses him and goes on to kiss ROBERTO.*)

GIOSETTA: What a morning it is.

ROBERTO: (*Kissing her.*) Every minute of it.

LUIGI: Here's someone else needs your attention, Giosetta.
Make me well again.

GIOSETTA: I don't take back a word.
I've told you what I think – (*Kiss.*) and there's
Confirmation of it.

LUIGI: Giosetta loves us.

(*GIOSETTA turns rather shyly to ALFIO. GRAZIA is standing
in the great doorway.*)

GIOSETTA: Cesare's boy. What do we say to each other?

ALFIO: Words are like dynamite here. Is it safe to apologise?

GIOSETTA: (*Approaching to kiss him.*)
Why? Because you happen to live?

ALFIO: (*Kissed.*) Thank you.

(*GIOSETTA turns away and comes face to face with GRAZIA.*)

GRAZIA: Yes, I've heard all about it, and I think it might
Have been better if I'd heard it before; but I'm too
Young for truth, I suppose. And yet, you see,

I brought it here. Good morning, truth.

ALFIO: Good morning.

GIOSETTA: I wanted to tell you, Grazia.

GRAZIA: It doesn't matter.

> (*There is a clatter of churns out in the street and a shout of 'Water!'
> A man – FRANCO – trundles in a metal churn, followed by a
> SECOND MAN with another churn.*)

ROBERTO: Thank God for that.

ANGELINO: In plenty of time
> For the travellers. Over there, that's it, Franco.

> (*FRANCO trundles the churn towards the great door.*)

ROBERTO: Here, wait a minute! Wait a minute, now.
> How many churns are you leaving, Franco?

FRANCO: (*Looking at his paper.*) Let's see.
> Palazzo del Traguardo… Two families,
> Two churns.

ROBERTO: It's not enough. The Palazzo
> Is going to be lived in. We shall have to have three.

FRANCO: Here's nothing about that, comrade.
> Two churns.

ROBERTO: Then we'll have it over here.

ANGELINO: Oh, no, we won't.
> No, no, this must be for the Palazzo.
> What a welcome, to find no water when they arrive!

> (*The SECOND MAN has taken a churn to GIOSETTA.*)

SECOND MAN: Sign here, please.

> (*GIOSETTA signs and goes indoors.*)

ANGELINO: Roberto, just think, will you?
> Coming from wherever they've come from, getting here
> With dust and sweat silting up their navels,
> And then to be told there's no water in the house.
> I'd never get over it. I'll let you take
> Enough to shave your obstinate jaw-line, and that's
> As much as you're going to have, my son.

> (*ROBERTO sits on the churn.*)

ROBERTO: Generous,
 But as you see, I'm establishing squatter's rights.

ANGELINO: Get off there!

ROBERTO: We don't yield a drop to the enemy.

FRANCO: Sign, comrade. Make up your own minds.

ALFIO: Grazia.

GRAZIA: What is it?

ALFIO: Can you spare a moment?

GRAZIA: I don't know that I can. What do you want to say?

ROBERTO: (*To FRANCO.*) Keep going, Aquarius.

FRANCO: What's that?

ROBERTO: Ciao, comrade.

FRANCO: Ciao.

ANGELINO: (*Following him into the street.*)
 Can you come back with another delivery?
 This is very important… You go and tell them at the office…

ALFIO: Are you minding this, Grazia, having a brother?

GRAZIA: I am, for the time being. I feel jostled.

ALFIO: When I came up to you to ask you the way
 You were as friendly as the first sun of the year
 On the back of my neck. Now that I'm your brother
 You can't wait to be rid of me.

GRAZIA: Yes, I can; I can wait.

 (*ROBERTO trundles the churn towards the Osteria.*)

ROBERTO: (*To LUIGI.*) Round one. Ahead on points.

LUIGI: Don't drop your guard, not for a second, Bobo.
 They'll nip in with a staggering right, when you least expect it.

ALFIO: (*To GRAZIA.*) When the race is over I shall go back
 to Naples.
 You don't have to put up with me for long.
 What's wrong with half a brother for less than a week?

GRAZIA: It's not so much that. But now I have to think
 Of a double father, yours and mine.

ALFIO: Dear God,
 I'd like to find the man who betrayed him.

GRAZIA: (*Sharply.*) Don't say it!

ALFIO: I'd make him feel sorry. If it were possible
 I wouldn't go back to Naples till I've dug him out.

GRAZIA: Then I don't want to see you again! You're like
 A dog scratching for an old bone
 With mud plastered on your snout
 And your paws going like a piston. I hate it!
 I can't stand here talking to you.
 I've got better things to do.
 (*She moves swiftly away.*)

ALFIO: Now what's the matter?
 Why shouldn't I want to know who did it?
 What's so wrong about that?

GRAZIA: Oh, go away,
 Be quiet! I've had more than enough of you!
 (*She goes into the house.*)

ALFIO: Well, that seems to be the end of my experience
 As a brother.

LUIGI: What do you mean, the end?
 You're one of the family now. It's only beginning.

ALFIO: I feel safer on my Vespa.
 (*ANGELINO returns from the street and finds that ROBERTO
 has moved the churn into the Osteria.*)

ANGELINO: What has he done with it?
 Roberto, bring it back here! Roberto!
 Listen to me, this is very serious,
 You're giving me the guts' ache, where's your consideration
 For other people, eh? Bring it back and behave
 Like a dear good son, you thieving scoundrel.
 I won't forgive you if you don't let me have it.
 What about equal rights and opportunities?

ROBERTO: (*Voice from Osteria.*) That makes it ours for certain!

ANGELINO: You're making me cry!
 (*He has followed ROBERTO in through the door and his voice
 disappears into the recesses of the house.*)

LUIGI: (*Laughing.*) As a family we're so close
 You only have to breathe and you hear a rib crack.

ALFIO: I'd better go and find a quiet corner
 Where I can pat my nerves down, otherwise
 I shall electrocute my horse at the practice run
 This afternoon. How do you all do it?
 My shirt's like a hot compress.

LUIGI: Very warm,
 Very warm.

 (*GRAZIA looks out of a window.*)

GRAZIA: Alfio, I wanted to say
 I'm sorry I flew at you.

ALFIO: That's all right.
 I'm just going, Grazia. Do you think we could – Oh.

 (*GRAZIA has left the window. ANGELINO enters.*)

ANGELINO: You must help me, Luigi! What am I going to do?
 He's threatening to pour it all into the bath
 And get into it if I say any more.

LUIGI: You know
 He won't listen to me, daddo.

ANGELINO: Why does he do it?
 Why does he want to ruin me? What a chance
 Will be gone for you, too, Luigi! Think of it!
 Offending people of such influence and wealth
 As they're sure to be. They might have taken
 A great interest in you, if we'd treated them well.
 What a brother!

LUIGI: Come on. It won't do any good,
 But come on!

 (*They go into the Osteria. ALFIO has thought of going to find
 GRAZIA but has thought better of it and lights a cigarette.
 GIOSETTA has entered in time to hear ANGELINO's distress.*)

GIOSETTA: The Brunos can make an anthill erupt.
 It's just as well some of us keep steady heads.
 Hold this, Alfio. I don't want the whole reservoir.
 We'll fill these bowls, and you can take the rest

Across for the big nobs. Will you do that?
Then I'll put some coffee on; we can talk to each other.

(*They set about filling two large bowls and a jug.*)

ALFIO: Isn't it natural I should want to find out
Who it was betrayed him? Grazia was against it,
But he is my father.

GIOSETTA: The night they came for him
Isn't half an hour old yet for you. But we
Have borne it nearly three years, and I can't stand
Any more anger being here instead of Cesare.
Neither can Grazia, I dare say. After a time
You have to want to look at people again.
You have to wake in the morning, without the light
Pushing you back down on the mattress.
I weigh a stone and a half more than I did,
And hope to increase when the warm weather's over.

(*She takes a bowl indoors and comes back to take the second bowl
from ALFIO.*)

Did you ever ask your mother about him?

ALFIO: Of course.
But she might have been talking about some Roman emperor.
I doubt if they ever met. She's ill, and has been
As long as I remember. We need the money
I make on this race, though it won't do much.

GIOSETTA: Come back and talk about her.

(*She goes back indoors while ALFIO trundles the churn across the
yard to the great door. At the same time LUIGI emerges from the
Osteria trundling the other churn. He is followed by ROBERTO,
naked except for a towel, his chin lathered with shaving soap, and
barefooted. Close behind him comes ANGELINO.*)

ROBERTO: You'll hand that over, Luigi. This is no
Business of yours.

ANGELINO: He's my representative,
I told him to deal with you.

ROBERTO: That's it: now
Cheat me of my birthright, give your blessing

To the hairless-chested junior. I don't accept it!
This goes with me.

LUIGI: I'm standing up for the rights
Of an alien minority.

ROBERTO: You're interfering
In our domestic politics. Give up
Or you'll get hurt!

LUIGI: You can't terrorise us.
Get back to your mountains.

(*ROBERTO loses his temper and attacks LUIGI.*)

ANGELINO: Stop it, Roberto,
You're a grown man! You've got a medical degree!
No, no, really, we've got things to do.

(*He is alarmed by the ferocity of ROBERTO's attack and tries to intervene.*)

For pity's sake, Roberto, what are you doing?
What's got into you?

LUIGI: (*Frightened.*) Do you want to kill me?

(*A beautiful woman, ANA-CLARA, enters through the arch. She wears a simple dress with one handsome brooch of diamonds. At this moment ROBERTO slings LUIGI against the wall; LUIGI slides to the ground. ANGELINO collapses onto a chair.*)

ROBERTO: Be more careful what you say.

LUIGI: Be careful yourself!

ROBERTO: You don't know what you do to me.

LUIGI: What I
Do to *you*!

ANGELINO: What I have to live with!

ROBERTO: Understood, the Nabobs have no claim on the water.

ANA-CLARA: Is this the Palazzo del Traguardo?

ANGELINO: (*Leaping to his feet.*) Dear lady!
I didn't see you.

ANA-CLARA: It's not to be wondered at.

(*ROBERTO is embarrassed by his state of undress, his face smeared with dried lather, and still shaken by what has happened. He thinks*

of making a bolt for cover, but decides to remain. LUIGI laughs.
ROBERTO takes a squashed packet from LUIGI's shirt pocket and
helps himself to a cigarette.)

Perhaps, before the naked arm of authority –
The handsome naked arm of authority –
Throws me down, too, for common trespass,
I should tell you my business is, in the first degree,
Lawful. This is the Palazzo del Traguardo?

ANGELINO: Yes, it is, Signora. I apologise.
My sons felt they must bring a difference
Into the open.

ANA-CLARA: (*Looking round her.*) What does the foreground
matter?
Here's the attraction. Built in fifteen ninety-two.

ANGELINO: Quite right, Signora; the architect –

ANA-CLARA: Bernardo
Buontalenti. You see I have brought my credentials.
And you are Angelino Bruno, born
At San Gimignano in eighteen ninety-three,
Three hundred years the junior. I'm happy to meet you.
You were expecting me, or I hope you were.

ANGELINO: Indeed, of course: we were all expectant,
And everything was in order, everything
Shipshape to receive you: only, last night
A most untimely cloudburst – and which of us
Can hope to discipline the storm? –
Confused the water and the sewage system,
And, of course, the Commune, alert to the dangers
Of epidemic, turned off the storm cock,
Not the storm clock,
I mean the stop clock,
The result is a breakdown in the water supply.

ROBERTO: And a shakiness in other communications,
As you can hear. My father is upset
Because the Palazzo is without any water.
Which, I'm afraid, I'm answerable for.

The main supply is cut, and no provision
Was made for any to be brought for you.
In my father's view, which I've been obstructing,
You should be given ours.

ANA-CLARA: But of course.
A dust-bath is all I need.

ANGELINO: No question who has it.
You mustn't take this son of mine seriously.

ANA-CLARA: I think I may have to.

(*LUIGI has noticed GIOSETTA's churn.*)

LUIGI: Who put this here?

ALFIO: I did. Grazia's mother didn't need it all.

(*ALFIO goes into GIOSETTA's apartment.*)

ROBERTO: Treachery!

ANGELINO: That's a good thing. Then our worries are over.

ANA-CLARA: (*To ROBERTO.*) Are you the black sheep of
the family?

LUIGI: No, madam, he's the red sheep. We have
A black sheep, but he isn't with us.

ROBERTO: If you'll excuse me, I'll put some clothes on.
It may spoil your fantasy of coming to live
Among the barefooted tribe of the poor, but it's better.
You shouldn't expect more romance than we can give you.
Excuse me.

(*He goes into the Osteria.*)

ANGELINO: Well, you will want to see the Palazzo.

ANA-CLARA: I embarrassed him. Now he will never like me.
As for the Palazzo, I had to promise
Not even to peer in through a window until
My husband gets here. May we sit and talk,
And feel less like strangers in a railway carriage?

LUIGI: May I fetch you a drink?

ANA-CLARA: No, thank you. – I'm in disgrace
With my husband, too. His eyebrows ran down his nose –
A bad omen always – when I told him I meant

To arrive without him. A man can't understand
Women prefer to spin a home,
Out of the belly like a spider,
Not be laid in it like a cuckoo's egg.
So I walked all the way, a willing novice
Learning her neighbourhood. Each façade
And little piazza, shop doorway and swag of washing
Instructed me into my different life.
You see how brilliantly your son diagnosed
The romantic in me.

ANGELINO: Roberto is a doctor.

ANA-CLARA: I believe it; he makes an incision with his eye.

LUIGI: You're not Italian. Is it Spain? Where do you come from?

ANA-CLARA: I'm Portuguese.

LUIGI: I see; and could you tell me
Is it just by chance that you arrive this week,
The week of the Palio – the sensational week
When the city celebrates an immortal identity,
When it hymns our power of survival over oppression,
Defeat and death?

ANA-CLARA: Not in the least by chance.
It has been my – do you say, lodestar?

LUIGI: Wonderful!
Then you understand how significant this year's race is,
The first since the war. You know how it all began?
Four centuries ago, or nearly that,
The city held out through a siege for months
Until the skeleton third of the population,
All that was left, pushed open the gates
And let the enemy in.
The parish companies were stripped of their arms
But were 'armed in the spirit', so history says.
Instead of being military defenders
They became civil protectors of our liberties
And the city straightened its vertebrae to a ramrod.
And that's what we celebrate in the Palio:

Pride in our flair for resurrection,
Excitement, violence and rivalry,
With the Mother of God as carnival queen.
Spare a lira for the guide, lady.

ANA-CLARA: He's worth a hundred.
(*She kisses his outstretched palm.*)　　　Like the poet's blind
Tiresias, I have seen it all.

LUIGI:　　　　　　　　　　　You've seen it?

ANA-CLARA: As an article of faith. Whenever I closed
My eyes on hot afternoons in Portugal.
I heard it so often described, never enough
To match my curiosity. I persevered
With endless questions, to trap the forgotten detail,
Until I could set it all in train by drowsing.
What I fancied I saw was common life,
Particularly the common male, glorified!
Striped, pied, blazoned and crested,
Pausing and advancing like courting sunbirds –
Indeed, the whole deliberate procession
Like an unhurried lovemaking. Isn't it so?
The first shock of the gun, and the trumpets
That stop the heart, until it beats again
With the rap of the kettle drums, and the pouring in
Of colour on the pale square. The huge voice
Of the crowd is like the roar of blood in the ears.
The Commune flag fluttering, while the Commune bell
Jerks in the erect campanile,
Like an alarm; and like a gloria; both.
And all the time the banners ripple and leap,
Circle the body, stroke and rouse
With creating hands. Oh, it really is, you know,
A lovemaking, a fishing in sensitive pools.

LUIGI: (*Undoing his tie and collar.*)
Excuse me; today's going to be a lion,
And it's only ten o'clock. – You won't make me
Believe you were never here, I won't have that.

ANA-CLARA: At last when the corporate body has been tautened
　　Absolutely to expectation's limit
　　There comes the violent release, the orgasm,
　　The animal explosion of the horse race,
　　Bare-backed and savage. After that – well, after that
　　I am lost in the dispersing crowd, I give way
　　To my siesta.

LUIGI:　　　　　Confess you have seen it.

ANA-CLARA: No, I promise. I have only lived it,
　　Not seen it. But I shall, now, after all.
　　What are our chances? – yours, I mean. What price
　　The Pelican? Have we any hope on earth?
　　What horse, what rider?

　　(*ANGELINO is open-mouthed, totally absorbed in ANA-CLARA.*
　　He has to pull himself together.)

ANGELINO: Eh? The horse? He's a hero, a black-veined hero.
　　But what's remarkable for us, what's really remarkable
　　Is to have Cambriccio to ride him, the greatest
　　In the land. And the mystery is how we came by him!
　　He's been hired at God knows what cost by no one.

ANA-CLARA: No one?

ANGELINO: A nameless one, a blessed unknowable power
　　Who loves us. We can be as sure we shall win
　　As we are of tomorrow's light. The entire parish
　　Have put their savings on it, and sleep dreamless
　　On their backs the whole night through.

ANA-CLARA:　　　　　　　　A lamb-like faith
　　In life's justice.

LUIGI:　　　　But this is a certainty!

　　(*ALFIO enters from GIOSETTA's apartment. He calls across to*
　　ANGELINO and LUIGI.)

ALFIO: Goodbye, then!

ANGELINO:　　　　You going?

LUIGI: Try to keep out of trouble.
　　Sorry you fared so badly with us. Did you
　　Have any better luck?

(*GRAZIA enters from the great door.*)

ALFIO: ...Well, I... What
Do you call luck? Yes, I suppose so. Goodbye.

(*GRAZIA crosses to him and kisses him on both cheeks.*)

GRAZIA: There, that's the best I can do.

ALFIO: Good enough.
Thanks very much. Ciao.

LUIGI: Don't imagine
You're going to win on that horse of yours.

(*ALFIO laughs, picks up his Vespa and wheels it into the road. LUIGI turns to ANA-CLARA.*)

He's the boy who's riding for the enemy parish,
Our deadly rivals. Don't ask what brought him here
It made the pebbles hop.

ANGELINO: Never mind about that.
Come along, Grazia, come and be introduced.
We all depend in the end on Grazia.
This is Grazia Scapare. I'm sorry to say
I haven't been told your name. I must apologise –

(*ALFIO has started up the Vespa and rides away.*)

ANA-CLARA: Who is it, did you say? I couldn't hear you?

ANGELINO: GRAZIA SCAPARE!

ANA-CLARA: I am happy to meet you.

(*As ANA-CLARA takes GRAZIA's hand there is a screech of brakes and the blare of a klaxon.*)

LUIGI: Mother of God!

ANGELINO: What has happened?

GRAZIA: (*Covering her eyes.*) No accident, please!

LUIGI: He's all right, I think. He's gone swerving on down
the road.
Two cars: one just kissed the backside of the other.
No harm done.

ANGELINO: Do you think this might be your husband?

ANA-CLARA: If he almost drove over someone, I think it
might be.

If he drove right over them, yes, it is my husband.

GRAZIA: They're unloading the luggage.

ANGELINO: They don't need help?

LUIGI: No, they don't need help.

ANGELINO: (*To ANA-CLARA.*) So now your patience
Can be rewarded, Signora. But remember,
Do bear in mind, the Palazzo's been occupied
By the military, used for billeting
The Germans and then the Americans, but only
The higher ranks, who knew the value of things
(You will find certain things are missing): although
We had one sorry adventure when a Colonel
Put several bullets through his own reflection
In a gilded mirror two centuries old. They say
He had seen himself once too often. And less than a week
Later he was blown up in his car. If only
He could have faced what he was five days longer!
We could put in some new glass, unless you think
It should be left as a minor historical
Souvenir.

ANA-CLARA: You mustn't be so nervous
No one ever sold my husband what he didn't want.

LUIGI: Here come the troops.

(*Enter a MANSERVANT carrying luggage, followed by one or two
more, a SECRETARY, a LADY's MAID, and a CHAUFFEUR
carrying hand luggage. ANGELINO takes the first MANSERVANT
to the main door, and turns in astonishment to see the rest of the
retinue.*)

ANGELINO: Ah, yes. Good morning. This is the way. If you
would take it through here. Can you see where to go? It's
a little dark at first after the light outside. Good gracious.
Yes, I see. Good morning. Just follow your…all right? Good
morning. Well, it's quite a load. A good thing we got the rain
over last night. Oh, excuse me – more. Is that everything,
then?

(*Meanwhile LUIGI is talling to ANA-CLARA.*)

LUIGI: Am I going to like your husband?

ANA-CLARA: We shall see.
Is it in his favour to say that I do, or will you
Hold that against him?

LUIGI: I haven't quite decided.
Is he at all interested in politics?

ANA-CLARA: Where they affect his interests; of course.

LUIGI: He may want to know more about the parties here,
In Italy.

ANA-CLARA: It's possible.

LUIGI: I could help him in that.
(*GRAZIA has gone indoors. Now she returns with GIOSETTA.
Into the archway enters a young man, ANA-CLARA's husband. His
wealth is subtly stressed in his clothes. LUIGI suddenly sees him.*)
My God! Daddo, look here! Excuse
My language, but here's Edmondo, Edmondo!
(*He bursts out laughing. EDMONDO stands grinning. ANGELINO
disengages himself from the servants in bewilderment.*)

ANGELINO: What? What do you say? On my living soul –
Edmondo!

EDMONDO: That's who it is.

ANGELINO: But does this mean
You came with the gentleman, too?

EDMONDO: If you put it like that.
I am the gentleman.
(*ANGELINO looks dazedly towards ANA-CLARA.*)

ANGELINO: This lady's…?

ANA-CLARA: Husband.
He's quite right.

LUIGI: (*To ANA-CLARA.*) You've had some fun with us.

ANGELINO: My son Edmondo!

EDMONDO: Daddo!

ANGELINO: My son Edmondo,
My dear son!

GRAZIA: He's off the Index for good.

(*ANGELINO embraces and kisses EDMONDO on both cheeks.*
LUIGI shouts into the Osteria.)

LUIGI: Roberto! Come out and meet the enemy.
You've missed the great moment, you poor man.
You're needed on the reception committee.

EDMONDO: I thought I'd surprise you. The surprise of your life
Isn't it?

LUIGI: (*Embracing him.*) You great crafty, secretive,
Successful squit, welcome home.

EDMONDO: You old orator!
Why haven't you got your feet up in the Qurinale?

LUIGI: How do you know I haven't?

ANGELINO: Remember the Scapares?
I've had astonishing dreams, but never so wild
As this.

EDMONDO: Do I remember them? Where's his mind gone?

GIOSETTA: You've done your best to shatter it.

EDMONDO: Dear Giosetta.
But what about this, eh? What magician
Has been busy here? Don't tell me this is Grazia!
Time changes us all, but here's a miracle.

GRAZIA: Hullo.

EDMONDO: Hullo? Is that all I get?

LUIGI: Edmondo,
Come to the climax. We know you own the earth;
What about your shares in some other heavenly body?
Present us to the lady. Until you do
I won't believe she belongs to a brother
Whose cold feet I once shared a bed with.

ANA-CLARA: I'm out of favour.

EDMONDO: You've already met her.
That was her own idea. She wouldn't wait
To be the culmination, the way I planned for her.

ANA-CLARA: Imagine what he wanted! I crouch in the car
Till the whip cracks, and the brass brays,

And in I shuffle, mad, in hot spangles.
Haven't we done better than that, father-in-law?
(*She kisses ANGELINO.*)

ANGELINO: Foof! My heart's like a pile driver. I've never
Gone up in the world so fast. What an outcome.
To my life, after all!

EDMONDO: Her name is Ana-Clara.
(*Enter ROBERTO. He wears a clean shirt and a rather worn grey suit, and carries a doctor's bag.*)

LUIGI: Here he is at last. How about this?

ROBERTO: God above, where did you turn up from?

EDMONDO: The authentic voice of my big brother, anyway.

LUIGI: Careful, my boy, he's the king of the castle,
He's taken over the Palazzo.

ROBERTO: (*With a hacking laugh.*) Is that true?
You've brought off the best joke of your life, then.
Congratulations. You should have seen the awful
Preparations. We've been putting grease on our joints
Ready to genuflect.

EDMONDO: And so you should.
Well, are you glad to see me?

ROBERTO: Why shouldn't I be?
I'm all for the substance, as a healthy change
From the old taboo.

EDMONDO: You haven't met him, Ana-Clara,
The eldest of us?

ANA-CLARA: Not this finished portrait;
Only a bare outline. I am very pleased –

ROBERTO: To watch the peasant wince?

ANA-CLARA: It was a compliment
In anyone's language but yours.

LUIGI: Tell us, Edmondo,
How you have done it, where in the world you have been,
Where have you come from?

EDMONDO: Portugal.

ROBERTO: Portugal?

ANGELINO: We can't have the story frittered away,
That won't do; I want to savour it,
Every blessed minute of the adventure
Since you went out through the door. I'm starving for it,
But I won't be fed with crumbs.

LUIGI: (*Ironically.*) We need excitement.
Nothing but a war ever happens
To us stay-at-homes.

EDMONDO: I've got about the world,
I can say that. Starting in South America.

ROBERTO: What were you doing in Portugal?

EDMONDO: Dad's right,
Let's keep the story until the evening, until
After he's gone to the cellar and brought us up
The best the old vineyard had to offer.

ANGELINO: (*Distressed.*) It's gone
It's all gone, my dear child. And I cossetted it
And nursed it all those years, if for nothing else
For the breath of the old summers when you were boys
And mamma living. I promise you,
I took such care of it you couldn't tell us apart –
Not for this occasion, of course: *this* occasion
I couldn't have imagined – but for when things would prosper.
But when the Nazis started to pull out
They smashed the bottles, and riddled the barrels with bullets.
I'd almost rather it had been my own blood
That swamped the floor. What a tragedy!
This is when it hurts again. That wine would have made you
A great speech of welcome.

EDMONDO: Well, don't let's have
Any tears – it wasn't the best in the world, anyway.

LUIGI: Never mind, we can give him the best horse and the best
Rider, can't we, daddo?

ANGELINO: That's what we can do,
What a blessing! How well it all comes together.

Edmondo, you're going to see the race of your life:
Our horse coming home in front, snorting clouds
In your honour. You can smile if you like,
But I'll jail myself for fraud if we don't win.

EDMONDO: Oh, yes, we'll win. We had to make sure of it
this time.

LUIGI: What do you mean? Who made sure?

EDMONDO: I did.

ANGELINO: Are you saying it was you who hired Cambriccio?

EDMONDO: That's what I'm saying.

ANGELINO: Every extraordinary thing
Turns into you. You got us Cambriccio?

EDMONDO: What? I couldn't leave such a thing to chance.
We're into the great festival week of the Brunos,
Nothing goes wrong, Edmondo's home; there isn't
Place for anything less than total pleasure,
Not in my organisation of life, anyhow.

ANGELINO: Even Cambriccio!

GRAZIA: (*Suddenly.*) How could you bear the silence?

EDMONDO: Me? What silence? – You know, it's remarkable!
I can't get over Grazia, a grown-up woman.
Thank God the skipping rope I brought her
Is made of pearls.

GRAZIA: While you have been away:
That silence; not exchanging a word
Or trying to find out what was happening.
How did you live your day or sleep at night
When all the time you could have known something?
I don't understand, when worse news came after bad,
How you could trust anything, and simply plan
To come back as though nothing could have changed.

EDMONDO: I'm in the dock, am I?

ANGELINO: The doctor said
When they'd got you off the umbilical hook
'*There's* a promising cranium.' The spirit
Of prophecy was in him, that's all I can think.

EDMONDO: I can tell her. You won't remember, Grazia,
 But I wasn't popular when I left home –

ANGELINO: *Mea culpa*, *mea culpa*.

EDMONDO: I don't blame anybody,
 But I couldn't know what sort of a reception
 A letter from me would get. So I thought I'd wait
 Until I was sure of a welcome.

ANGELINO: *Mea culpa*.
 The pride and pleasure I've missed.

EDMONDO: Stop moaning, daddo.
 Anyway, I soon got on the right side of life.
 It all worked like sap in a happy tree.
 And the old war-god wasn't averse to me either
 When I saw how to handle him. I say that because,
 When things turned rough, it meant I had my spies
 Useful contacts in high places,
 Who would give a preserving eye to my family.
 Anxiety could be kept at a minimum.

 (*There is a general gasp at this.*)

LUIGI: I see now what has happened. He has taken
 Over the world, that's it, of course it is!
 How did you get along with my guardian angel,
 Or was he too disillusioned to say anything?

ROBERTO: But it's not a joke. And a very long way from it.
 Who *were* these sinister contacts he was coupling
 Our name with? *Who* were these benefactors?
 The Black Brigades? The SS? Or the genocides
 Of Berlin? What circle of the inferno
 Do we owe our preservation to?

ANA-CLARA: (*Her face in her hands.*) Oh, dear.

EDMONDO: Steady on. I was talking about business connections.
 I'm an internationalist, the same as any
 Reasonable business man. My interest
 Is where the market is.
 (*With a flash of anger.*) I must say *you*
 Made it just about as difficult for me

 As any man could!

ROBERTO: Crucifixion! Made

 It difficult! Hasn't one maggot

 Of what's been happening crawled into your head?

 Would it surprise you to know, we've not been tormented

 By flies, but bloody torture of the spirit.

 This land has fought and suffered, do you know what

 that means?

 While you were piling up profits, however you did it.

 (*ANGELINO has been whimpering to intervene.*)

ANGELINO: Edmondo was doing his best to help us – how

 could he

 Guess all the circumstances? I won't hear any more!

EDMONDO: I'm sorry, I apologise. That was a hark back

 To resisting the elder brother talk; I'm sorry.

LUIGI: You underestimated your effect, 'Mondo.

 We're a local lot here; we have to get used to you.

GIOSETTA: Cesare was taken.

 (*A pause. EDMONDO nods.*)

EDMONDO: Something went very wrong there.

 (*GRAZIA suddenly goes into the house.*)

ANA-CLARA: Let me say this: no man born could have talked

 About you all with such relentless affection

 As Edmondo did, until I could hear you breathe.

 Even turn to the door expecting you to be there.

 You were more real than the world I grew up in.

 Any man can make a woman his wife,

 But Edmondo made me daughter and sister, too,

 As if I always had been, by the force of his memories.

 From the day I first met him his guiding thought

 Has been to come home with his arms crowded with blessings.

 It became my purpose, too.

ANGELINO: There has never been

 A prouder day. To think of my own son

 Master of the Palazzo, and bringing with him

 Such a –

ANA-CLARA: Wife and daughter.

ANGELINO: Sky-born lady.

EDMONDO: Well, you can all have the life you want now,
 That's the point.

LUIGI: Good old Edmondo, you can
 Lead me by the hand anywhere you like.

EDMONDO: It's time we made our tour of inspection. See
 If my memory slapped the gold on too thick, shall we?
 There's never been a sky for me like the blue skies
 Painted on the ceilings. I had pubic dreams
 Of flying up and butting the pink nipples
 Of the sprawling nudes with my little bullet head.

ANGELINO: The paint is flaking here and there.

EDMONDO: We'll see to that.
 Where's Grazia? There are presents to unwrap.
 You'd better all come and stand in line.

GIOSETTA: I'll find her.

 (*GIOSETTA goes in.*)

EDMONDO: – How's Giovanni Levanti?

ROBERTO: He died last night.

EDMONDO: Damn. Last night. Oh, damn. I'd brought him back
 A small fortune, the fruits of his investment.
 Only last night? Well, his son must have it.

LUIGI: Mario was killed.

EDMONDO: Oh.

LUIGI: There's just his daughter.

EDMONDO: That's right, then Rosa must have it. What a shame
 I can't surprise him, though. I had it all planned…
 Pity. Now, where are the keys of the kingdom, daddo?

ANGELINO: All hanging here.

EDMONDO: What a size, eh?
 St Peter must have a forearm…

ROBERTO: Look at the time.
 I have calls to make.

135

(Chauffeur – ETTORE – and a MANSERVANT come out of the house.)

MANSERVANT. Excuse me, sir, the Mayor's office is on the
telephone.

EDMONDO: Roberto, why don't you have the car to drive you
Wherever you have to go?… Yes, you have it.

(LUIGI laughs delightedly.)

ROBERTO: No, thanks, they would think I had come with
the hearse.

EDMONDO: Well, we shan't need you, then, Ettore,
Until, let's say four o'clock. All right, Luciano, I'll come with
you now.

*(He goes in, followed by ANGELINO and the MANSERVANT.
ETTORE also leaves. LUIGI hesitates in the doorway.)*

LUIGI: What are you doing, Edmondo? – *(To ANA-CLARA.)*
The great moment of the ceremony,
Taking you over the threshold – and he forgets it!
Who is to do it: me?

ANA-CLARA: The ceremony
Was already in shreds.

LUIGI: Oh, Bobo! He had no sleep.
He's more than ordinarily sensitive
To the shame of life this morning. I found that out.

ANA-CLARA: Go in, don't wait. I'll join you.

LUIGI: Right.

(He darts into the Palazzo.)

ANA-CLARA: Do you always give dreams such a rough reception?

ROBERTO: If they call for it.

ANA-CLARA: I'm trying to imagine
Your bedside manner.

ROBERTO: What was he doing in Portugal?

ANA-CLARA: He was making love to me. Does that disturb you?

ROBERTO: There's no mystery there. But what's his line
of business,
How have all these profits piled up on his hands?

ANA-CLARA: Too much gold in his bloodstream, is that
 The symptom that worries you?

ROBERTO: Yes, it is
 When I think of his adolescent ailments.

ANA-CLARA: Why
 Ask me? What he wants you to know he will certainly tell you.
 It's not very generous to let a brother's success
 Fill you with spleen.

ROBERTO: If you're imagining
 I'm envious of him you are wrong. I only want
 To know the exact nature of the bird
 Who has come back to crow here.

ANA-CLARA: Human nature,
 And your brother's. Didn't you ever love him?

ROBERTO: Of course.
 And want to still. That's the tormenting part of it.
 But the health of the present time is too critical
 To swallow tainted meat for the sake of the garnish.

 (*EDMONDO looks out of a window.*)

EDMONDO: Where's the queen of all this? Are you coming,
 Ana-Clara? The kingdom's in suspense.

ANA-CLARA: In a moment.

 (*She turns back to ROBERTO.*)

 How can I tell, after two not entirely
 Poised encounters, where the line divides
 Your shalt from your shalt not? Whether I should find it
 Just, or merely got out of the handbook?
 I can only say that Edmondo wants to please.
 You could start from there. You could suspend judgement
 On him, and perhaps on me till you know me better. –
 As I do on you, in spite of all provocation.
 You're an open question to me; we shall have
 To see how you answer, won't we?

 (*She smiles and goes into the Palazzo. ROBERTO stares after her.
 GIOSETTA has already entered.*)

GIOSETTA: A pretty tangle.

Who's going to sort the grins from the groans?

ROBERTO: Tell me,
What do you think of the woman?

GIOSETTA: Grazia
Has been crying her eyes out.

ROBERTO: What's wrong?

GIOSETTA: If you can't think,
Don't ask me to parade the reasons for you.

ROBERTO: I'd better go to her.

GIOSETTA: She is all right now.
She – went to change her dress.

(*Enter GRAZIA. She is wearing her best dress, some beads, and has put her hair up, a flower in it.*)

ROBERTO: I can see she has changed.
What's all this for, Grazia?

GRAZIA: (*Gaily.*) All this for?
In praise of life, of course. For the traveller's
Return, and pots of gold, and the sound of the world
Flying into the sun, whatever we ought to celebrate.
(*She hugs ROBERTO.*)
Can't you stay and see what he's brought for you?

ROBERTO: I know what he's brought for me: enough to wonder
What to do with.

(*GRAZIA takes the flower from her hair and puts it in ROBERTO's buttonhole.*)

GRAZIA: Perhaps this was too much.
But I've been to trouble's funeral. Poor thing,
She's dead. For a while, anyway.

(*EDMONDO looks out of a window, a glass in his hand.*)

EDMONDO: Where's that wonder-to-behold Grazia?

GRAZIA: Here I am!

(*She goes into the Palazzo. ROBERTO leans against the wall near to GIOSETTA.*)

ROBERTO: I can't altogether size her up.

GIOSETTA: You've known her ever since she existed. It's time
 You did.
ROBERTO: I don't mean Grazia. I was thinking
 About Edmondo's wife. She has every
 Characteristic you might expect in someone
 Brought up never to doubt she was well chosen.
 Drank homage with her mother's milk. Understands
 Nothing with the air of an authority.
 Plays the human game very skilfully
 In expensive gloves. All that. But then there's something
 I don't fathom. A pulse she is keeping hidden
 Or doesn't know she possesses. Interesting.
 Perhaps she has ambitions outside her class
 Or why the hell did she marry my brother?
 What made her go and do that?… She has made up her mind
 Naturally enough not to approve of me.
 Pompous and censorious, shaggy tempered
 With a permanent grouch, that's what her verdict is.
 I'm not going to change her short-sighted mind.
 O God, Giosetta, why won't they see? I care
 What they think and do, my bloody family.
 Haven't we all learnt enough, without
 Going back to learn it again?… What do you think of her?
GIOSETTA: I've done all the thinking I mean to do today,
 Why don't you go and visit your sick?
 (*ROBERTO looks at his watch, grunts, picks up his bag and leaves
 GIOSETTA to her work.*
 Curtain on Act One.)

ACT TWO

(The courtyard, a day later. Evening. ANGELINO is reading a newspaper outside the Osteria. GIOSETTA comes out of her doorway.)

GIOSETTA: When do you think they will want to eat, Angelino?

ANGELINO: The minute they get back. They think we can hear
 The rattle of stomachs right down the street.
 What on earth is keeping them? I know
 They'll have chewed the best off the bone of the news
 Before we come near it.

GIOSETTA: *(Sitting.)* I'll take things slowly, then.
 After the feast that 'Mondo gave us last night
 I wouldn't want him to think we fed on clinkers.

 (ANGELINO has wandered out into the street.)

ANGELINO: There's no sign of them yet. It's really too bad.

GIOSETTA: It means we're getting old, if we start fussing
 About the clock. When the war broke out
 I had hardly begun to notice I wasn't young.
 I was upstairs then looking out of the window.
 Now I'm downstairs looking along a passage.
 The war took the bottom two steps away.
 It brings you down with a jolt.

ANGELINO: Nonsense! Impatience
 Isn't a sign of age, quite the opposite.
 I want to get on with life, that's all; I'm restless
 To know everything.

GIOSETTA: You know what stopped you
 From going to watch the practice run yourself?
 You weren't young enough to last the day
 Without a three-hour siesta.

ANGELINO: Ridiculous!
 Age hasn't got anything to do with it.
 I slept in the afternoon the day I was born.

GIOSETTA: You could find out what happened if you wanted to.
 You like feeling neglected.
ANGELINO: I don't at all.
 I like to think I mean something. And if
 They half loved me, they would have remembered
 I was waiting here on tenterhooks for them.
GIOSETTA: While the war was on there weren't any young
 Except the children, and only the very old
 Were old. We were all equal, as far as thinking
 What to expect out of life. But now we have been
 Divided and sorted back into generations.
ANGELINO: I could still fall in love. Every so often
 It crosses my mind. And now we're back to normal
 I may give it some thought.
GIOSETTA: Back to normal?
 My dear man, ever since Edmondo came home
 You haven't known where the ground was. Back to normal!
 You can't decide where to put your poor feet.
ANGELINO: That's just it. The heart has been roused up.
 The dreams I used to have are coming true.
 You hear the ground under you purring again,
 Warm, like a cat's back. – Suppose, Giosetta –
 Not to be considered for many a day –
 What would you do if your hopes gave out for Cesare?
 Nothing to do with the present time, of course not.
 But as time went by (if it did), as time went by,
 Would you live alone, for the rest of your life?
 I am really putting the question to the air.
 I don't imagine you will hear it, not at all.
GIOSETTA: I got a message today. Somebody threw it
 Out of a train that was passing through the station.
 Tied to a piece of wood.

(*She takes a piece of paper out of her pocket.*)
ANGELINO: From Cesare?
 Where are my glasses? A good thing, a bad thing?

GIOSETTA: It's about Cesare. Whoever wrote it
 Says: 'Dear Signora, I saw him at Bratislava
 On June Second.'

ANGELINO: Well, thank God, thank God.
 And you kept it in your pocket! Cesare
 Alive and well. It says he is well, does it?

GIOSETTA: No, there's no more. They can't even spell.
 'Bratslavio' they've put. And they sucked their pencil.

ANGELINO: What a settling up God's having this week!
 Both of us within two days. Well, once
 The bit's between His teeth things start to move!
 And Grazia, isn't she in the seventh heaven?

GIOSETTA: I haven't told her. I don't want to tell her
 Unless we're sure.

ANGELINO: But, woman, aren't we sure?

GIOSETTA: Maybe. She was singing this morning almost
 Before she opened her eyes. Suppose I told her
 And he didn't come to us.

ANGELINO: But, look, he's alive
 And on his way home. Where else would he go?

GIOSETTA: Don't say anything, that's all. Forget I told you.

ANGELINO: I don't know how you contain yourself? However…

(*He wanders towards the archway; then his feet give a sudden little skip.*)

 On his way back! Bless the man. He's doing
 Better than my lot. Why hasn't Grazia hurried them?

GIOSETTA: She isn't with them.

ANGELINO: Where is she, then?

GIOSETTA: In the Palazzo, being photographed.

ANGELINO: Photographed?

GIOSETTA: Yes, Edmondo arranged it.
 He thinks she could have a career modelling fashions.
 Such dressing-up and grooming! It's best I keep
 Out of the way. She's like an eight-year-old
 Going off in white to her first communion.

ANGELINO: What a game!

GIOSETTA: The last few years she hasn't
 Had much playing. She deserves a little fun.

ANGELINO: No complaints, have we?

GIOSETTA: No, not many.
 She won't disappoint Cesare.

ANGELINO: Neither her
 Nor either of you.

GIOSETTA: We can't tell, can we?

ANGELINO: Certainly we can. My dear girl,
 You know yourself better than that.

GIOSETTA: How do I?
 I only know what he saw in me – three years ago.
 Since then he has known things we haven't known.
 I may not answer anymore.

ANGELINO: What a way to talk!
 How can you say such a thing?

GIOSETTA: I don't know why
 I did. I suppose it was because you seemed
 To be thinking of me as a woman.

ANGELINO: I can't help it
 If that's what you put me in mind of. I guarantee
 Whatever he's been through he won't have lost
 The memory of you turning down the bedclothes.
 He will have kept you with him: like any other
 Marooned man who has to improvise
 His woman out of a desert, out of a breathing
 Cinder from the stove, or holding his boot
 In his hands as he used to hold your face, anything,
 I don't know what, anything to keep
 Body and soul together until he's rescued.

GIOSETTA: Trust you to make an opera out of it.
 I'm bothered enough without having to be
 Madam Butterfly with the boot face.
 What are we going to recognise in each other,
 That's all I wonder.

ANGELINO:　　　　　Well, you needn't wonder.
　　You'll mend the world for him, if he wants it mending,
　　Or nobody can. Goodness me, if *you*
　　Start wondering what you are, what happens to the rest of us?
　　(*GIOSETTA has thought of going indoors but is impelled to talk.*)

GIOSETTA: If we could have married, it might have felt
　　Something solid, divided and come together.
　　In the early years whenever I went to confession
　　And had to call our love a sin
　　I felt I was being unfaithful to him with God.
　　Cesare laughed, and said it was God who was jealous,
　　Not him. But when they took him away
　　I even thought it might be the punishment
　　For our life together. It wasn't a good thought
　　To my mind, anyway. Only, if we were married…

ANGELINO: Yes, well, but that wasn't the way it was.

GIOSETTA: His wife has always been an ill woman, almost
　　From the day they were married. And now, Alfio says,
　　The arthritis has tightened its knots terribly.
　　But when Cesare was there it seemed to be
　　Hardly more than a fear of being made love to.
　　He got it in his head he was crucifying her,
　　And hated the life in his own body.
　　It was like having a foul tattoo-mark on him
　　Which he couldn't get rid of. He began to avoid
　　Good innocent people (what he imagined were)
　　As though his presence was insulting them:
　　Children in the street, even his son. His mind
　　Lost its way altogether. He even felt
　　The sky draw away from him. He said that once.

ANGELINO: Poor Cesare!

GIOSETTA:　　　　　So he ran for his life.
　　He has been happy here – not always happy.
　　Questions would come rolling over him
　　Like tanks every now and then: was he sure
　　She was better off without him? Was a mad

Father better than none for Alfio
Had he run from what God wanted of him?
It was then he would go drinking.

(*Enter PIERO MARTINI, a photographer, from the Palazzo.*)

PIERO: Ah, Signora!
She has been an enchantment, your little girl.
You have a major artist for a daughter.
Really! She has the secret: plasticity,
An intuitive body – and *bones.* Honestly,
I've never known such movement in stillness.

GIOSETTA: Fidgety?

PIERO: Certainly not, you should be very proud of her.

GIOSETTA: If she has bones I suppose so.

ANGELINO: I'm surprised
She didn't mention it to us.

PIERO: Use your eyes –
Here she is – you'll see what I'm talking about.

(*GRAZIA comes into the doorway, elegant; the LADY's MAID beside her, making last adjustments before withdrawing. GRAZIA pulls a face at GIOSETTA.*)

Stay just where you are, Grazia. There. Imagine
You have come out to feel the evening air –
Relax in it, breathe it in –

GRAZIA: (*Breathing in.*) Mother,
Is there something on the stove?

GIOSETTA: That's all right,
Nothing to spoil.

PIERO: Never mind about the stove.
Turn a little to your – good; I don't have to tell you.
Chin a mill-imetre – marvellous. That's perfect.
We'll make each other's fortunes. Now, I wonder,
What would be – ah, yes! Let's see you over there,
Over there in front of the broken plaster.

(*GRAZIA dances a step or two, kisses GIOSETTA, and goes obediently to where PIERO points.*)

I want to make just a bare statement of texture,
A comment on flesh, silk and stone.
Look dead straight into the camera. Economise
On Body as much as you can. Try to think
Vertically, narrow… If you're going to laugh,
Grazia, we're destroyed. I want to see you
Without history or class: a pure, simple
Human idea without human fallibility.

(*ROBERTO and ANA-CLARA come into the archway.*)

ANGELINO: He doesn't ask much! He certainly puts her
 through it.

PIERO: Superb. Just one more. We're almost there.

ROBERTO: Will someone explain?

GRAZIA: Oh, Bobo, I'm being shown
 How to be economical. Isn't that good?

ROBERTO: In that high-class rig-out? What's going on?

ANA-CLARA: An idea that Edmondo had, an experiment
 To see if she's photogenic. It occurred to him
 She could model fashions.

ROBERTO: Oh, *did* it?

ANA-CLARA: And why not?

PIERO: I pick words gingerly like a rose out of thorns,
 But this girl has genius. She is going to start
 A revolution in the appearance of women.
 Mark what I say, by nineteen forty-seven
 No one will recognise his own sister.

ANGELINO: That seems a pity.

ROBERTO: Thanks, now pack up and go.

PIERO: My instructions don't come from you, as I understand it.

GRAZIA: We can lose the last one. And the light is going.
 Anyway I'm tired of being other people.

PIERO: Other people! You couldn't be other people.
 Other people are going to be you.
 And every film producer worth his salt
 Will want to be the first to let the world see it.

ROBERTO: For God's sake go, will you? Take yourself off.

ANGELINO: That's no way to talk, when the young man
 Has gone to such trouble. There you are, gun happy
 Again!

GRAZIA: (*To PIERO.*) We're easily startled. But thank you
 For all your patience. I'm sorry I laughed so much.

PIERO: Be strong, my dear. No one can alter destiny.
 Good evening.

 (*They all wish him a good-evening as he bows and goes.*)

ANA-CLARA: (*To ROBERTO.*) You bully.

GRAZIA: He went quite pale.

ANA-CLARA: And then he faded
 On the blowing of the horn.

ANGELINO: What a way to behave!

ROBERTO: Yes, I'm sorry. I should really have let him
 Wind himself off with the spool. I'm sorry, Grazia.
 I suddenly took against him.

GRAZIA: You came back
 Too late to catch the beauty of the joke.

GIOSETTA: I shall leave you two to fight it out between you.

GRAZIA: I'm going to change into myself again.

 (*GRAZIA goes into the Palazzo, GIOSETTA into her apartment.*)

ANGELINO: You didn't have to bark at the wretched fellow.
 Anyhow, what happened at the practice run?

ROBERTO: I haven't heard. Aren't they home yet?

ANGELINO: No.
 I can't understand it. What have you been doing?
 Going round with your brimstone and treacle?

ROBERTO: Yes.

ANA-CLARA: And with a new Sister of Mercy.
 I'm trying to keep tomorrow unspied on.

ANGELINO: That's it – let the great day take you unawares.

 (*ANGELINO goes into the Osteria.*)

ANA-CLARA: The great day when I weigh the actual event
 Against my dream of it. I have great hopes.

And tell me, bear, why shouldn't Grazia blossom?

ROBERTO: Doesn't she please you?

ANA-CLARA: Of course she pleases me.

ROBERTO: Then why want to change her? What do you all
Think you're doing? I could kill Edmondo!
Make her a model! Turn her into a clothes horse!

ANA-CLARA: Better that than a pack horse.

ROBERTO: Which isn't
The alternative. Just tell me what went on in you
All this afternoon?

ANA-CLARA: Went on?

ROBERTO: It shocked you,
Didn't it, to see the conditions they live in?

ANA-CLARA: No, I wasn't shocked. I tried to feel
Responsible because I knew you expected it.
But no, most of the time – most of the time –
Well, I was happy.

ROBERTO: Happy!

ANA-CLARA: Yes; so were they.
You made them laugh. You somehow changed each room
Into a little ark bobbing on the flood.
That certainly opened my eyes. I wasn't to know
You kept a sense of humour curled up
In your black bag.

ROBERTO: I see. So it was all
A big entertainment. I might have expected it.
But when I saw how at ease with them you were
At once, and they with you, I let myself
Think I'd achieved something.

ANA-CLARA: So you had.
And what you most wanted to achieve.
You didn't really think I should come home
And sell all my jewellery, or so fall out
Of love with life I should never eat caviare.
You wanted me to see you at work, your cuffs

Turned back, relaxed in your own element,
And obviously worshipped. And I saw this, marvellously.

ROBERTO: You're so female, it's almost obscene.
How did the male genes come to miss you?
Reduce everything to personalities
If that's all you're capable of. I'm disappointed.

ANA-CLARA: I never met anybody so ready to take
Admiration for mockery. I don't know why you object
To being generous to me, and human – the very
Charm in you that does them good.
If you lectured *them* as you lectured me on the way
They would all think death a happy release. You came
Far nearer to prodding my social conscience awake
By letting me see they loved you, than with all
That rhapsody of statistics. What touched me was
That you wanted me to see the work you were doing,
Wanted *me* to see it. And not as one
Of the unconverted being offered salvation;
As a woman welcome to share it. You don't need
To look so crestfallen.

ROBERTO: I need to look
Exactly what I feel, mortified.
What in hell did I think I was doing
Exhibiting their lives to you, like specimens?
It serves me right that what impressed you most
Was my performance as a clown.

ANA-CLARA: I didn't say so.

ROBERTO: You have my full leave to. The whole thing
Was a prat-falling comedy. There I was
Solemnly delivering a shock
For your own good, and I'm the one who gets it.
I'm the one whose dignity's flat on its chin.

(*Enter ANGELINO with a large tablecloth.*)

ANGELINO: They can't be much longer now unless they're dead.
We may as well lay.

(*ROBERTO and ANA-CLARA, at the table, hardly notice him.*)

ANA-CLARA: You don't know where your strength is.
You deploy in the wrong direction.

ROBERTO: But nevertheless
This doesn't let you out. If I was the clown
You were the undiscriminating audience.

ANGELINO: Elbows, please.

(*ROBERTO absent-mindedly raises his elbows so that ANGELINO can spread the cloth. ANA-CLARA, also with her mind elsewhere, gets up and helps.*)

ROBERTO: I'm thoroughly baffled by you.
You were so right with them, and you come away
Apparently quite untroubled. There seem to be
Two totally different people in you.

ANA-CLARA: Only two? Isn't that rather sub-normal?
You don't have to condemn yourself for anything.
You may have set out to use them as facts against me
But, if so, flesh and blood got the better of you.
Affection triumphed.

ANGELINO: Do I hear them coming?

ROBERTO: Who?

ANGELINO: Edmondo and Luigi.

ANA-CLARA: Yes, here they are.
I suppose I should go and change.

(*EDMONDO and LUIGI come into the archway.*)

ANGELINO: So you've managed to get here at last. About
time too.

LUIGI: Prepare yourselves for a shock. Cambriccio is out of
the race.

ANA-CLARA: Oh, no!

ANGELINO: You can't mean that!

EDMONDO: Yes, out of it. We've been down at the hospital.

ROBERTO: What happened? What's the report on him?

EDMONDO: He had
Some sort of vertigo – came off the horse,
Anyway; and got kicked on the head.

When we left him he was still unconscious.

(*GRAZIA has come out of the Palazzo.*)

ANGELINO: What a disaster! The end of a career,
Gone on too long. What a terrible thing the years are.
There's the finish of all our bright hopes.

EDMONDO: Don't panic. I'll find a substitute.
I've got some contacts who can take care of this.

ROBERTO: Of course he has.

EDMONDO: I'll put a call through now.

ANGELINO: What a blessing to have you, when the devil
turns ugly.
I can't believe it. Who won, then?

LUIGI: Alfio did.
He's three times more impressive up on a horse
Than he is on the ground. Without Cambriccio
We haven't a chance if he rides like this afternoon.
Except, thank goodness, 'Mondo seems indestructible.
Excuse me – I want to study his methods.

(*LUIGI follows EDMONDO into the Palazzo.*)

ANGELINO: Shall we be in his way if I come, too?
I can't wait about. Grazia, we must tell your mother.

GRAZIA: Isn't it awful? I'll tell her.

(*Exit GRAZIA. ANGELINO goes to the Palazzo door.*)

ANGELINO: What a minefield
Life is! One minute you're taking a stroll in the sun,
The next your legs and arms are all over the hedge.
There's no dignity in it.

(*Exit ANGELINO.*)

ANA-CLARA: How wretched for Edmondo
After all his contriving.

ROBERTO: Wretched for Edmondo!
He arranged the whole thing for his own prestige,
But the parish has to suffer for it. Of course
You're not concerned with them, the real victims:
Only the blow to poor Edmondo's vanity.

ANA-CLARA: Will you stop bullying me?

ROBERTO: No, I won't.
 I should like to haul you by that elegant neck
 Up and down the land, till you saw the truth.

ANA-CLARA: You want the truth. All right, then you shall have it.
 I've taken enough preaching. – I was born
 In a Lisbon slum, in a room more polluted,
 More of a crowded dungeon under a moat,
 Than anywhere you have shown me today. At five
 I was a better beggar than all the nuns
 Of Portugal, and as sharp as an adult rat.

ROBERTO: If you want to take the wind out of my sails
 Invent something believable.

ANA-CLARA: Do you think
 I like giving up the part? I was loving it.
 It was only your bloody nagging made me tell you.

ROBERTO: How could you love it if you knew it was false?

ANA-CLARA: Oh, false! What's false, what's real? That squalid
 childhood
 Lied about every living thing that was in me.

ROBERTO: If it ever existed. If it ever could have existed.

ANA-CLARA: You don't believe in people who find their own way.
 You suspect them.

ROBERTO: Not necessarily.

ANA-CLARA: Oh, yes you do. You don't trust what they are now
 Unless you know how they came to be what they are.

ROBERTO: I don't ask how you came to be. I'm content
 to marvel.

ANA-CLARA: You mean, to wonder; curious to know
 What code I offended on the upward climb.
 Well. You shall hear.

ROBERTO: I don't want to hear.
 I accept your self-creation.

ANA-CLARA: I'm not chancing
 Those under-the-brow looks you give Edmondo.

ROBERTO: You wouldn't get them.

ANA-CLARA: I know you couldn't choose.
Can imagination's environment
Alter heredity? You can't help asking.
On my fifteenth birthday I went to live
With a young actor. He was like a redeemer
Piercing the darkness for me. If it wasn't
Morality, it was always love and always
Learning.

ROBERTO: If you love you learn, a simple truth.

ANA-CLARA: He thought he could make me an actress, and
for two
Patient years he taught me to speak and move.
But fury and tears took over. The characters
We played together began to seem ridiculous,
Making their gestures in the nine-foot square
Of a rented room, lit by a fifty-watt bulb.
I began to crave for reality.

ROBERTO: Whatever that is,
As you said just now. You mean you wanted
To have a genuine victory over life.

ANA-CLARA: Something was dancing on ahead of me.
I fell in love with knowledge, which appeared to me
In the body of a university lecturer.
I was a kind of pupil mistress. Dived
Into the poets, or tangled with philosophers,
Or lay back and let the mind of music
Do my comprehending of life's hard things.
I felt limitless and very happy.

ROBERTO: But not
Forever.

ANA-CLARA: No, not forever. He exchanged
Our bed for a Chair in Comparative Anatomy
In Salamanca.

ROBERTO: A careerist, if ever there was one.

ANA-CLARA: I felt lost for a while; taught Portuguese
 To foreign businessmen. Which brought me
 To Edmondo.

ROBERTO: Ah, Edmondo!

ANA-CLARA: Ah, Edmondo.
 This time I could love from a level start.
 He and I were climbing the same pitch,
 Though Edmondo had the impressive male advantage
 Of being ruthless. Bless him, he could have bought
 A real duchess, but he settled for silvergilt.
 And now no matter how far I stretched my arms
 No walls were there, nothing to frown on me.

ROBERTO: Then what do you shy away from?

ANA-CLARA: What do you mean?

ROBERTO: I never saw a woman whose eyes were so transparent.
 Every half-thought flies past there naked.
 At first I thought you were over-bred, but now
 You've proved me wrong. What is it that puts your ears back?
 (*ANA-CLARA is silent for a moment.*)

ANA-CLARA: Can anyone be at perfect ease with life?

ROBERTO: With life, or with himself – which do you mean?
 I suppose life is willing, when we can find
 What it's groping for. This afternoon I felt
 Somehow that we seemed to belong to each other
 And to all the rest of them as well.

ANA-CLARA: You see?
 You are understanding at last why I was happy.
 We belonged to each other.

ROBERTO: While the illusion lasted.

ANA-CLARA: You don't give truth a chance to declare itself.
 Poor foetus in the womb, condemned as illusion!
 It had the kick of life for *me,* I may say.
 Your hands were capable and kind. They made
 The worst things… in a way serviceable.
 Without touching me, you took me in your arms

And lifted my body across a new threshold.
Exactly as you meant to.

ROBERTO: How do you know that?
Did you see any professional negligence?

ANA-CLARA: No; your concentration was part of the love-making.
An oblique seduction can be very successful.
This one was.

ROBERTO: I could feel you charging my body
From any distance. What are we to do?

ANA-CLARA: Are you asking that seriously?

ROBERTO: Don't breathe on me, or I shall break.

(*If they were not in a public place they would kiss. Enter from the Palazzo, EDMONDO, LUIGI, ANGELINO. EDMONDO looks at ANA-CLARA and ROBERTO*)

LUIGI: Don't fret, Edmondo. We all know you can do it.

EDMONDO: I'm not fretting.

LUIGI: We shall leave you alone
When this long-distance call has come through;
We may be curdling the magic.

ANA-CLARA: Aren't you having
Any luck?

EDMONDO: It's taking time, that's all.

ANGELINO: Who can wonder? Even the Creator
Took a week over us – too quick,
A scamped job in some ways. We can't expect
A Cambriccio on every telegraph pole.

EDMONDO: (*To ANA-CLARA.*) How was your afternoon?
Profitable?

ANA-CLARA: Friendly. I wish yours had been happier.
But I never yet knew you to fail in a crisis.

(*ANA-CLARA goes into the Palazzo.*)

ROBERTO: Ah, well, we shall have to fall back on Luigi.

LUIGI: Fall back on me? In what way, fall back on me?

ROBERTO: Aren't you the nearest thing to a cavalryman
In this parish of foot-sloggers?

ANGELINO: Have *Luigi* ride?

ROBERTO: Yes, why not?

EDMONDO: You don't need to get frantic.
 It's being dealt with.

ROBERTO: Well, if the black mass fails
 You might give a thought to our off-white hope here.
 We need someone prepared to spill his guts
 To stop us losing, not a coerced celebrity,
 Blackguarded into coming, with his heart not in it.
 Here's your chance, Luigi, to pull in the votes
 At the next election. The man of gold
 Who slew the dragon for us. It's high time
 One of us gave Edmondo a run for his money.
 (*ROBERTO goes into the Osteria.*)

LUIGI: Here, wait a minute! It's all very well.

ANGELINO: Do you think you could do it? What a stroke it
 would be!
 Why don't you tell Edmondo about the time
 Your jeep sank in the mud, or the sand dune,
 Whatever it was. He commandeered a horse
 And was up with the head of the mechanised unit
 Before they had travelled half a kilometre.
 Or was it a camel?

LUIGI: A camel. All the same,
 It would certainly be a great political platform –
 As long as I won. But there's the horse: you can't
 Be sure how the horse's vote is going to go.
 And, worse than that, there's Alfio Scapare.
 It would take a thunderbolt to beat him.
 (*ETTORE, the chauffeur, comes in from the street. He carries a
 bundle of clothes and a pair of shoes.*)

ETTORE: Excuse me, if you're talking about Scapare:
 Here's all of him that's free to get about
 Just now.

EDMONDO: What's this?

ETTORE: His shirt, trousers, and shoes, sir.

The boys said they weren't taking any chances.
They want you to look after them.

EDMONDO: You mean
They've picked him up?

ETTORE: He strolled up here, sat down
In the local café, and started asking everybody
About his father.

LUIGI: Magnificent! He's gone mad.

ANGELINO: After all we told him about what would happen
If they found him here!

EDMONDO: Fetch him, Ettore.
I'll have a word with him. We'll try to avoid
The Dragons breathing fire all over us.

ETTORE: You don't mean to let him ride, do you, sir?

EDMONDO: I won't let him win, at any rate.

LUIGI: He knows we're amiable; you can persuade him.

ETTORE: Very well, sir.

LUIGI: You will need these, won't you?

(*ETTORE takes the clothes, and exit.*)

ANGELINO: What a stroke of luck he should be born so simple
And trusting! Our hopes are looking up again.

LUIGI: What will you do, 'Mondo? Make him listen to money?

EDMONDO: Leave it to me.

ANGELINO: We certainly don't want
To have any violence, fighting in the streets
Or anything like that. Diplomacy is the way.

(*Enter GRAZIA.*)

GRAZIA: Mother wants to know if you're ready to eat now?

LUIGI: We're ready for anything!

GRAZIA: Have you found somebody?

ANGELINO: We think there's a light on the way.

LUIGI: Enough to feed by,
At least. We can sit down and be nourished.

(*GRAZIA goes in. ANGELINO pours wine.*)

ANGELINO: Now that we've guessed who isn't going to win
 We come back to the question of who will.
 How do you feel about trusting your brother to it?
 You never know, he might have something of *you*
 In him, if he was given the chance.

EDMONDO: You don't
 Trust me to get us out of this, is that it?
 If we have to scrape the barrel, well, here he is.

LUIGI: It's nice to know I'm valued, that's encouraging.
 I know what you mean, though. I haven't ever
 Brought anything off yet, not, at any rate,
 On a scale you'd recognise. But the smell of success
 Has always been in my nose, hasn't it daddo?
 One happy lurch and I should be into it.
 (*He pats himself on the belly.*)
 And I'm not in bad condition, really; not more
 Than two months pregnant. I'll win the race or die.
 Put your shirt on it, or my shroud on me.
 (*GIOSETTA enters with food on a tray, followed by GRAZIA with
 another tray. They put the food on the table. ROBERTO comes
 out from the Osteria.*)

GIOSETTA: Grazia says you are all more cheerful.
 What's the situation now?

ANGELINO: Shall we tell them?

EDMONDO: Why not? They're going to know as soon as he
 gets here.

ANGELINO: Young Alfio crossed our frontier this evening;
 They've got him under lock and key.

ROBERTO: They have?

GIOSETTA: Then I think it's shameful, I think it's wicked!
 It isn't fair to treat him like that, you bandits!

ANGELINO: Now, wait and hear. He walked right into Rosario's
 And started asking questions about Cesare.

GRAZIA: Then I'm glad they caught him!

GIOSETTA: You're as bad as they are.

It's a mean, brutal trick. I'd rather lose

All my money than have this happen to him.

GRAZIA: I told him, I told him to leave it alone.

EDMONDO: Don't get so worked up, Giosetta. Nobody

Is going to stop him riding in the race.

GIOSETTA: You're going to bribe him to lose, then.

EDMONDO: I'm going

To talk to him. We'll come to an understanding.

ROBERTO: Where's Ana-Clara? Has anyone thought of calling her?

(*LUIGI, who has been touching his toes, comes to the table.*)

LUIGI: The only question is, will he accept?

GRAZIA: No, I don't think he will.

GIOSETTA: It's possible.

ANGELINO: You think he might?

GIOSETTA: I was thinking of something he said.

(*ROBERTO meets ANA-CLARA at the Palazzo doorway.*)

ROBERTO: I was on the way to find you.

ANA-CLARA: By a silly mischance

I've made the future more insecure than ever.

EDMONDO: What's happened now?

ANA-CLARA: I looked at the new moon

Through a closed window.

ROBERTO: And why shouldn't you?

ANA-CLARA: It's bad luck. An English salesman told me.

Whenever he saw the new moon through glass

Business dropped. You must all look at it now

To change my luck; bow to heaven and wish.

EDMONDO: It's how the English keep up their exports.

LUIGI: Where is the little sliver, then?

ANA-CLARA: Up there,

Balanced on the roof. You see? Invest your wishes.

ANGELINO: With all *we* want, it will be enough to sink it.

ANA-CLARA: 'Gentle Siena evening. A light-giving pearl
In the proud cloak of Provenzan Salvani
And the moon curved like a begging hand
Beside the Commune tower…'
Your poet Fiorentino.

(*A silence, everyone with his own thoughts.*)

GRAZIA: I don't think mother wished.

GIOSETTA: Oh, yes, I did. I wished you would all get on and eat
your food
Before it's cold as charity.

ROBERTO: Good appetite.

EDMONDO: I bet I know what each one of you was wishing.
Do you want me to try?

ANA-CLARA: No.

LUIGI: All right, then, tell us.

EDMONDO: To start with, father was wishing life was all smiles
Like it was this morning.

ANA-CLARA: Don't you tell him, angel,
Or it never will be.

EDMONDO: Luigi wished he could win
The race, standing up on the horse's back
Shouting 'Citizens of Siena!'

LUIGI: Well, of course.

EDMONDO: Roberto – he's the tricky customer.
He was probably wishing he could steal my wife.

ANGELINO: Now, 'Mondo! I won't have that, even as a joke.

EDMONDO: It was in bad taste, was it? Excuse me.
Excuse me, Roberto. Suppose we move on
Into the clearer waters of Grazia's mind.
She wished for fame and riches, to spin the world
Round her like a dirndl in a dance.

GRAZIA: No.

EDMONDO: Oh, yes. With all this Cambriccio trouble
I haven't even asked you how you got on.
They say Piero Martini's a great artist.

I meant to have got back in time to talk to him.

GRAZIA: He was here for hours.

ANGELINO: He said our pony had genius.

EDMONDO: Did he? I thought he'd like her. So will everyone.
 Imagine the rustle in the Via Veneto.
 'Did you see who that was? Grazia Scapare!' –
 Who will care about the moon, that old graffito
 Chalked up there? There's a new planet in the sky,
 Discovered by the keen-eyed astronomer
 Edmondo Bruno, all set to plot
 Her trajectory across the skies. Excited?

ROBERTO: Just what I thought – a business proposition!

EDMONDO: What's wrong with that? Individuality
 Is a very valuable property;
 It needs professional handling.

ROBERTO: Exploitation.

ANGELINO: Now for heaven's sake, don't you start shooting
 Your quills again. We want to eat in peace,
 Not have to peer twice at every mouthful
 In case we're spitted. You haven't been looking pretty
 Since the night of the storm.

ROBERTO: Maybe not.

ANGELINO: Just be
 Your usual sunny bloody-minded self.

GRAZIA: Luigi, what's the matter? You're not eating anything.

LUIGI: I know, but I may have to ride the horse tomorrow.
 You can't eat, with something like that on your mind.

GIOSETTA: I doubt if any of you would have noticed
 If I'd grilled the horse *tonight.*

ANGELINO: But every mouthful
 Gives a memory to my palate, Giosetta!
 Come along, we must drink your health, we certainly must.
 (*They drink GIOSETTA's health.*)

ANA-CLARA: Grazia isn't the only one with talent.

ROBERTO: Why don't you sell Giosetta to the Grand Hotel,
 Edmondo?

EDMONDO: For God's sake! Let's get this over with.
 You resent me taking care of Grazia's career.
 That's just too bad.

ROBERTO: If you'd only try and make
 One small effort to comprehend something.
 You thought you could come back to where you grew up
 And take it over. You can't; it doesn't exist.
 It's gone, like the old wine that father lost.
 We're having to make do with something nondescript
 Till a new vintage is given time to mature.
 But even so, nothing is the same.
 We've all been dragged out of bed and shot, in some way,
 By what we've seen, or what we were made to do
 To stop another grotesque world being born.
 We owe such a debt to the dead ones, it will take
 Generations to pay back.

EDMONDO: Don't fool yourself,
 Nothing's the same! It's only too pathetically
 The same, exactly as I remember it.
 And if we listen to you it always will be.
 I came home to change all your lives for you,
 And a lot of thanks I get, from you, anyway.

ROBERTO: If you owned all the silver in Potosi
 You couldn't touch our trouble.

LUIGI: Why couldn't he?
 If we attract big business here, encourage
 Free enterprise, build up heavy industry,
 Pump money into the dry cisterns
 Prosperity snowballs.

ROBERTO: Into whose pocket?
 Up and down the land how many will profit?
 You've never told us what your business was
 In Portugal.

EDMONDO: Raw materials. Wolfram, mainly.

ROBERTO: And you sold it where, to Germany?

EDMONDO: Not only Germany: America, England, Japan…

ROBERTO: Anybody willing to buy! My God, don't you
Believe in anything in life except money?

EDMONDO: At least there's no blood on my hands, like
some people.
It's not bad to have made a good life in a world gone crazy.
(*ROBERTO leans across the table and grabs EDMONDO by the shirt.*)

ROBERTO: I'll kill you!

ANGELINO: Sit down, Roberto!
Why did you have to bring up the subject? A nice
Meal time you're giving us. If this
Goes on I shall go to bed. Why can't we
Have some music, eh? I'd even welcome
(Saint Cecilia forgive me) a song from Luigi.

ROBERTO: And you think you can bring your filthy money here
And buy us over again into the old
Discredited welter of greeds we've just been fighting
Our way out of! And drag Grazia into it!
Into a rehash of the old tribal dance
Designed to show off their beads and feathers
Grazia, the best one of all of us,
Who has lived these years without a mark against her.
(*GRAZIA, suddenly agitated, starts collecting the plates.*)

GRAZIA: It isn't true!

ROBERTO: Yes, it is, it's quite true.
And Edmondo thinks he's giving you a future
To have you dressing and undressing for a doll-headed
Decadent lot of fashion-hunters. It makes me
Shudder. That's all I'm saying.

EDMONDO: All *you're* saying.
How about Grazia? What does she say?

ROBERTO: I can trust Grazia.

ANA-CLARA: Well, if you trust Grazia,
What are you so concerned about?

(*Enter ETTORE with a dishevelled ALFIO.*)

LUIGI: Hold on,
 Here's our friend. Good evening.

ANGELINO: Yes – well –
 We must leave him to Edmondo.

GIOSETTA: It's a shame.

EDMONDO: I hear that you've made trouble for yourself,
 Scapare.

ALFIO: Who's at the back of this – are you?
 If so I want compensation for assault!
 I've been beaten up, stripped, and shut in a cellar.
 There are laws against that. It's about time
 This slum found out there isn't a war on now –

ROBERTO: Everything's a war.

ALFIO: – we don't have to get
 Permission to walk about your town! I'll sue you!

EDMONDO: Suppose you stop shouting, and we can think
 How to deal with the mess you've got yourself into.

ALFIO: I don't wonder none of you was able to tell me
 Who betrayed my father. The whole district
 Is a crawling snake's nest!

GRAZIA: (*Crossing with plates.*) I told you to keep
 Your fingers out of it.

GIOSETTA: I expect he's hungry.

EDMONDO: He and I have something we have to discuss first.
 (*EDMONDO leads ALFIO away. GIOSETTA follows GRAZIA
 out with the second tray.*)

ANGELINO: I mustn't start feeling sorry for him, when fate
 Has delivered him into our hands. I'll fetch more wine,
 We're going to need it, if only to cry into.
 (*ANGELINO takes the empty bottles to the Osteria. ETTORE
 leaves.*)

LUIGI: I think I'll take a walk while this is going on.
 It's a bit embarrassing, really. I'll warn the horse
 We may have a closer relationship tomorrow.

(*Exit LUIGI. EDMONDO and ALFIO come downstage.*)

ALFIO: All I want to hear from you is an apology.

EDMONDO: Because you took it into your infant head
　　To cross into enemy territory. You're mad.
　　It's lucky for you you fell into good hands.
　　All you're going to lose by it is the race.

ALFIO: Are you trying to twist my arm?

EDMONDO: 　　　　　　　　　　　　To fill your pocket.
　　Money in your wallet can carry you farther
　　Than a cheering crowd can. I'm prepared, what's more
　　To give you a steadier currency than money:
　　American cigarettes. As you're a Scapare
　　I'll give you ten thousand Lucky Strike.
　　That's wampum anywhere, and gold in Naples.
　　The Black Market price, if you don't happen
　　To be familiar with it, is, as at this moment –

ALFIO: You can't bribe me. I'm not going to break
　　Faith with the men who hired me.

EDMONDO: 　　　　　　　　　　　You did that, son,
　　The moment you sat down in Rosario's.
　　If we can't do business, I simply have to return you
　　To your captors, and I can't vouch for them.
　　This will be a profitable experience,
　　Teaching you more than you learnt in all your years.
　　Not only your pocket, your character will benefit.

ALFIO: Character! Give up trusting anybody,
　　Is that what you mean? And never be worthy again
　　Of being trusted! No, you can't make me do it.

EDMONDO: I suggest you calm down with some mental activity
　　Like a simple sum: if a cigarette and a half
　　Cost a lira and a half… You can take your time.
　　We have all the night ahead of us.

ALFIO: 　　　　　　　　　　　　You swine!

(*EDMONDO wanders towards the table as ANGELINO comes
back with wine.*)

EDMONDO: That's well managed, exactly at half-time.
 How about you two, staring into empty glasses
 Like unemployed crystal gazers? Open a bottle.

ANA-CLARA: What success are you having with our destiny?

ANGELINO: How is he taking it?

EDMONDO: He's thinking it over.
 The temperature is cooling. – A drink, Scapare?
 (*ALFIO, leaning against the far wall, shakes his head. EDMONDO
 fills his own glass and returns.*)

ROBERTO: I'm sweating in sympathy with him, the poor devil.

ANGELINO: The hard birth that mamma had with you,
 That was terrible.

ANA-CLARA: Was he resisting the world
 Even then?

ROBERTO: I was giving it a hard look.

EDMONDO: (*To ALFIO.*)
 Well, Scapare, have you done your arithmetic?
 (*ALFIO gives a Neapolitan gesture of succumbing to fate: the base
 of the palm of the hand strikes a glancing blow on the forehead,
 ricocheting off to describe an arc in the air, the gesture finishing above
 the head and to the side, palm upward to the sky; the shoulders are
 shrugged, the head on one side towards the flung arm; the other
 arm bent upwards, the hand palm upward, the fingers spread; the
 mouth drawn down, the lips pursed.*)
 What does that mean in Naples?

ALFIO: What in hell can I do about it?
 There are things you don't know, things that give you
 An unfair advantage over me. Otherwise,
 I can tell you, you'd never be able to buy me.
 But I'm cornered. The pain my mother is in all the time
 Plays right into your hands. I need the money.

EDMONDO: There you are, you see, I'm acting providence.
 I'm rather good at it.

ALFIO: The doctor has said
 Only one thing can help her, a new drug

Called cortisone. It's just possible to get it
From America, at a price. The cost of it
Would pay for half a minute of a war,
A minor royalty's ransom. No other reason
In the world would make me surrender.

EDMONDO: Ah, there's nothing
Like the influence of a good mother.
I'm glad to have been of some help.

ALFIO: You've destroyed me.

EDMONDO: Nothing of the sort. Come over and have a drink.
You can afford to relax now, and enjoy yourself.

(*Enter GIOSETTA and GRAZIA with trays.*)

ALFIO: I don't feel like company. I don't know
Who I am any more. I'm not fit
To be with other people, anyway.

EDMONDO: Nonsense. You've never done so much good
By one decision in your life before.
Come on.

GIOSETTA: What has become of Luigi?

ROBERTO: He's gone off to use his charm on the horse.

(*EDMONDO brings ALFIO to the table.*)

EDMONDO: Here's a good friend who could do with a drink.

ANGELINO: And he shall have it, bless him. Alfio,
Hard decisions make ready minds. There you are.

EDMONDO: Let's drink his health. Happy days, Scapare,
And no looking back. Always onward and upward.

ANGELINO: That's it. Fame and fortune.

GIOSETTA: (*Kissing ALFIO's forehead.*) Poor Alfio.

ROBERTO: To the conscience-haunted night that we deserve.

EDMONDO: Now if only that call would come through –

GRAZIA: Alfio, I'm sorry for you, and it's my fault.

ALFIO: What do you mean?

GRAZIA: I could have stopped you getting into this trouble.

ALFIO: No, you couldn't. I had to try and find out.

GRAZIA: Not if I had told you what you wanted to know.

GIOSETTA: Grazia!

ALFIO: For God's sake! Why didn't you, then?

GRAZIA: Oh, I wish I could go away from here! I'm sick
Of the smell of the war in our hair, on everything I touch.
I want to be where nothing reminds me of anything.
Rome! I could lose myself there, couldn't I
Edmondo? I should feel better there.
Not to be quite real, however absurd –
A fancy person, someone else's invention,
Whose clothes, even, aren't her own clothes.
I'll go, if they invite me.

EDMONDO: Of course you will!

ALFIO: But you know who gave him away? Tell me Grazia:
I promise I won't make trouble. I think I deserve
To know, after what's happened. Who betrayed him?

GRAZIA: I did.

GIOSETTA: No, Grazia.

GRAZIA: Yes, I did.

ANGELINO: I never heard such nonsense!

GRAZIA: I told Rosa,
Rosa Levanti. Of all people! I told her
We had him here. I knew Rosa could never
Keep quiet about anything, and yet
I babbled it all out to her.

ANGELINO: My dear, my dear,
There was no harm, with a family friend like Rosa.

GRAZIA: I went back and begged her to forget
I had ever told her. She laughed and promised.
But if God had struck her dumb there and then
I had done it, I betrayed him. Now you all know.

GIOSETTA: Why didn't you tell me, you silly girl? How could you
Make yourself so miserable? Is that all
You think of me – someone you can't confide in?

GRAZIA: Sometimes, later on, I would almost forget
Now and then, for a little while. Because no one knew.

If I had told you, whenever we were together
I should all the time have known it was in your mind.

GIOSETTA: Oh, no! Grazia, no one would have blamed you.

GRAZIA: Say I was still a child! That's no help.

(*ROBERTO has walked away from the table, deeply moved.*)

ROBERTO: But it isn't you who ought to be in despair.
What about me, who think I can finger a pulse,
And can't even notice the racing heartbeat of someone
As near to me as you are. What's the matter with me?
I could have told you; once you had blamed yourself
You let a fear take substance, and become
An ogre of certainty, who was never there.
We all felt in some way self-accused
For Cesare's arrest – all of us.

ANA-CLARA: It was love and joy made you tell Rosa.
That's no betrayal. But when you let remorse
Wound the light in you, *then* you betrayed him.

GRAZIA: Well, we won't talk about it any more!
I'm going for a walk!

(*GRAZIA runs towards the archway. ROBERTO catches her as she goes.*)

ROBERTO: Why didn't you help me? Wasn't I there for you?

GRAZIA: I don't want to go over it all again.

(*GIOSETTA has made to follow, but moves into the archway as ROBERTO leads GRAZIA downstage. GIOSETTA looks into the street. EDMONDO also makes a move; ANA-CLARA retains him.*)

ROBERTO: You don't have to, but I'm the one now
Who needs attention.

ANA-CLARA: (*To EDMONDO.*) Leave them alone.

GRAZIA: I only wish I hadn't said anything.
I was sorry for Alfio.

ROBERTO: What worried me
Was whether the SS watched out for me
To visit here, to be able to follow me

 Back to the hideout; which could have been why
 They found Cesare.

GRAZIA: Of course not; it wasn't you.

ROBERTO: We don't know. It isn't a murder mystery
 With a traceable villain. Am I to forgive you
 Or you forgive me? Or twelve other possibilities.
 We have to live with not knowing, sometimes:
 Why this man contracts a cancer, or another's
 Family burns in a house, or Cesare is taken.
 It's not your fault that the world's name is Hazard.

GRAZIA: I hope it isn't, I hope not.

ROBERTO: Believe it.
 Can you? While we live we must expect
 To be haunted, often, but not now. Help me
 By not hiding.

GRAZIA: No more secrets, I promise.
 You are like this. I didn't know that.

ROBERTO: Odd,
 What strange news we can still bring to each other.

GIOSETTA: (*Coming forward.*) Grazia, I want to tell you something.
 We had a message today.

GRAZIA: About father?

ROBERTO: From Cesare?

ALFIO: Is he coming back?

 (*GIOSETTA has passed the note to GRAZIA.*)

GRAZIA: Someone has seen him!
 Someone has really seen him! Mother, who wrote this?

GIOSETTA: I'd say an archangel if it wasn't for the spelling.

GRAZIA: But he's coming home! Why didn't you tell me before?
 What are we doing? We ought to be at the station
 Ready to meet him.

GIOSETTA: But we can't say how or when –

GRAZIA: Every train, every day until he gets here!
 We can sleep in the waiting room. I'll fetch your shawl.

Why did you let so much time go by? We must
Be the first faces he sees when he comes back.

(*GRAZIA disappears indoors.*)

ANGELINO: There, now, you have your orders.

GIOSETTA: A thousand days
Of torturing herself without telling me!
Dear God.

ANA-CLARA: It's over now. Did you ever see
Such daylight in a face as that?

GIOSETTA: Thank goodness
We're going down to the station anyway.
I've been in two minds all morning and afternoon.
I don't know why I made such a hurdle out of it.

(*GRAZIA comes back with the shawl.*)

GRAZIA: Here you are: now let's hurry!

(*ANGELINO and ROBERTO follow them into the street.*)

ANGELINO: Have a thought for your mother's legs.
I hope the vigil won't be too wearisome.
Bring the truant back soon.

GRAZIA: Yes we will!

(*She suddenly embraces ROBERTO.*)

I'm sorry, I'm sorry.

ROBERTO: Goodbye. Good luck.

(*GIOSETTA looks back, her hand on her heart, and tries to smile.
She follows the hurrying GRAZIA. They are gone.*)

ALFIO: (*To EDMONDO.*) Do you see what this means, if my
father comes
He may be here for the race – to see me ride.
The very first time he will have seen me
Out of a squalling cot. Do you realise?

EDMONDO: Oh, for God's sake, don't start on that again.
It's all been settled to everyone's advantage.
Now shut up.

ALFIO: No, but listen. I have to show him
I'm worth something. He put me out of his head,

But I want him to be glad for what he fathered,
Not ashamed of me. Surely you see that?

EDMONDO: Stop following me about. You brought it on yourself.
You needn't think it can all be dropped
Because you want to show off to your father.

ROBERTO: Even though it's a feeling my brother should be
the first
To appreciate.

EDMONDO: You keep out. I'm doing this
For the sake of the parish.

ALFIO: Listen –

EDMONDO: Listen to *me* –

ALFIO: No, listen, it's more than that. The only time
I know who I am, or know I belong anywhere
Is when I'm riding well – when I can master
An animal stronger than I am. I know now
Tomorrow is what my whole life has been leading up to.

EDMONDO: I'm not surprised. So it is for all of us.
Has the other parent dropped out of your thoughts,
Or the miracle drug suddenly lost its virtue?

(*ALFIO collapses in despair.*)

ALFIO: Oh, Christ, I don't know what I'm to do. I don't know.

EDMONDO: Just make your peace with necessity, my boy.

ANGELINO: Come along, come along. Don't take it so hard.

ANA-CLARA: Oh? And why shouldn't he? It *is* hard.
It's impossibly hard. It's ethically, emotionally,
Rationally disgustingly impossible.
I'm on Alfio's side. I don't care about the race,
Which was going to be all love and excitement for me,
Not any more. What does it matter who wins?

ROBERTO: But it does matter.

ANA-CLARA: You can tell your precious people
It's better to lose their money than their good nature.

ROBERTO: Very compassionately said!

EDMONDO: (*To ANA-CLARA.*) Since when
 Have you taken over the role of mother goddess
 And the bleeding heart? This is a new game.

ANA-CLARA: I might teach you to play it when you have the time.

ANGELINO: How I see it, if Cesare's coming home,
 The situation is different, in the nature of things. –
 In the nature of things. – This isn't a bad wine.
 I don't know that I should drink any more, though.
 – Cesare, yes, he's been going through it.
 We don't want an uneasy situation
 Happening here when he gets back. We should let
 The boy be free to make up his own mind.

ANA-CLARA: If it isn't too late.

EDMONDO: I give up!
 I might have known it was no good trying to get
 This bunkered family onto the fairway. Do
 What you like with him. Chuck the race away,
 If that's what you want. Don't come crying to me.

ANGELINO: Now you don't need to kick the milk bucket over.
 We appreciate what you've done – but the truth is
 You tried to give us too much – that's what it was,
 It all came in a flood, everything came
 Together, except, somehow, us, we didn't
 Come together. And that's what I looked forward to.

EDMONDO: How do you expect us to come together
 When none of you knows a peach from a rotten apple?
 This family! I feel I've never been out of it:
 Still sixteen, and swaddled in disapproval.
 As soon as I got here things began to go wrong.

ANGELINO: What an accusation! Are you holding *me*
 Responsible for Cambriccio's blood pressure?
 Did I foul up the telephone wires? Did I
 Split this unfortunate boy's mind
 Into two equal contradictory parts?
 This is how you always used to go on

When you got into trouble – trying to make out
Everybody else was responsible for it!
EDMONDO: I'm not saying that – I'm simply saying
Life hasn't got a chance here. I can feel
Any self-confidence draining out of me.
I knew I had made a mistake to come back home
As soon as I saw my brother's critical smirk.
He's been waiting for the chance to cut me down
To the size he first knew me.
ROBERTO: That's not true!
EDMONDO: If not, it's because you're anxious to keep the peace
With Ana-Clara. I've no doubt you reached
Some sort of pact on the subject. Don't imagine
I haven't seen how this sentimental limbo
Has got into her bloodstream.
ANA-CLARA: Let's not forget
This is the place you love, whatever it does to you.
ANGELINO: The afternoon turned wrongside out, that's
 the trouble.
You won't be feeling like this by morning.
EDMONDO: If I don't, it will be all over with me.
I'll be so far into the domestic bog
I would never get out. The draggers down
Would have power over me again, instead of me
Having some power over them. I won't chance that.
We can wait for the race for Ana-Clara's pleasure.
We may as well bury our late hopes in style
And have the nodding plumes on the black horses
But as soon as that's over, I'm very sorry, daddo,
We shall both be ready to leave. As a matter of fact
I've got some business to attend to in Milan.
I'll have one more go at that long-distance call.
Then you can work out the rest of life for yourselves.
(*He goes towards the Palazzo door.*)
ANGELINO: If that's your judgement on us, I've nothing to say,
Not while you're in this mood; what would be the use?

ROBERTO: Look, Edmondo, if I'm your grievance –

EDMONDO: Well, I'm yours,
And that's the fairest arrangement we can come to.

(*A man is in the archway, dressed in an odd mixture of clothes, his feet tied up in rags. It is CESARE SCAPARE.*)

ANA-CLARA: We seem to have company.

ROBERTO: (*Seeing him.*) What can we do for you?

(*CESARE makes a negative gesture and starts to go.*)
What were you wanting?

CESARE: Nothing – I won't disturb you.

ANGELINO: Were you looking for somebody?

CESARE: That's all right. I thought Giosetta – might be here.

ANGELINO: Giosetta?
It isn't – Cesare? Cesare Scapare!
Why, of course! In this light I didn't know you.
What a welcome to give you, my dear, dear fellow!
We've just been talking about you.

ROBERTO: Cesare?
I'm sorry, my mind was all over the place.
Come on, don't look such a stranger.

CESARE: No, excuse me;
There are people here.

ANGELINO: No people at all.
My daughter-in-law, Edmondo's wife. Come along.
Here's Edmondo himself, come home like you.
And – ah…

(*He has looked uncertainly across at ALFIO, who shakes his head vigorously. But CESARE, after a brief nod of acknowledgment, is retreating into the archway.*)

CESARE: Excuse me. Giosetta isn't here, then?
Nor Grazia?

ANGELINO: It was when you smiled, I realised –
Giosetta and Grazia have gone to meet you.
You've just missed them.

CESARE: I was walking about
 Round the side streets, to give the years a chance
 To pull themselves together. And to get to know
 This man I was walking with, who could go anywhere.

ANGELINO: They haven't been gone more than five minutes.

CESARE: Are they all right?

ANGELINO: They will be when they find you.

CESARE: Think so? You're a hard fact to deny,
 Angelino. There isn't much doubt about you.
 I'll see you presently.

ANGELINO: (*Following him into the street.*) We shall be here.
 (*Everyone is silent. After a moment EDMONDO goes sharply into
 the Palazzo. ANGELINO comes back to the table and starts to
 clear the plates away.*)

ALFIO: He wouldn't have wanted to meet me yet – even
 If I had been ready for him.

ANGELINO: Suppose you help me
 Clear these things away.
 (*ANA-CLARA silently offers to help.*)
 Don't lift a hand.
 This, if you can believe, was meant to be
 My evening in your honour.

ANA-CLARA: Thank you, angel.

ANGELINO: It's not one of the days when life co-operates.
 (*ANGELINO and ALFIO carry the trays away.*)

ALFIO: They say my mother can't live very long.
 (*They go into the Scapare apartment.*)

ROBERTO: What's it doing, this corner of the world –
 Falling apart, or reshaping itself?
 If Edmondo goes, do you go with him?

ANA-CLARA: It's the first time I have ever seen him afraid.

ROBERTO: Afraid? Edmondo?

ANA-CLARA: Terrified of losing
 The self-confidence that worked his wonders.
 Afraid of seeing himself in the old mirror

And now, I can see, afraid of Cesare's shadow
And the war he hasn't experienced. Afraid
Of losing the person he has worked so hard
To make a reality.

ROBERTO: Self-glorification
Whoever suffers – do you call that a reality?

ANA-CLARA: Maybe not. I'm not sure of ours, either.
I doubt if Cesare was convinced we were real.
There may always be another reality
To make fiction of the truth we think we've arrived at.

ROBERTO: I can only imagine what Cesare's been through,
But it doesn't change my experience. On the contrary,
It plays such a livid light onto it
It screams in protest.

ANA-CLARA: Like a political prisoner
Starved of sleep, who answers whatever you insist on.
Suppose reality isn't *what,* but *how*
You experience. Would that not contradict you?

ROBERTO: Speculation won't save us. Let's cope with what we
know about.
Are you going to sink back again into 'Mondo's world?

ANA-CLARA: Yes, I am. He gives me the patience I need
To make my mistakes, which you would never give me;
And the leisure I need to realise myself,
How far my mind, unhounded, and my free senses
Will take me, which you would never give me.

ROBERTO: So you whittle down the promise of this afternoon
To a mere biological thrust between us,
And take shelter in 'Mondo's self-delusion.

ANA-CLARA: He was real enough to make you want to show him,
Or anyway show yourself, you could take me from him.

ROBERTO: That's absolutely untrue! – Or if I did feel it,
For a second, it was gone before I could act on it.

ANA-CLARA: For a second you would have used me as he has used
People, to convince himself of his strength.

ROBERTO: Do you think I would have destroyed you?

ANA-CLARA: Yes, I do.
 There was the scent of sapphire-coloured blood
 That sauntered in my veins, or so you thought.
 The hunt was up – to lay the *donnanobile*
 On her back in love or confusion.

ROBERTO: A monstrous slander!

ANA-CLARA: Is it? When I owned up to what I came from
 I could see a view-halloo fade out of your eye.

ROBERTO: God protect me from a woman's intuition!
 It's the one incontrovertible proof
 Of spontaneous generation. You needn't think
 I shall try and refute a fantasy.

ANA-CLARA: I won't press it.
 None of this has any significance
 Beside the plain fact that you love Grazia.
 (*ROBERTO is silent.*)
 I know. I saw it take you by surprise
 When you turned and rent Edmondo. You hadn't bothered
 To mark its gradual height on the kitchen door.
 It's much taller than you imagined, isn't it?

ROBERTO: So you say. But nevertheless –

ANA-CLARA: I welcome that.
 I could do with a nevertheless.
 (*ALFIO comes to the doorway of the Scapares', drying a plate.*)

ALFIO: I have to tell you
 I've cleared up the trouble in my mind now.
 I shall ride in the race, as though this evening
 Had never happened. Nothing else is possible.
 I just had to banish the last two hours or so
 Out of my memory. I thought I ought to warn you.

ROBERTO: I see.
 (*ALFIO goes in.*)

ANA-CLARA: Nevertheless?

ROBERTO: What we found in each other –
 (*LUIGI enters from the street.*)

LUIGI: Well, that's the introduction over. I let him
 Get to know the pressure of my knees
 Against his rib-barrel. A beautiful creature,
 But as nervous as I am. Did Edmondo fix it?

ROBERTO: Yes, he fixed it.

LUIGI: Where are they all?

ROBERTO: Cesare has come back.

LUIGI: No? By God,
 Has he? Is he all right?

ROBERTO: I didn't recognise him.

LUIGI: Really? Remember how I told you yesterday
 The starting gun had gone off? It's not a bad omen.
 What with the heat and anxiety, I'm exhausted.
 There's a snake of lightning twitching low on the hills
 Towards Arezzo. The storm is still around somewhere.
 Well, a drink, a wash, and then home for a night's rest.

 (*LUIGI goes into the Osteria.*)

ROBERTO: We won't tell him about Alfio.
 Let's leave him in good heart, as long as we can.

ANA-CLARA: Yes, why not? – I wonder what sort of heart
 Edmondo is in. It's time I went to find out.
 As for me, I reflected the light behind your head
 And made you turn to look.

ROBERTO: These two days,
 Can I tell you what they meant?

 (*LUIGI re-emerges.*)

LUIGI: There's water in the taps,
 Did you know? Arterial red, like the Tiber.
 I'll leave it running and see if it comes clear.

 (*He goes back inside.*)

ANA-CLARA: Nevertheless will do. It's a river word
 Flowing past and never leaving. Sleep soundly.
 There's a challenging day tomorrow.

ROBERTO: And you, too.

(*The light swiftly fades to darkness. In the dark, the sound, gradually increasing, of an excited crowd, the emphatic ringing of the bell in the campanile. A gunshot. The roar of the crowd as the race begins. Above the dark stage, light strikes on rippling banners. The light returns to show CESARE at his doorway listening to the noise. A gunshot signals the end of the race. It is the next afternoon. CESARE is neat and shaven. A number is tattooed on his forearm. He calls back into the house.*)

CESARE: That's it, Giosetta!

GIOSETTA: (*Off.*) All over, is it?

CESARE: It's all over. You're either richer or poorer.

GIOSETTA: I should like to know which.

CESARE: Haven't you a premonition?

(*GIOSETTA comes out to him.*)

GIOSETTA: Is it likely? If I was given to premonitions.
 Those shunting trucks would have shaken me silly
 All these weeks you were trying to get back here.

CESARE: You should have gone down and seen what was
 happening.

GIOSETTA: Don't imagine you're the only one
 Who doesn't like being buried alive in his neighbours.

CESARE: I'll get back to them, but the herding is over
 Thank God. – After you had gone to sleep
 I tried breathing in rhythm with your breathing.
 I wasn't far out. But it kept me awake
 And I gave up.

(*He laughs, kisses her, and sits on a stone seat by the wall.*)

 If Alfio has won
 He is going to be disappointed I wasn't there.

GIOSETTA: And relieved if he lost. Don't let that worry you.
 You met last night like two donkeys
 Eating a thornbush to get at the grass.
 You don't have to *earn* each other.

CESARE: It's all
 Given away free with the daylight, you mean…?

When we crossed the Brenner we all knew where we were
Even though it was still dark. We started to sing
But couldn't keep it up. You never know
How many disguises fear can take.
This one took me off my guard. A kind of
Rising panic to find myself without
Anything to fear. It was almost comic.
Dropped into life, after so long in a place
Where life was like a belief in the supernatural.
(*GIOSETTA sits beside him on the seat.*)
Then coming down from Verona in the daylight –
The farms, the people going about the roads,
They kept coming at me like waves of pain:
I seemed to be forcing them out of me
And the muscles were cramped with not being used.
If anyone ever asks you
Who gave birth to Venezia and Emilia
You can tell them I did.

GIOSETTA: I'll remember that.

CESARE: Just as well you weren't at the station, both of you.
When I got down, my legs were trembling and sprawling –
Like a calf some cow had just dropped.
Not seeing you I felt lost, and then thankful,
And then so horrified, remembering
I didn't know what had happened to you, my legs
Ran me down the platform as though I had seen you.

GIOSETTA: You coming to look for us was a good way
Of finding you.

CESARE: (*Laughing.*) The time it took, after I shouted,
Before your faces exploded!

GIOSETTA: Don't imagine
I didn't know you. There wasn't a second
When I didn't know you. You can beg my pardon.

CESARE: All right, but, I'll tell you, I was thankful
To get that first look over, and you started to laugh.

GIOSETTA: You looked such a ragman, I never saw the equal!

(*CESARE leans his head back against the wall.*)

CESARE: A good idea, the sun.

GIOSETTA: Yes, it helps.

CESARE: When do you think I ought to tell Grazia
 What I'm thinking of doing?

(*GIOSETTA doesn't speak for a few moments. CESARE takes her
hand.*)

GIOSETTA: Before Alfio gets here
 Or anything's decided. Talk it out
 As you and I did, so that she can understand.

CESARE: It's not easy to talk of half-seen ghosts by sunlight.

(*GRAZIA runs in from the street, ROBERTO follows more slowly.*)

GRAZIA: Here we are!

GIOSETTA: Well, let's hear the worst, then.

GRAZIA: I'm not to tell you, Angelino says;
 He wants to be first with the news.

ROBERTO: We're sworn to be silent.

GIOSETTA: It isn't fair. Why did you trouble to run, then?

GRAZIA: To see my father, who is better than any horse race.
 How does the morning find you today, silent one?

(*She has sat beside him, and puts her head on his shoulder.*)

CESARE: With such treasure stored up, for me, in a daughter
 And her mother, I want the key to their kingdom.

GRAZIA: Something is troubling you isn't it?

CESARE: I've got to re-learn
 The skill of being earth-borne, which I was never
 Much of a hand at. You may have to forgive
 The laborious apprentice. As it happens
 There's a place prepared for a beginner in Naples
 If Alfio's mother and Alfio will accept me.

GRAZIA: Oh, no!

CESARE: You see, I have to find my way.
 And easing the sting of death in the next bunk
 Is something I know about. It will give me a chance
 To feel less at sea with the run of the world.

GRAZIA: No, I won't understand, I won't give you up!
　　We can't let him go, can we?

GIOSETTA:　　　　　　　　　Not easily,
　　None of it is easy.

GRAZIA:　　　　　　You tell him, Roberto,
　　How soon we can mend the world for him here.

ROBERTO: You can't say what anyone had better do.
　　As we very well saw just now at the race.

GRAZIA: (*Laughing in spite of herself.*)　　　That's true!

GIOSETTA: Don't tease us!

GRAZIA: (*To CESARE.*)　　I deserve to be without you
　　After what I did.

CESARE:　　　　Oh, daughter, where's your promise
　　That you would never have such thoughts again?
　　Moonshine. One wincing member of the family
　　Is enough. You have to be my maker of quiet.
　　Ask Roberto. What good's a healer for a neighbour
　　If you don't make use of him?

ROBERTO:　　　　　　　　Ah, what good *is* he?

CESARE: Ask Grazia.

GIOSETTA:　　　　If we're all going to live
　　By asking questions, here comes the answer
　　To one of mine.
　　　(*Enter ANGELINO, ANA-CLARA and EDMONDO.*)
　　　　　　　Angelino, tell us,
　　Take us out of our misery, out with it.

ANGELINO: What an experience! We shall never live through
　　The like of that again!

ANA-CLARA:　　　　Or we shouldn't survive it.

ANGELINO: Alfio rode like a perfect master.

GIOSETTA:　　　　　　　　　　　I see —
　　So it was Alfio, as we all thought it would be.

ANGELINO: No, no, no, he didn't win. We won.

GIOSETTA: We won? Are you serious?

183

ROBERTO: Yes, he's quite serious.
 Isn't he, Grazia?

ANGELINO: I always said
 Luigi was the one to succeed. All he needed
 Was the opportunity.

GIOSETTA: I can't understand it.
 If Alfio rode so well, how did Luigi beat him?

ANGELINO: How? It doesn't matter how.

ROBERTO: Of course it matters.
 That was the brilliant part of it. He fell off.

GIOSETTA: Fell off?

ANA-CLARA: And of course I thought Alfio had won.
 I couldn't imagine why they were all throwing
 Their arms round each other's necks in an ecstasy –
 Till they said if the horse comes in, the race is won,
 Never mind what happened to the man.

GRAZIA: The horse was so happy
 Not to have Luigi on him, he flew past Alfio
 Right on the last corner like a bird.

ANA-CLARA: It was a miracle!

ROBERTO: The miracle would have been
 If Luigi had stayed on. But nature rallied.

EDMONDO: He nearly came off in the first two yards,
 But he clung on like a crab for a circuit and a half.
 And fell off when he angled at the San Martino.

ANA-CLARA: I hardly had time to scream before he was up
 On his feet and clear of the track.

ROBERTO: With Luigi's bounce
 It's odd he didn't land straight back on the horse.

GIOSETTA: It's a shame to mock him.

ANGELINO: We don't want him to feel
 Discomforted after such a victory.
 What we must do is show him we're celebrating.
 He can't help it if things didn't turn out
 Quite as he planned them; that's the world for you.

(*He goes into the Osteria.*)

EDMONDO: For some people it may be. If you like
 To travel standing about thumbing a lift
 And then do most of the distance on foot.
 Nobody ever made a future that way.

CESARE: How is it made?

EDMONDO: What do you mean?

CESARE: I was wondering
 Just what state of mind gives us a future.
 I suppose you mean the future; not the present
 Made more bearable or more efficient.
 What's the good if it's not a difference in kind?
 There's not a lot we know can be called the future.

EDMONDO: I'm talking about taking care of tomorrow,
 Cesare.

CESARE: Oh, tomorrow, the next man's present.
 I thought you were talking about something more cheerful,
 A revolution.

EDMONDO: Revolution? That's Roberto's province.

CESARE: No, no. I mean a real revolution,
 The transformation.

ROBERTO: I don't know what's in your mind.
 If we get the conditions straight the rest will follow.

CESARE: The rest of what? That's what I'm asking.
 Where does the mind go next, in your well-cared-for
 System of being born and being buried?
 I haven't your simple faith that a man can be doctored
 Out of his tragedy into the millennium.

ROBERTO: God knows you've got every reason to feel
 The human experiment has failed. But I promise, Cesare,
 We're not going to forget what happened to you.

CESARE: Failed? That's not it. I never set
 So much value on us as I do now,
 Heart, mind, and vision: all we can call human,
 Not wolf, jackal, vulture, and pig.
 In the camp, you don't know what utopias

We built out of some flicker of humanity.
How, in what way, won't you forget?
Don't, for God's sake, reward us
By staring so long at the gorgon's head
It grips the muscles of your living face.
We've been in the dirt. We don't want to be remembered
By generations playing at mud-pies
And calling it the true image of life –
I'd rather come soon to the clean skull.
Purify us, Roberto, purify us!
Insist on all the powers that recover us!

GRAZIA: But, father, what has he said, what's the matter?

CESARE: I was getting excited. That was a shouting
Out of the old nights before I got back to you.

(*A sound of chanting and cheering, growing louder. ANGELINO comes back with a tray of wine and glasses.*)

ANGELINO: Here we are, all ready for the conqueror.
We won't have Luigi thinking he's disgraced himself.
Let's hope that he hasn't slunk away somewhere.
We want him with us.

EDMONDO: By the sound of it
You're going to have him.

ANGELINO: Did you hear that?
They're shouting my name. What a morning to have lived for!

(*In the archway comes a group of MEN in fifteenth-century costume, carrying LUIGI in his jockey cap and shirt, in triumph on their shoulders. They bear him once round the courtyard, chanting:*)

MEN: B-R-U-N-O, BRUNO!
Who is Bruno? You know Bruno!
Bruno son of Angelino.
Luigi Bruno the fantino
B-R-U-N-O, BRUNO!

(*As the chanting stops LUIGI jumps down and embraces ANGELINO.*)

LUIGI: I've done it! I've done it! I've brought it off!

ANGELINO: Bravo, you have, I knew that you could do it.

LUIGI: I've put us on the map, haven't I, eh?

ANGELINO: Bruno, son of Angelino – what a triumph!

(*LUIGI goes round embracing everybody; he dances GRAZIA in his arms; kisses ANA-CLARA.*)

LUIGI: Well, there, was it anything like the vision you had?

ANA-CLARA: Yes, and beyond. I was lifted off the earth.

LUIGI: That wasn't what it did to me. – Giosetta,
You'd be proud of me, if you thought of me at all
Now Cesare's home. And here is the man himself.
You see what I go through to give you a welcome.

CESARE: Well done. Give my compliments to the horse.

LUIGI: How was that, Bobo? I just gave life a chance
To find her own way. – There, 'Mondo, you see,
I wasn't such a bad substitute after all.

ANGELINO: I propose the health of the man who saved the parish.

(*Calls of 'LUIGI!' from the MEN and the others.*)

EDMONDO: This is the moment to tell you what's in my mind.
As Ana-Clara and I won't need the Palazzo
I intend to make it into a restaurant:
Angelino's, the paradise of gourmets,
The shrine of pilgrim gastronomes, the goal
Of epicures. We'll have a gala opening
With everyone here who counts for anything.
The rest of the world will follow like sheep to be fed.
You'll prosper all right, daddo. It will be as easy –
I was going to say as falling off a horse,
But I don't want to reflect on Luigi's success.

(*ROBERTO has given a private groan.*)

LUIGI: Learn by it, 'Mondo dear. You've cast a gloom
Over Bobo again. Drink up, boys. We haven't
Finished the lap of triumph yet. Are you ready?
This was only a wayside halt in our progress.

(*The MEN thank ANGELINO for the wine and hoist LUIGI onto their shoulders. They march out into the street, taking up their chant of 'B-R-U-N-O! BRUNO!'. ANGELINO follows them as*

far as the street. CESARE, GIOSETTA, GRAZIA and ROBERTO
are laughing.)

GIOSETTA: I needn't have been anxious about his feelings!

ROBERTO: There won't be any holding him now.

ANA-CLARA: Except
 That you can't fall off a horse every day of your life.

CESARE: I think Luigi could. And if there aren't any shoulders
 To ride on, he will find a way to invent them.
 (*ANGELINO comes back from the street.*)

ANGELINO: He has turned the whole district into heroes.
 They all think they could have done it themselves,
 Cheering themselves like champions. They don't realise
 It takes Luigi's particular ability.

GIOSETTA: Has anyone been to see Cambriccio?

ROBERTO: Yes, I went with Grazia. He's doing all right.

EDMONDO: What do you say about the restaurant, daddo?
 It's what you've always wanted, isn't it?
 The day's come round, to see things turn into gold.

ANGELINO: Yes, I appreciate that.

EDMONDO: Appreciate it!
 Well, I hope you do.

ANA-CLARA: (*To CESARE.*) I'm still thinking
 About the future you see for us, as if
 Our variation to adapt to life
 Was hardly begun. – All through the afternoon
 I felt as though the barriers were breaking
 Between our world and another.
 (*CESARE has withdrawn into himself.*)

EDMONDO: (*To ANGELINO.*) Can't you think
 Of anything more to say than that?

ROBERTO: (*To ANA-CLARA.*) The old
 Stimulant: bells, trumpets, drums, flag juggling,
 It's a heavy mixture. It comes very near
 Even to seducing me, and I'm used to it!

ANGELINO: (*To EDMONDO.*)

 I shall turn it over in my mind, of course,

 Of course.

EDMONDO: Turn it over? What does that mean?

 Isn't it good enough? I don't understand.

ANA-CLARA: It's a great slow love-making, anyway,

 And left me vibrating like an instrument.

 So nearly the city had no need of the sun

 Or the moon to shine on it. I could almost see.

 By the light that streamed from the trumpets

 And shimmered from the bell. The courting sun birds,

 The birds of paradise, so nearly sang.

 The indwelling music which created us.

ANGELINO: (*To EDMONDO.*) I seem to be full of misgivings.

EDMONDO: You're impossible!

 Hopeless!

ROBERTO: (*To ANA-CLARA.*) You have to feed your bird of paradise

 If you want it to sing.

ANGELINO: (*To EDMONDO.*) When I start to think

 Of all those mouths opening and shutting,

 Chewing on my efforts to please, day in, day out,

 I feel discouraged at the prospect. I don't believe

 I could love them, even on closing day.

EDMONDO: (*Outraged.*) Please yourself. Don't say I haven't tried.

 Ana-Clara, it's time we got going.

ANA-CLARA: I won't be long.

 (*EDMONDO goes into the Palazzo.*)

ANGELINO: I don't know whether I'm a greater disappointment

 To 'Mondo or to me. I like to enjoy

 A glittering prospect, but not to the extent

 Of letting it take you over body and soul.

 I draw the line there. It's one rule of conduct

 I *can* say that I've got.

ANA-CLARA: I could stay and talk

 All night, and rivet the stars with attention,

 About what we are, to ourselves and to each other,

What things destroy us and what things create –
They are better guides than any rule book,
Though as intricate as a meeting of waters.
But it's not to be now: all for some other evening.

ANGELINO: Now that's what I like to hear you say –
That makes me more cheerful.

GRAZIA: (*With her arm round CESARE.*) Some other evening
When we're all together again. I wonder
How we are going to get on until then.

(*ROBERTO looks at his wristwatch and moves away.*)

ROBERTO: I don't know what I'm doing sitting about here.
I've some calls to make.

CESARE: Blessed the profession
Where a man's meaning is plain.

ROBERTO: (*Suddenly turning.*) Ah! But would you
Trust your daughter to me? –

GIOSETTA: About as much
As I trust life, which is every now and again.

ANGELINO: Have you found your way to asking her, at last?
I knew you were the one with the intelligence.
If you mean to get married you will have to find
Some patients who can pay you. What a mercy!

GRAZIA: Angelino, he hasn't asked me anything.
You mustn't start prospecting again.

ANGELINO: Oh, mustn't I?

ROBERTO: We'll see what we can do. Don't lose heart.

(*He goes into the Osteria. A procession emerges from the Palazzo: the three MENSERVANTS, the LADY's MAID, the SECRETARY, the CHAUFFEUR carrying luggage. They go off through the archway.*)

ANA-CLARA: Here's my wagon train moving off. And I must fall
Into step behind them.

(*She goes to the Palazzo doorway.*)

ANGELINO: The poor empty Palazzo.

ANA-CLARA: Suppose Edmondo started a clinic here?

How do you think Roberto would feel about that?

(*A scream of motorcycle brakes outside in the street.*)

CESARE: With an accident ward for the unlucky.

GIOSETTA: It sounds like Alfio again.

ANA-CLARA: And it is Alfio.

(*ALFIO wheels his machine in through the archway.*)

ANGELINO: We thought it was you. Why don't you look where
 you're going?

(*ALFIO grins, and gives the extravagant Neapolitan gesture he gave
before, but this time ironically. CESARE makes the same gesture in
sympathetic reply. The others are laughing.*

The curtain falls.)

SIEGE

Characters

GASTON FLOIRE, a minstrel

A GIRL

TWO PRISONERS

A CAPTAIN

GUARDS

THE BISHOP OF BEAUCAIRE

GENERAL BOULGARS

AUCASSIN

NICOLETTE

A SERGEANT

THE COUNT OF BEAUCAIRE

THE COUNTESS OF BEAUCAIRE

MILLOW, a steward

MRS LOMBRICK

TALMOUSE

MRS GRASSET

JAPHET

SOLDIERS

PERK, Governor of the Prison

JAILER

WILLIAM BIGHT

MRS WILLIAM BIGHT

THOMAS BIGHT

HENRY BIGHT

BEGGAR, selling flags

MEN AND WOMEN OF BEAUCAIRE

Scene: The Castle of Beaucaire, France, and surrounding area

Time: Spring, 1015

ACT ONE

(*An open space in the Castle of Beaucaire, during the Siege of Beaucaire, 1015. GASTON FLOIRE, minstrel, is making up his latest report on the way, with the help of his lute.*)

FLOIRE: Listen, you people, here's Gaston Floire
 Singing the news. A vivid report
 Of the spring defensive.
 The only authentic description. I was there.
 The anniversary of the Siege of Beaucaire.
 I tell you, spring's in the blood of those chaps.
 They've got your forgetmenots in their caps.
 There isn't any need to get apprehensive.
 Here's the news of the spring defensive –
 (*A GIRL is passing by.*)

GIRL: You might stop that, I should think.

FLOIRE: Should you indeed?
 What for?

GIRL: Why aren't you fighting with the others
 You lead-swinger?

FLOIRE: Lead-swinger, that's good.
 If you think I'm the kind of minstrel who accepts
 Second-hand information for his news
 You're gravely wrong. If you really want to know
 I've just come back from where a heavy battery
 Is operating under the walls. You'll see.
 In ten minutes the city will hear about it –
 A frank eye-witness account.

GIRL: You're out of date.

FLOIRE: Me, out of date? That's very good, I must say.
 The most-on-the-spot war-minstrel in the city;
 What did you call me?

GIRL: I could listen to you
 A year ago. That's what I mean. But now

When you sing desolation like the latest dance-tune
I can't listen. That's all.

FLOIRE: That's just the way you feel.

GIRL: Yes, all right. – My brother has started fighting.

FLOIRE: Good for him.

GIRL: He was fifteen today.
Blood and bone are essentially patriotic.
They've marched my baby brother into manhood
In record time. The Count inspected them.
He said something of that sort, something like
'With an inch or two you have caught up with your heroes…'
And the boys cheered. And what about his son?
Where's Lord Aucassin? He's a grown man
And a trained soldier. Why not write a song
To shame him into fighting? For a year
This siege has starved and buried us. Here's
Spring back again and here's the Count's own son
Letting us struggle on as best we can.
Make a song about that and earn your keep
If you've any decent feelings.

FLOIRE: Don't be silly.
I should lose my job.
(*Uproar offstage.*)

GIRL: What on earth's all that about?
It sounds like trouble.

FLOIRE: It looks like trouble.
That's Gaston's luck. I'm always on the spot.
(*Enter two PRISONERS between GUARDS, followed by a CROWD
shouting and hissing.*)
What's happened?

CROWD: They attacked Lord Aucassin.
They knocked him down.

FLOIRE: My goodness, what a story!

GUARD: Clear away there.

FLOIRE: Listen, brother. My name's Floire.
 You know me. Give me a break and I'll split fifty
 Fifty on this news.
GUARD: You run off, sonny;
 We've got a job to do.
FLOIRE: Here's something down.
 Nobody's going to notice. Take the thing.
GUARD: You've heard just about everything. These two
 Had just come back from fighting, pretty done in,
 And found their wives were dead. Due to starvation.
 Undernourishment, the doctor said.
CROWD: We shall all die.
 We all are undernourished.
 The men don't get enough!
 You can't fight for months
 On horsemeat and harness.
 Found their wives were dead
 And came into the streets, yelling and carrying on.
 Poor chaps. Poor souls.
 And then they saw the Count's son.
 Him that won't fight. Young Aucassin.
 Well then, I suppose,
 Then they saw red. Who wouldn't? We're all as bad
 In thought, if it comes to that.
 Him that won't raise a hand
 To help his father's city damn well asks
 For a hiding. Coward!
 Our babies are like old men.
 Our children are crying all day long. They're hungry.
 So they saw red and hit out. Who wouldn't hit out
 If he got the chance?
GUARD: Here, what's the big idea?
 Keep out of this!
CROWD: The Count's son ought to be hanged!
OLD WOMAN: Ought to be hanged? Who says he ought to
 be hanged?

I nursed the boy; I nursed the little dear.
He's a good boy.

CROWD: We'll nurse the little dear!
We'll give him suck, you sentimental old fool.
The Count's son ought to be hanged.

OLD WOMAN: A sentimental old fool? Almighty God!
Why do you men grow too big for our laps?
I'd rather put up with the bawling of twenty babies
All the night, than hear a man talk of his honour.

CROWD: The Count's son ought to be hanged!
The Count's son ought to be hanged!
(*Enter a CAPTAIN.*)

CAPTAIN: Clear away from here. Clear off the lot of you.

CROWD: Shame. Shame. Shame. Shame.
Are you hiding the rat? The coward! The traitor!
Conscientious objector! Who would expect a
Son of the Count's to be such a sop?
Where is he now? Let's go and collect a
Bunch of white feathers and give him the lot.

CAPTAIN: Get a move on there. You don't want to be jailed.
Come on, now, look slippy.

CROWD: All right; we're going. You don't need to shoot us.
Boot us all out, that's all you can do.
He's had his deserts – not all he deserves
But they gave him something to make him sit up.
And they ought to go free. They've done nothing wrong.
All right; we're going, we're getting along.
(*Exeunt. The BISHOP OF BEAUCAIRE and GENERAL
BOULGARS from a little distance have been watching the CAPTAIN
and the GUARDS disperse the CROWD.*)

BISHOP: That looks rather unpleasant, General.

BOULGARS: Damned unpleasant.

BISHOP: The seeds of rebellion there, General.

BOULGARS: Rebellion? Oh dear me no, sir. A demonstration;
an ugly demonstration; a most unfortunate incident. We're at
war, sir, and the city is loyal to a man.

BISHOP: Or perhaps we should say, *except* for a man, General.

BOULGARS: Exactly so – except for one young fool – the very man we should be able to count on – that's the thing that turns my stomach. It'll break his father's heart, I shouldn't wonder. And what's more it's breaking the heart of the city.

BISHOP: Oh dear me no it isn't. I sense danger, General, and there's no danger in a broken heart. When it had dawned on the people that Aucassin had no intention of fighting, first they were sick with disappointment and then they were angry. They weren't heartbroken. They have enough terrors and sorrows of their own to break their hearts over.

BOULGARS: Well, that's possibly so; that's as maybe. Nevertheless, it's an appalling business. I used to believe the boy had spirit. I can't understand it.

BISHOP: You were right; he has spirit; but it happens not to be public spirit.

BOULGARS: Look here – it seems to me that you're supporting this fellow.

BISHOP: Oh no, oh no.

BOULGARS: In my opinion his attitude amounts to nothing short of a crime. Here we are at a crisis greater than Beaucaire has ever known before, and he deliberately brings a loyal and suffering people to the verge of rebellion –

BISHOP: Rebellion, General? –

BOULGARS: In the moral sense, sir.

BISHOP: The people have no moral sense; that is why we give them moral precepts. Most fortunately so. Morality, General, is apt to be very disconcerting when it isn't State-controlled. That is why I cannot find it in my heart to support this unfortunate young man. He thinks too much.

AUCASSIN: (*Above.*) No, my Lord Bishop; you've got the fellow wrong.
　　It's something in his bones that has him jumping.

BISHOP: Why, sir, you're bleeding. Someone should have given Those wounds attention.

AUCASSIN: My Lord, Beaucaire is bleeding
And gets no attention either… Oh, our prayers
Yes. But blood runs out quicker than prayers
Can run to heaven, gabble as we may.

BOULGARS: That's a nice kindly speech, sir. We had noticed
Beaucaire is bleeding. Strange you noticed too.
Extraordinary. In time, sir, you may notice
That men have gathered round to aid Beaucaire
With their own blood as well as prayers, their blood
As well as speeches.

BISHOP: General –

AUCASSIN: No,
This is fair. This is talk. It's talk I'm after.
My father, as you may guess, I fail to talk to.
My mother is busy in the hospital and canteens.
My friends are fighting or dead, or picking a bone
At Headquarters. And till now I've only known you
As the Bishop and the Chief of my father's army,
Part of an old world that I can't remember.
A world that you were young in, peace and plenty.
Peace is a word
That I can't find a picture to.

BISHOP: You are young –

AUCASSIN: And the heart is high, and spring is under the guns,
And spring is budding against the ear of the sniper.
Yes, my Lord, I am young.

BISHOP: With your youth you'd give
Beaucaire new confidence.

AUCASSIN: And bring her victory.
And then we could live to fight another day.

BOULGARS: That's the way.

BISHOP: He's laughing.

BOULGARS: Laughing? Well
There's nothing more to say.

AUCASSIN: I'm sorry, General.
Don't go off yet. – I've been a fairish soldier

From my sixteenth birthday. You know that.
You liked me once, remember?
Battle had always been my best playfellow.
Even my nurse had got me off to sleep
To march-time. And our enemies weren't men
Like us. The world was black and white, and war
A spot of colour. Then I grew a little
And my eyes ran level with the grass and rose
In the air some way from where my heart was nesting
So that you never found my hatching thoughts,
Until they were hatched; and we were at war again.
A grand new war.
It started like a dry argument that took
An ugly turn, and goes on without us.
What cause for war is a farm, a pigsty farm,
A farm of seven acres, and the eviction
Of one man? It was a little argument
To burn down so many candles.
Not all who listened to it have stayed awake.

BOULGARS: A question of prestige, a question of
 Encroachment –

BISHOP: The farm was like a text
 To base our sermon on.

AUCASSIN: Successful preachers,
 We can convert more men from flesh and blood
 To the spirit than the twelve apostles
 Would have thought possible in so short a time.

 (*Enter NICOLETTE.*)

NICOLETTE: Father –

BOULGARS: Coming, my dear. I'm sorry I'm late.
 I was kept talking. I must leave you two
 To thrash it out. If you will take my tip, sir,
 You'll thrash it out for yourself: it's a devil in you.
 Now come along.

AUCASSIN: Good evening, Nicolette.

NICOLETTE: Good evening, sir. The horse that Peter rode
　　Hasn't got to be shot.
AUCASSIN:　　　　　　　I know, I know.
　　I went to see him. Peter is going to be pleased
　　When he gets better and hears how near it was.
BOULGARS: We must be getting along.
AUCASSIN:　　　　　　　　　　Good night.
NICOLETTE:　　　　　　　　　　　　Good night.
　　(*Exit BOULGARS and NICOLETTE.*)
AUCASSIN: Peter's is a lovely horse. I've ridden him.
BISHOP: And rode him well, I haven't any doubt.
　　You're a good horseman and a clever fighter,
　　In the tournament you were like Noah's rainbow
　　A shining promise, and we hung Beaucaire
　　Like a green triumph round your neck.
　　And now you let it wither up. My Lord,
　　Fight; fight in God's name; come, fight.
　　　　　　　　　　　　　　Your city needs you.
　　Remember poor Beaucaire.
AUCASSIN:　　　　　　　Of seven acres.
　　Funny I should forget the old man's name.
　　Flints, I remember, and the barley's beard
　　And how I watched the fanatic mill-stream, storming
　　And broken on the wheel. I am tired, sir,
　　Of gutting my neighbours. It's my father's war.
　　I've got no quarrel with the enemy.
　　I have a quarrel with new graves. And spring
　　Badgers me to live longer.
　　My father's generation are stored like hives
　　With long limbering Aprils. But not we,
　　We who were born with the wind in the dead quarter.
　　For us April is dancing on a live coal
　　And summer may root in our brains. Besides, my Lord,
　　I love this city, as my father loves it,
　　But this is a city's waste. It's sour and rotten
　　And I'll not be a party to it.

BISHOP: I wish
 You weren't so young.

AUCASSIN: I'll age, my Lord, if a gun
 Doesn't call my mortgage in.

 (*Exit BISHOP.*)

NICOLETTE: (*In a doorway.*) May I come
 And speak to you?

AUCASSIN: Of course. Have you left the General
 To feed himself?

NICOLETTE: He gave me some bad news.
 I made an excuse and came to you. It's Peter.

AUCASSIN: It's Peter.

NICOLETTE: He died about an hour ago.

AUCASSIN: It's Peter.
 Yes, that's quite clear.
 Have you noticed how the orchard takes this war?
 The trees know their business and take their time in budding.
 I had a savage feeling that I must
 Shoot his horse. Do you know how to find
 The Outrider in the stars?

NICOLETTE: No. Only
 The Plough and Orion.

AUCASSIN: And the Pleiades.

NICOLETTE: Not even that.

AUCASSIN: It's dusk. They'll soon be here.

NICOLETTE: Why are you bleeding?

AUCASSIN: You know why I'm bleeding.

NICOLETTE: Yes, I know.

AUCASSIN: The Bishop wished me older
 Nicolette. I think so too. If he
 With a prayer could give me full command
 Over my little company of years
 I'd soon dismiss these raw recruits of days
 That play me up so. We're a pathetic bunch
 Of stragglers, my years and I. I turn

The year's new leaves like an official
Memorandum that I can't make out.
One day I'll have it clear.

NICOLETTE: I think maybe
Perplexity grows on us.

AUCASSIN: So it does. It does.
I can well remember when I was little
Sun and moon and stars were on the doorstep
Of heaven, and nearly on the window-ledge
Of earth. Heaven was our neighbour.
If I was naughty I knew the neighbours would hear.
If I was good, one day I'd be asked in
And the party would be a good one.
 When I came
Out of school heaven's door came off its hinges
Torn off by hawk's talon and tiger's claw.
Even the deep-sea anemone
Sucked out a screw. And heaven was not behind it.
Perplexity was there.
Space swamped my little craft of understanding
And I was adrift.

NICOLETTE: There's a wind running in the sky that knows
Its course.

AUCASSIN: Just say Where's Peter now? Where's Peter?
We two together remember a single thing
That from today no one will memorise.
'We two together.' It's a way of thinking
I've got accustomed to, although we've spoken
Hardly at all. You've stolen up on me
Like night thunder.

NICOLETTE: In the dry breaking of this spring I knew
A hand like a green leaf.

AUCASSIN: Nicolette, Nicolette, remember the regulations.
We must talk in whispers, keep our heads down.
 We have said

Two things like the striking of a match.
There mustn't be a third.

NICOLETTE: Are you afraid?

AUCASSIN: Yes, I'm afraid. Not of the sudden spring
Of death, the leap of the tremendous dog.
But love plays like a cat, and in this city
Has lost its reason looking for its home.
It's not the time; not the time and not the season.
Not in this drenching hour that we live in.
We have small enough hearts, God knows;
But the whole earth packs in. It's enough.
Quite enough!

Your hands are bruised.

NICOLETTE: Trying a man's work.

AUCASSIN: You! A man's work!

NICOLETTE: It wasn't so amusing.

AUCASSIN: When I look into the palm of your hand
I wonder if I'm lined up there.
I half believe against all common-sense
Old Egypt and the fairy hills
Shepherds dividing their bodies to the stars
Under St James' Highway and the traipsing
Of dark measures in the moon, have left their breath
Across our hands. If I am really there
Mrs Lombrick would soon tell us. —
No, Nicolette!
I'm as besieged as the town is, and your hand
Would be against me with another thunder.
There is no place in this wilderness
For our roots to strike in.

NICOLETTE: There's the moon again
With its face fresh from the fire.
Aucassin, we aren't noticed. A massacre tonight
Wouldn't make her hesitate. Our dropping off
Is the sand falling and makes no noise, and this
Wreckage that we cry in is split dust;

It will blow with the rest.

 Hunger and desolation
May be the business that we start at nine
That leaves us no time for the garden;
But love will branch from stone and will survive there,
Not being part with the dust, but being part
With the green policy that brings the moon
On us so regularly. You know that's true.

AUCASSIN: I know it's true. And yet what you call dust,
 This small split dust, weighs pretty heavily.

NICOLETTE: You're still afraid.

AUCASSIN: Yes.

NICOLETTE: What are you afraid of?

AUCASSIN: Perhaps of Aucassin, son of Beaucaire,
 That bothered boy whose world smells of sulphur.

NICOLETTE: If you were fighting you'd be free of him.

AUCASSIN: Do you want me to do that, Nicolette?
 That's a judgment I should like to have from you.
 Should I be fighting?

NICOLETTE: I think so, Aucassin.
 Not fighting, you're alone; alone, you're lonely;
 Like a stranger in a noisy crowd,
 Like coming in sober to a warmed-up party.
 You're angry at being cheated of your fun,
 Of all the men and women on both sides
 Being cheated of their cheerful days, and spring
 Falling on stony ground. But in the fighting
 Spring will run down your arms like sweat
 Even if only for a moment.

AUCASSIN: My father was responsible for this.
 My father and your father-by-adoption.
 This is their world, this pretty thing we live in.
 And I was born to serve this pretty thing,
 To tear the heavens away from an enemy's eyes
 And rob him of sun, moon, stars, rain, wind and sea

With the fall of my arm because my arm is part
Of my father's body and he made this war.
If we could be produced without a parent
We should at least make our own kind of sorrow,
But being as we are, which right are we right to follow?

NICOLETTE: How can I help you there? This is your question.
And yet I think you should fight.

AUCASSIN: The earth's about
Our ears too much to be so sure. A dead man knows
If a dead man could reckon up.
Let's meet again when the world's stopped rocking.
(*A SERGEANT crosses the stage carrying a whip.*)
What are you doing with that?

SERGEANT: My Lord, the Count's given orders for a flogging.

AUCASSIN: Of whom?

SERGEANT: Two men, my Lord.

AUCASSIN: What have they done?

SERGEANT: My Lord –

AUCASSIN: Two soldiers; am I right?

SERGEANT: Why, yes,
They're soldiers, sir.

AUCASSIN: Guilty of what?

SERGEANT: A breach of discipline, my Lord.

AUCASSIN: Of striking
Their superior, is that it? Striking me.

SERGEANT: My Lord –

AUCASSIN: Give me the whip.

SERGEANT: The Count has ordered –

AUCASSIN: Nicolette, go in.
(*Exit NICOLETTE.*)
 Now give that whip to me.
There'll be no flogging.
(*Enter the COUNT and COUNTESS OF BEAUCAIRE.*)

COUNT: Sergeant, you've had your orders.

AUCASSIN: He has them, sir.
 These men will not be whipped.
COUNTESS: Be sensible, my dear; be sensible;
 Be sensible.
AUCASSIN: Very good, so I am. More sensible
 To justice than you'd like. These men had cause,
 Cause enough, heaven knows, to attack me. Wait.
 Their wives are dead. Cover your heart with soil
 Two feet thick and tell me what you see
 Of loyalty. Tell me what you see
 The first hour, that first wet hour of fog
 They met me in. And judge them.
COUNT: Sergeant.

 (*Exit SERGEANT.*)

AUCASSIN: No,
 You can't do it!
COUNTESS: Aucassin, be sensible.
 Your father's made up his mind and that's enough.
 There's nothing you can do.
AUCASSIN: Made up his mind!
 Yes, indeed. He's made it up before
 If you remember, like the dawn
 That rouses the condemned-cell to a breakfast.
 Father, you take only a middling size
 In hats, I fancy,
 But underneath you keep a nest of terrors
 To scare three generations. Let them go.
 No, father, stop that flogging!
COUNT: That's enough.
 I've already let you damage more than enough.
 You've shaken the city and me as much as the guns
 Of Valence. If I should let these two men go
 Where should I stand in my own country? It's you
 Who did this thing. Don't shift the blame. It's you
 Who made this flogging possible. This city
 At peace, at war, was united; and it loved us.

You were my son. You were my guarantee
Of the city's future. They had watched you grow
Pretty gallantly to be a man.
Then like a lunatic you hurled yourself down
And half the structure with you. That's enough.
You must be content with that.

AUCASSIN: No, there's no need
To shake your head a minute longer, mother.
Your little secret warnings are all finished.
You're right, father; it's enough. I'll fight.

COUNT: Why –

AUCASSIN: Wait a minute, father. I shall fight
On two conditions: you'll release these men
Before a stroke has touched them. Give one lash
And I'll not play war. You've brought me to the jump
But twitch me back a second and I'll not
Be over. What's your answer?

COUNTESS: Oh, my dear,
Of course your father will release those men.
Isn't it splendid?

COUNT: He's done the right thing; yes,
He's made a happy decision. I thank God
You've come around to this at last. You'll not
Regret it, never regret it, Aucassin my son,
To your dying day. Beaucaire will thank you for it.
Your mother and I will be proud of you again
As we used to be, as we always prayed and believed
We'd be again. We'll talk about this together.
Leave us together, mother.

AUCASSIN: The flogging, father.

COUNT: Yes, yes; I'll call it off.

AUCASSIN: You'd better hurry.

COUNTESS: Shall I go down and tell them the men are free?

COUNT: Yes, would you my dear?

COUNTESS: I'll go down now. My son,
You've made me very happy, dear. So happy.

Don't fret about those two poor men; I'll go
And see about them now. I must just kiss you.
It's like old times again. I expect you thought
I was very unkind these last few months, but mothers
Are also wives; and you'll be glad it's so
One day when you are married, if your wife
Is a wise mother.

AUCASSIN: By all these wives and mothers,
Mother, run and get those men out.

COUNTESS: Yes, dear.
I'll leave you with your father. (*Exit.*)

COUNT: Do those cuts of yours need washing? You must be
Rested and strong before the morning.

AUCASSIN: Father,
There were two conditions.

COUNT: What?

AUCASSIN: I said I'd fight
On two conditions. You've had one of them.

COUNT: Ah.

AUCASSIN: If I'm going to curb the rest of my days
To decorate your world, I'd like a song
Of my own to sing in private.

COUNT: Listen, son,
Is this some double-dealing?

AUCASSIN: In a sense.
I'm tired of being single.

COUNT: That's the story!
I thought one day I should hear it.

AUCASSIN: Right! I'll tell it to you.
Once upon a time, upon
A world like a meadow of marsh-water, where men
Sank systematically like stars in daylight,
There was a young man out-at-elbows with
Hopping like the flame of the marsh-gas
To keep on the surface. (Do you like the story?)
Then a flame grew in his flame a happy stroke

Of chemistry. He found he was now burning
Up like a candle. Nothing will convince him,
You can imagine, that burning like the marsh-gas
Is better than burning like a wick in wax.
So if the flame should happen to burn your fingers
Don't imagine you can blow it out.
Heave up your hands and bless me.

COUNT: What's all this?
Don't shuffle round the point, you silly boy.
What's in your mind?

AUCASSIN: Love's in my mind.

COUNT: And who's the woman?

AUCASSIN: Nicolette's the woman. —
Well, am I still in trouble?

COUNT: You know, of course,
The story of this girl? Boulgars is not
Her father.

AUCASSIN: I know that. He adopted her.

COUNT: You know that. Do you also know Boulgars
Brought her here as a slave from some adventure
He'd been away on?

AUCASSIN: Yes, I know, and also
That he and his wife became so fond of her
She grew to be their daughter.

COUNT: But the fact
Remains. She was a slave-girl.

AUCASSIN: Yes. — I love her.

COUNT: Well, I suppose we all have our early fancies.
Laugh at yourself, my boy. It's an excellent thing.
We all go through these phases when we're young,
But keep a sense of proportion, son, and laugh
It off.

AUCASSIN: Yes, father. — Get this clear, I love her.
Get this quite clear, because the moon is up:
In not so many hours the tongue of heaven
Will come out with the old lie of a new day

And then where shall we be? Still trying to make
Contact, to get it clear I'll only fight
On one condition? Need we be so long
About it?

COUNT: There's no need to get excited.
What's this condition?

AUCASSIN: That I marry her.

COUNT: That's the condition. That's how you would play me.
You know I've been patient with you up to now
And a fool and soft. You're not afraid to try me.
Conditions! Conditions! Oh, yes, you will fight,
Only too pleased to save your city
If I'll do this and that; if I'll applaud
All your contortions. Is there nothing in you
For me to recognise? No traces left
Of the boy on the horse who still rides in my mind?
Who are you? Stranger than a stranger.
Something that's taken possession of my son.
Get out of him for pity's sake!

AUCASSIN: Conditions,
God knows, are only pasture for my horse.
I said I'll fight. Leave me a vein or two
For my own blood to run in. What's the quarrel?

COUNT: Marriage is out of the question, you know that
As well as I do, or you wouldn't have used
These methods. You can see the difference
Between this girl and you, but you prefer
To shut your eyes to it because you want her.
You! Never mind Beaucaire. Never mind your mother
Who would have to stand beside her. Where's your pride?

AUCASSIN: In Nicolette.

COUNT: Boy, you will do me the favour
Not to return to this subject again. I've said
All I intend.

AUCASSIN: No fighting?

COUNT: I'll not have it!

Get out! I won't be badgered by your cunning –
There's nothing can be done for you. If this
Broken city can't shake you into honesty
What can a father's hand do? That's the end.
I think there's nothing further.

AUCASSIN: Very well,
I should have been half a son at any rate.

COUNT: Aucassin – I've not been a hard father.
I'm getting on now, but I can still remember
What it was to be young; I shall always remember:
I could tell you plenty of tales. But on your side
You must look ahead. There's plenty of time, plenty,
Before you need marry. But in your position
When marriage comes it's business of the state.
Love on the other hand belongs to these
Lively years of yours. We needn't quarrel
Over that.

AUCASSIN: I see your argument.
You're a brave man, father, to explain so clearly
The dignity I was born to. Wild oats
And obligations. But I think my star
Had wandering thoughts, and undid in the cradle
All my very enviable birthright.
I am not with you.

COUNT: No! I don't know where you are.
You dodge and trick. You're not with me. You're not
A natural boy at all.

AUCASSIN: Father, forget
Relationship and get down to the business.
Am I to fight?

COUNT: That's what I'm hoping for.

AUCASSIN: I marry Nicolette.

COUNT: Stop! Every word you say
Drives you away from me. A boy who whips
Himself to sorrow.

AUCASSIN: My mother should be back.

COUNT: Are you fond of your mother?

AUCASSIN: Very fond of my mother.

COUNT: Will you fight for her?

AUCASSIN: For her or you
Or the peace of Beaucaire or the frogs in the well
So long as I marry Nicolette. Well, father,
What's it to be? – I think my mother's coming.

COUNT: Keep your mouth shut to her. She's pleased about you
And I should be sorry to have it spoiled so soon.
So keep your mouth shut.

AUCASSIN: If my mother says
When do you go to the walls, Aucassin? What
Do I say then?

COUNT: Say nothing.

AUCASSIN: Oh, I see;
Just smile a little.

COUNT: Tell her you are going
Tomorrow. What the devil is the use
Of this pretence of father and son?
Do what you can to save Beaucaire, and then
How you fetch up against the future's nothing
To me. I say it's nothing to me. Nothing.
Marry into the gutter. Here's your mother.
(*Enter the COUNTESS.*)

AUCASSIN: Were you in time, mother?

COUNTESS: In time? Oh yes, my dear;
Of course. You needn't bother your head any more.
Have you had a nice little talk?

AUCASSIN: Quite nice.

COUNT: He's going off tomorrow.

COUNTESS: Splendid, darling.

AUCASSIN: Father, what time does the next contingent go?

COUNT: This evening?

AUCASSIN: Yes.

COUNT: At seven o'clock.

AUCASSIN: I think
 I'll go with them.

COUNTESS: Tonight? But dearest heart you're tired.
 You got so knocked about.

COUNT: Your mother's right.
 You'd better get some sleep under your belt.

AUCASSIN: I'll go tonight before I dream. Tomorrow
 The sun might throw me to the ground again
 Like a tiresome shadow.

COUNTESS: But, dear –

COUNT: Let him alone.
 He knows his business.

COUNTESS: I wish it had been tomorrow.
 But at least come in and wash your cuts, and say
 Goodbye, won't you?

AUCASSIN: Of course, mother. – Mother,
 Do you see how the sky counsels peace?
 It shines its silver shield and hangs it up.
 But then it's some way off.

COUNTESS: Let's go indoors
 So that I can see to your cuts. The time
 Is getting on. These things can set up trouble
 If you don't look after them.

 (*They go in. Enter Gaston FLOIRE and MILLOW, an old
 steward.*)

MILLOW: Well, what do you say?

FLOIRE: (*Looking up from tuning his lute.*) What did you say?

MILLOW: I said 'What do you say?'.

FLOIRE: Oh. I say no.

MILLOW: Come…come! You haven't understood what I've
 been saying, young fellow. In fact, to be quite open with you,
 sir, you don't know your business. Now I should be in your
 shoes. I used to play on one of those things most tenderly
 – very tenderly indeed – but I could never thread the damn

strings through the holes. If you'd only listen to what I've got to tell you you'd be worth something.

FLOIRE: Very likely. In time of peace you might have been good for a line or two. But not now, sir, oh dear me no.

MILLOW: Perhaps you'd be kind enough to give me your reason.

FLOIRE: You're not news, Mr –

MILLOW: Millow's the name.

FLOIRE: I just don't think you'd be good news to anybody.

MILLOW: Of course you shouldn't be a minstrel at all. That's all there is to it. Given the opportunity I should have been Beaucaire's greatest son my dear young fellow. Let me impress it upon you, sir, that if I was fighting, this siege would end like *that*.

FLOIRE: Very sudden.

MILLOW: You're beginning to understand, I can see. I'm a fighting man, sir, through and through; a born commander.

FLOIRE: Tell me, Colonel, what campaigns can you call to mind for me?

MILLOW: There's my tragedy, sir. There's the human appeal. None at all, sir. Lack of opportunity buries the country's greatest general before he fires a shot. First of all, sir, I was a widowed mother's only support. Then I was essential to the proper conduct of the Count's estate. And now when the smell of gun-powder is making me sneeze as though I was hay-making – what's the latest thing? Too old for military service! Too old! – feel that muscle, go on, sir, feel it. That's the man they call over military age. 'Please, please,' I said to them, 'consider what you're saying. The very man you should be building your hopes on.' But was it any use? No, my dear good fellow, it wasn't any use at all. I was screwed down in the kitchens with the old women, and all the war I get is their bombardment of tongues.

FLOIRE: That's too bad.

MILLOW: It would make a great song; no doubt about it. A great subject for someone with the talent.

FLOIRE: Listen, old man; I've got my hands full with material at the moment. Come to me when the war's over. I've got to turn a line or two about the two poor chaps who attacked Lord Aucassin.

MILLOW: Just no idea at all, I can see that. 'When the war's over.' What do you think my story will mean when the war's over?

(*Enter from the prison the two PRISONERS.*)

– You might as well go round today singing about Christmas –

FLOIRE: Do you see who that is? They're the men I'm after. Now do you see what I mean. This is news! – I'd like to offer you my congratulations on your release, gentlemen. The arrest should never have been made; a scandalous business altogether. You had the whole city behind you and they knew it. Oh yes, they knew they'd made an unpopular move all right. If you could give me a brief resumé of the course of events following your arrest –

1ST PRISONER: What the matter with you? Can't you keep out of this?

(*A CROWD has begun to gather.*)

FLOIRE: Just a few words, old chap; that's all I want – I'll do all the embroidering that's necessary.

2ND PRISONER: Take your hand off my arm, go on.

1ST PRISONER: Clear off.

FLOIRE: No, listen. You've been released, haven't you –

1ST PRISONER: Oh yes; oh yes, we've been released all right.

FLOIRE: Just what I could have told you.

1ST PRISONER: Just what you could have told us. Well, you can tell us another thing. You can tell us they flogged us first and that won't surprise us neither.

CROWD: They flogged them. Did you hear what he said! They were flogged. They were flogged.

FLOIRE: Look here, boys, you've got to give me the whole story. This is going to be a song that will make their ears burn; it's

seeping into me already. You'll be hearing it at all the street corners before the morning, with a tune you can march to.

MILLOW: This sounds to me like a crisis. If there's going to be a rebellion come to me; come to me and I'll bring you out on top…

FLOIRE: Shut up, you old fool. Come on, boys, what have you got to say?

2ND PRISONER: Clear out; clear out. Leave us alone. I'm going to sleep.

1ST PRISONER: Keep your dirty hands away from us.

FLOIRE: That's all right, boys; you can go to sleep. But you wouldn't like your story forgotten after what you've been through. I'll set light to it like a bonfire. It'll still be burning when we're all in our graves.

CROWD: We'll set light to the prison. Let's burn the prison down!
Burn the prison! Burn the prison down!
All right! We'll show them who we are. Burn,
Burn, burn, burn! Who's got a torch?

FLOIRE: Wait, you – Friends, friends, friends, FRIENDS!
Let's hear their story. It's a song we want
And I'll have it if you wait.

MILLOW: I'm in the thick of it.
In the thick of it! That's the best of it.

FLOIRE: You see, boys, what the city's feeling is.
It's a proud moment for you. Give them something
To talk about. Show them the marks of the whip.

CROWD: Yes, yes! What have they done to you?
Show us. How many did you get?
We'll have it out with them if you won't.
We'll give them gyp. Show us the marks
The marks of the whip!

FLOIRE: Immediately following the castigation
The actual marks of this terrible scandal
Through the agency of Gaston Floire.
Remember the name. It's Gaston Floire –

Here, stand back! Let them take their own time.
No, give them a chance!

CROWD: Let's see what they've done
The Molochs! We'll see this atrocity!
The marks of the whip!

1ST PRISONER: Christ, let me get away.

MILLOW: There ought to be some kind of order. This won't do.
Stand to attention until you get your orders.

(*The CROWD have torn one PRISONER's shirt off and have him on their shoulders. They work themselves into a state of excitement.*)

CROWD: Shame! Shame! Look at their work, the swine!
There's a limit to being trodden and starved. It's fine
Work! Fine work! They send them up the line
And this is all their pay. This is the way
They think they'll treat us! Starve and beat us!
Are we letting them get away with that? No,
We're not. Burn the prison down.
Burn 'em all out!

(*Enter CAPTAINS and MEN.*)

FLOIRE: Listen, you fatheads! You've got the whole thing wrong.
You wanted a song.

CROWD: Look out; they'll shoot us down.
Bring us the Count. We'll show him what he's done.
We'll tell him where he stands. We'll tell him how
We'll wash his stinking hands. We'll show him who!

(*Enter GENERAL BOULGARS.*)

Shame! Shame! Why didn't you stand by them?
You're a soldier, aren't you? He's a soldier too.
Theses blokes are soldiers. Look at them now, because
They hit a conshy. What's the game? That's what
We want to know.

BOULGARS: Listen to me my friends.

CROWD: Who's going to win this effin war? The privates!
Not you. Not likely.

BOULGARS: I'm the first to admit it.
You're right to be sorry for them; and I'm sorry

> And the Count is sorry for them. And we're not
> The only ones who're sorry for them. One
> Who you know well is going to fight to show
> He's sorry for them. Yes, Lord Aucassin
> Is going to fight. You have my word for it.
> I'm glad to be able to tell you –

CROWD: Aucassin
> Is going to fight. He's going to fight. The war
> As good as over. Three cheers for his Lordship. Hipipip
> Hoorah!
> We want Aucassin! We want Aucassin!

> (*Enter the COUNT. Renewed cheering.*)

COUNT: My son is already preparing to go into action.
> Your hearts will go with him I know. In unity
> We shall win through. We've got our backs to the wall
> But shoulder to shoulder we'll see it through to the end.
> The victory we hope is not far distant.
> Go and take your news through the whole city.
> We've a new impetus now.

> (*Cheers. The CROWD disperse shouting the news.*)

FLOIRE: (*To MILLOW as they go.*) That's news, old man. That's
what the public wants.

MILLOW: You haven't got any eye for the future, my dear good
fellow. That news will be on the larder shelves tomorrow.
You'll never get another chance of a story like mine, not as
long as you live.

FLOIRE: Listen to them. That's the effect of news. Five minutes
ago they were starving and now listen to them.

> (*Exeunt all except the COUNT and GENERAL BOULGARS.*)

COUNT: Thanks, Boulgars. Trouble nicely averted.

BOULGARS: Timely action of your son, my Lord.

COUNT: Maybe, maybe.

BOULGARS: If you'll permit me, sir,
> At heart he's the soundest youngster in the city.
> I've always said so.

COUNT: No, Boulgars. At heart
 My son's a twister. Yes, you heard me, sir,
 My son's a twister. At heart my son has plans
 Of his own that makes this little victory
 Of ours an idiot's sanctuary.
 You understand, Boulgars. My son is fighting
 On one condition. Yes, Boulgars, he foxed me.
 The moon's glaring in my face. Come down.
 I gave him his head. You know why; you know
 As well as I do that it probably
 Meant all the difference between defeat
 And victory, between a united front
 And the complete and utter disintegration
 Of everything our lives are made of. That's
 The reason I didn't cross him at the time –
 As you can well believe. He'd cornered me.
 That's my son, Boulgars! But still by God
 In spite of that I'll do the best I can
 To be a decent father to the boy.
 I'll see he doesn't run his crazy hand
 Into a tragedy. For the boy's own sake
 And for Beaucaire, Boulgars – and for Beaucaire –
 We have to put an end to all this nonsense.

BOULGARS: May I hear the condition, sir?

COUNT: He wants to marry
 Nicolette.

BOULGARS: My daughter!

COUNT: Your adopted daughter.
 A slave-girl. It is no discredit to you
 To say that no such marriage can take place.
 She came here as your prisoner. The people
 Remember that. A very charming girl;
 My wife and I are very fond of her,
 But as a wife for our son, you'll be the first
 To agree, quite out of the question.

BOULGARS: Absolutely
 Entirely out of the question. It's incredible
 That any such idea is in their minds.

COUNT: In their minds and their hearts; I can see that; anyhow
 It's so with my son. It's not indelible
 I hope, but we must see that they don't chance
 Across each other any more; or rather
 Not for some time. And by that time the fit
 Will have taken them another way, or I'm
 No judge of a young heart. They'll find a rhyme
 For almost any name in time. Till then
 She shall be hidden.

BOULGARS: Yes, my Lord, but where
 In a besieged city? There's no way
 Outside the walls.

COUNT: Inside the walls. The tower
 To the south.

BOULGARS: My Lord, that tower's a prison-house.

COUNT: Stronger walls, Boulgars – my son will pry
 Through the whole city.

BOULGARS: Not stronger walls, my Lord,
 That tower's the weakest point in our defence.

COUNT: I fancy not, Boulgars.

BOULGARS: I know it is.

COUNT: I say I fancy not. The southern tower's
 The place to hide her in. See that it's done
 Early tomorrow.

BOULGARS: I think that you'll agree, sir,
 From the day that I became an NCO
 And you were with me then
 I've been a loyal soldier to your house,
 My rule and the rule of my father and their fathers
 To obey without comment. But Nicolette is now
 My daughter, though in the past she was our prisoner.
 Your orders are that I must imprison her
 For an indefinite period in a tower

In the theatre of war. May I suggest, sir,
That you may wish to reconsider this.

COUNT: I'm sorry, General. I have more to consider
Than you alone. I, as well as you,
Have a loyalty to my house, a responsibility
To keep it uncorrupt.
I don't forget your years of tireless service,
Your shining example to the generation
Who have grown under you. No, no, Boulgars,
Nor the excellent conduct of the war.
Because I remembered this I came to you
Without any hesitation, to demand
An extent of loyalty that trespassed
On your own property. I'm sorry, General.
You have my orders.

BOULGARS: I would be grateful, sir,
If you'd reissue these orders in the morning
When we have slept. This is a heavy commission
To carry throughout the night, sir.

COUNT: Very well;
Thank you, General.

BOULGARS: Thank you, sir.

COUNT: The moon
Won't give our men much peace. I'll go with you
For an hour over to the walls, Boulgars,
When the next contingent's off. You'd better see
My son before he goes.

(*Enter MILLOW with a lighted brand. As the COUNT and BOULGARS are going in, the flame light reflects on the wall in front of them.*)

(*Turning.*) What is it?

MILLOW: Come to light the torches, my Lord. Sorry I'm late
with them, my Lord.

COUNT: Have you been waiting in the dark there ready to light
them?

MILLOW: Just come, my Lord. Trouble in the kitchens delayed matters. Mrs Lombrick was put about because of the holy relic she's lost; a toe-nail paring of St Simeon Stylites. She had us all looking.

COUNT: Goodnight.

MILLOW: She says if you could forbid all toe-nail cutting until she's found it she could sleep better at night. (*The COUNT and BOULGARS have gone in.*) Oh well, that happened this afternoon but that's neither here nor there.

(*He goes up and lights the first torch. Then he stands and laughs to himself. A bell starts to sound. The boom of a gun. The BISHOP crosses the stage to the house.*)

BISHOP: Goodnight, Millow.

MILLOW: Goodnight, your reverence.

BISHOP: God protect and keep you
Now and for evermore. Amen.

MILLOW: If He protects me tomorrow and tomorrow only I shan't grumble. If you can keep it in mind, sir, pray for me in the morning as early as you can.

BISHOP: Don't you think if I pray for you tonight it will see you through tomorrow?

MILLOW: I'd rather have it new-laid if you wouldn't mind, sir. I have some business to see to, and I imagine it will need the Almighty's undivided attention.

BISHOP: I shall remember. Goodnight.

MILLOW: Goodnight, your reverence.

(*Exit the BISHOP. The bell continues and the gun occasionally to boom. MILLOW lights a second torch. A few others pass across the stage. Enter GASTON FLOIRE, playing his lute.*)

FLOIRE: 'Gaston Floire in the midstream of battle
Caught at flying death and made a song.
He saw the souls of heroes herd like cattle
Through the five-barred gate of heaven, along
An April road of stars. He saw the souls
Of the enemy dive like hail into the sea –'

Goodnight, old man. I'm being kept busy, I'd say I am.

MILLOW: Goodnight, you old incompetent. I shall be busy
tomorrow myself. I've some business on hand that'll bring
you running to me for an interview. But I'm not at all sure
that you'll get it. I shall make my own song. Oh, you needn't
laugh. I used to write verses on the walls when I was a
schoolboy, and heroic or dirty it's all the same technique…
Goodnight you old discord.

FLOIRE: Goodnight you decaying cockerel.

'My horse takes the field
Like a volley of muted drums,
Death's in his nostrils
He snorts it out like a cloud…'

(*Exit FLOIRE, MILLOW laughs again and lights another torch.
The bell stops ringing. Enter NICOLETTE.*)

NICOLETTE: Goodnight, Millow.

(*MILLOW looks at her, smiles to himself and whistles a bit of
FLOIRE's tune.*)

MILLOW: Goodnight, chick.

(*He watches her as she goes through the doorway.*)

NICOLETTE: This moon's a danger, but clouds are riding up
Like reinforcements; that's a mercy.
We can sleep under the clouds, but not when heaven's
wide open.
There's marching over there. Some men are going
Back to the walls. God keep them safe.

MILLOW: The lucky devils.

NICOLETTE: Would you go with them, Millow,
If you were younger?

MILLOW: They ought to have taken me,
I begged 'em to; you know I did.

NICOLETTE: The moon's
Topping the clouds.

MILLOW: Listen to me, my dear,
There's something you should know. Whether you take it

227

 Ill or well won't keep it from you long.
 Lord Aucassin is with 'em.

NICOLETTE: Safer; the moon's
 Covered again. – Who told you that?

MILLOW: Your father
 Told the people so. They cheered like mad.
 And then by accident I overheard
 The Count telling it all again to your good father
 – Together with some other business. Pretty,
 Don't fret.

NICOLETTE: It's good news. Millow. There's that sound of
 marching
 Faintly, back on the wind. That's the last gust
 That will bring news of them tonight.
 I'll get away to bed; goodnight.

MILLOW: Goodnight.
 Mind that you get some sleep.

NICOLETTE: Yes, I shall sleep.
 Goodnight, Millow. (*Exit.*)

MILLOW: Goodnight, my wren. (*He goes to light the last torch.*)
 We'll keep you out of your cage. I swear it by this heat – no,
 it will cool too quick. Well, by this hand – why, no, that'll
 grow cold too. I swear it by this everlasting air that has given
 suck to so many fools it weans us as soon as it can. I'll show
 them who's a man. I'll do a deed or two before they dig me
 under. We'll have a good noisy speech before we make our
 exit. – Here's tempestivity to sink in! I shall laugh in my
 sleep.

 (*Curtain on Act One.*)

ACT TWO

Scene One

(*The kitchens of Castle Beaucaire, very early the next morning. MILLOW, with a book on modern warfare in his hand, is working out problems on the table. MRS LOMBRICK, an old woman, and TALMOUSE, an old man, are watching him.*)

MILLOW: (*From his book.*) … 'Necessities for defence… The obstacles of acclivity of marsh, or of water…' Here's water – mustard for marsh, near enough –

LOMBRICK: Gather-me-up-charming-and-swipe-me-over. H'if this is what you've raked us all up two hours early for I'll pay twopence to the devil to 'ave you put away, and be happy to do it. H'out of our warm beds by candlelight jest to see you mucking about with a tommyrotting cookery-book! – Mustard and water and acidity! – If that's what you think –

TALMOUSE: Now, now, Mrs Lombrick; don't be so hasty. Mr Millow here knows what he's a-doing of. And you know you wanted to get up early and look for your toe-nail; you told me you did.

MILLOW: Cookery? This is war, woman. That's why you're out of bed. You're going to fight a battle.

LOMBRICK: Oh! – did you hear him, Mr Talmouse? Now we 'ave got a parcel of cats to keep orf the carpet. He's gorn dotty. But h'I can manage 'im, Mr Talmouse; don't you worry. Old Jim Wilcocks went jest the same way. He behaved so comic that Jessie Wilcocks, poor soul, she laughed so much that she was gone in an hour and she wasn't no older than I was neither –

TALMOUSE: Shush. He's working something out.

LOMBRICK: 'E should try sweating it out. Often enough it works wonders.

MILLOW: Adequate fortification, that's the thing. Strong generalship – well, we've got that; yes, we've got that… 'Fortification increases the relative value of our own forces

beyond their mere numerical value. One man behind works can prevent three men from going forward past those works…' You'll be behind works, Mrs Lombrick, and you'll prevent three of the Count's men going forward past those works; do you understand?

LOMBRICK: (*To TALMOUSE.*) Keep 'im happy, go on. Don't let 'im think there's nothink wrong. (*She giggles immoderately.*)

MILLOW: Stop that now; stop woman. STOP THAT NOISE. You're under camp-discipline now and I'll have no sniggers. Captain Talmouse –

TALMOUSE: Yes what, Mr Millow?

MILLOW: Call me Colonel, will you, Mr Talmouse? – just this morning. It gets my military instincts working.

TALMOUSE: Yes, Colonel.

MILLOW: Stop this woman laughing, Captain Talmouse.

TALMOUSE: Mrs Lombrick, Mrs Lombrick! Mind your manners. You've got to be a soldier.

LOMBRICK: A soldier? Not me. I know too much about 'em.

MILLOW: What material for a man of genius! We've got enough cause to start the longest war for a thousand years – a companion piece to the Trojan business; and a quarter of my army bursts out laughing. I've always seen this coming; I was born too late. Chivalry's petered out in smoke. But if you had a daughter, Mrs Lombrick, if Miss Nicolette was your daughter, wouldn't you drown in your own bloodstream to get her out of trouble?

LOMBRICK: That little Miss Nicolette? I'll make over my things to my niece and die for her any time, give me a kick or give me a prize.

MILLOW: So you should; and so you may have to. Miss Nicolette *is* in trouble.

LOMBRICK: I might have known; I saw it in her 'and as clear as day; a dark man and a pretty kettle of fish.

TALMOUSE: That's him, Mr Millow. A dark man, she said, and that's Lord Aucassin or nobody. You're a wonderful woman, Mrs Lombrick.

LOMBRICK: Oh dear oh, never. Lord Aucassin, is it? That's climb high, fall further. That's taking a sieve to get the milk in and no mistake. Dear oh lor.

MILLOW: The Count's going to put her into prison, Mrs Lombrick – if an honest man doesn't rise up and stop him. Well, I have risen up. And so have you and Mr Talmouse.

LOMBRICK: Two hours early.

MILLOW: We're at war, Mrs Lombrick.

LOMBRICK: Lord save us. Whatever 'ave you got riding round in your onion, Mr Millow?

MILLOW: Call me Colonel, Mrs Lombrick, and I shall call you Lieutenant, just for the present. Early this morning – will you stop giggling, woman?

LOMBRICK: I was jest thinking of a lieutenant what I knew once.

MILLOW: Early this morning General Boulgars will send soldiers to Miss Nicolette's room and arrest her.

LOMBRICK: What, not her own father won't, Mr Millow?

MILLOW: Her own father, Mrs Lombrick.

LOMBRICK: Oh go on, call me Lieutenant; I like it. Her own father! Whatever is everybody coming to?

MILLOW: To nothing. They'll come to nothing. Millow has risen up. They'll go to her room but she won't be there; she'll be here.

LOMBRICK: Here, Mr Millow?

MILLOW: Call me Colonel, will you, there's a good soul (*More giggling from MRS LOMBRICK.*) – and don't start that again.

LOMBRICK: You mentioning a Colonel jest reminded me of somethink.

MILLOW: I've sent Mrs Grasset to bring her down. And when she's in here and they're outside the door, it'll be war, Mrs Lombrick.

TALMOUSE: You're a wonderful man, Mr Millow, a wonderful man. You ought to be doing big things.

MILLOW: Before you go to sleep tonight, Captain, we shall all have done big things. Where's Japhet?

TALMOUSE: I woke him up and said you wanted him, Colonel. But he's gone to sleep again I shouldn't wonder.

MILLOW: Gone to sleep? Is that camp-discipline? Fetch him up Captain double-quick.

TALMOUSE: Yes, Colonel; camp-discipline, I'll tell him. (*Exit.*)

LOMBRICK: Whatever and Jerusalem 'appens if the Count comes of himself to get 'er?

MILLOW: We keep him out, Mrs Lombrick; we keep him out.

LOMBRICK: Take me for a sinner, he won't 'alf be in a fine do. We won't be so ticklish neither. We'll be eating greenstuff with Nebuchadnessar before we're a day older, you see if I'm a liar.

MILLOW: They ought to be back, they ought to be back. The sun's up and the General will be about. Stand to, stand to. Where can they have got to? Look at my hand, Mrs Lombrick, there's a dear woman, and tell me if you see a victory.

LOMBRICK: My God if this isn't the day of all days. Come over into the light.

MILLOW: Speak the truth, woman. What's there?

LOMBRICK: Well now, look at that; that just shows you. Two children, Mr Millow, at your time of life.

MILLOW: The victory; do you see that, Mrs Lombrick?

LOMBRICK: I always knew what you men are. While you've the strength jest to crawl a leg over a piece of straw you'll keep on to the last.

MILLOW: The war, Mrs Lombrick! How will the war go?

LOMBRICK: You was born under the occultation of Mars, Mr Millow. When you first yelled out Mars was behind the moon. There's no war here, not what I can see. You was born under Venus, you wicked old scoundrel, say what you like.

MILLOW: What, no slaughter?

LOMBRICK: Nothink but 'omely carving, Mr Millow – that's what your hand says – jest 'omely carving.

MILLOW: Who's there?

(*Enter NICOLETTE, with MRS GRASSET.*)

GRASSET: They're after us, Mr Millow; saw us just as we turned to come down here. They'll be knocking at the door in two shakes.

MILLOW: A surprise attack and no barricading! No barricading! No barricading! Where's the army? Where's Talmouse?

NICOLETTE: What is it, Millow?

MILLOW: Not a minute to lose – fast working –

LOMBRICK: Now he's got a flitter up his tail.

(*Enter TALMOUSE and JAPHET, a small boy in his nightshirt.*)

TALMOUSE: Here he is, Colonel. Did you ever know a boy to sleep so heavy?

MILLOW: They're here, they're at the door. They've surprised us, Captain. Get the table to it, chairs to it! Lieutenant, they're on us; get a hand to the table. A barricade – run, run, run – a barricade.

LOMBRICK: Well, 'ere's fivepence to do for a bob if ever there was.

(*TALMOUSE, MRS LOMBRICK, MRS GRASSET and MILLOW barricade the door.*)

NICOLETTE: (*As MILLOW flies to and fro.*) What's the matter, Millow?… Millow, what are you doing?… Mrs Grasset! You didn't warn me of all this fun… Why did you want me here so early in the morning? Millow! What am I here for? What's the barricade for? Heaven's, it's like being backstage between the scenes of a play. Wherever you are you're in the way of the stagehands. – Do you know what all this is about, Japhet?

JAPHET: I'm blowed if I do, Miss. Twice they come and woke me, Miss, and didn't give me no time to put me clothes on. Mr Talmouse he kept saying 'It's a war, me lad, a war, me lad', 'e kept saying.

MILLOW: Captain, see that they all have weapons; a weapon in every hand. We'll be ready for them yet.

TALMOUSE: Japhet, Japhet, get something in your hand. You've got to be a soldier. It's a war, me lad; Mr Millow said so.

JAPHET: Well, who are we fighting? That's what I want to know.

TALMOUSE: Never mind who we're fighting. 'It everybody over the 'ead who comes near the window. It's a war, me boy.

NICOLETTE: Am I in this too, with a weapon in my hand? If so, what is it?

TALMOUSE: No, you don't have a weapon. It's you we're fighting for, I take it. That's so, isn't it, Colonel? She don't have a weapon?

MILLOW: What d'you say? No time for talking, Captain. Action, that's the ticket. What the devil are you doing, Mrs Grasset?

GRASSET: Talking the bones out of me bodice, Mr Millow. You needn't worry; I shan't spill over.

NICOLETTE: Millow, stand still just for a moment. You must tell me what all this is about. Am I the cause of it?

MILLOW: Why that's so, that's so – in a sense, in a sense. What's happened is – Ssht! I can hear steps. Here they are! I wish my mother could see me now. Ready for action, my darlings. We'll make them sweat before the sun's two feet up. Ah! (*A knocking at the door.*) Come in, come in.

CAPTAIN: (*Outside.*) The door is locked.

MILLOW: There's been a landslide.

CAPTAIN: Open the door.

MILLOW: Come in, come in.

CAPTAIN: In the Count's name!

MILLOW: Come in, come in. Blow through the keyhole, man; it's been the burial ground of moths for the past century. Blow the last trump over them and walk in.

CAPTAIN: Damn your impertinence. You'll be sorry for this. Is the Lady Nicolette inside there?

MILLOW: Within an arm's length, Captain. Put out your hand and you'll have her.

NICOLETTE: Why, Millow, if it's me they want let me go out to them –

MILLOW: Pipe down. Don't get me vexed when I'm sitting in sunshine. They want to put you in prison. – Don't stand on ceremony, Captain; come inside.

NICOLETTE: To put me in prison, Millow? –

MILLOW: They're talking together; something's coming to us. – Get up at the window, Captain – and be ready; you and Japhet together. Get water, Lieutenant, buckets of it. What a war! No tuckets but plenty of buckets!

NICOLETTE: Millow, if you're doing this for me, it must stop now.

TALMOUSE: Did you hear that, Mrs Grasset? What a fellow he is – no tuckets but plenty of buckets!

NICOLETTE: If they want to imprison me, that's between me and them. Why, I think it's a mistake that an hour will put right; but not if this goes on. Millow, for both our sakes –

MILLOW: No mistake; no drawing back. Don't vex me.

CAPTAIN: For the last time, you in there, are you going to send her out to us?

NICOLETTE: Yes – I'm coming –

MILLOW: No, sir; no, sir; not this side of Christmas.

NICOLETTE: Millow, think for a moment –

MILLOW: Ssht! Keep her away from me.

CAPTAIN: All right, old fellow; then it's your own look-out what you're in for. You'll have to take what comes. Understand, old man, you're in trouble.

MILLOW: Thank God, thank God. I've been praying for it for fifty years, and now it's all come in a lump.

NICOLETTE: Please, Millow, please let me go out to them. They can't do anything to me – what could I have done that makes a criminal of me? So let me go. This makes me guilty where I was innocent before. Millow, have sense.

JAPHET: They're coming round, Mr Millow, they're coming round! What shall I do?

MILLOW: Souse the mackerel!

GRASSET: Oh here, they're pushing the door down!

MILLOW: Bars and bolts, that's safe. Pail and bucket reserves, bring 'em here. Let them come to the water, we'll make 'em drink. Lieutenant, second line work's most heavy so keep your skirt tucked up. Take it, Talmouse.

TALMOUSE: It's a war, me lad, a war, me lad!

JAPHET: Golly, get a second bucket ready. Look out!

(*He empties the pail over the enemy and roars with laughter.*)

MILLOW: Come on now, keep them served. Woman, what d'you think you're doing?

LOMBRICK: Tucking my skirt up.

MILLOW: Bah! what good's a woman in a war? Give me men like Rinaldo of the White Thorn and Walter of the Olive Trees who died in the bloody fight at Ronceval.

GRASSET: Oh my dear, 'ave we got to talk like soldiers as well?

NICOLETTE: Millow, you fool of a man, tell them to stop. – This is a windy corner in Bedlam.

LOMBRICK: (*To TALMOUSE.*) Here, look where you're throwing. The enemy's in front of you; it's me behind.

TALMOUSE: I can see 'em, woman, but you've got to take and chuck – that's it – take and *chuck* –

(*His bucket goes out of the window.*)

MILLOW: Here, mind your weapons, mind your weapons!

TALMOUSE: Fortune o' war, Colonel, fortune o' war. Chuck me a poker – I'll be Samson the Israelite and poke the Philistine fire out.

GRASSET: He's a good Christian, you can tell that.

JAPHET: They've drawn off. They're talking together.

NICOLETTE: Let me go to the window and talk to them, Millow. There may still be time to put this right.

MILLOW: Keep her away from me. She'll be my downfall. If you go to that window I'll have put you safe in the cellars. I'll keep you safe, I'll keep you safe.

NICOLETTE: Nothing but a miracle can do that now, Millow.

MILLOW: That's me. I'm a miracle of a man, I tell you, but they didn't know till now.

LOMBRICK: There's no more water if somebody don't go out to the well, and if somebody goes out to the well we'll all die of thirst before you can turn round.

MILLOW: The brooms and the fire-irons; bring 'em up, Lieutenant. Mrs Grasset, Mrs Grasset.

GRASSET: What's the trouble with you, Mr Millow?

MILLOW: She said a miracle and that's what I am. But am I doing it right? And when it's done, what happens when it's done?

GRASSET: Deary, deary, you're no Colonel if you worry about that. The world takes itself along and us with it, willy nilly, Mr Millow.

TALMOUSE: Come here, Colonel. They're moving amongst themselves. There's a new attack coming on us.

MILLOW: Lieutenant! Where's the armaments? Where's that woman, Mrs Grasset?

GRASSET: I'll fetch her out.

JAPHET: Here they come, here they come!

LOMBRICK: Here, Mr Millow! Pinch yourself black and it's large as life. I've found me relic! St Simeon's toe-nail swept up in the dust-pan. I'd have never have forgiven meself if it'd been gone for good. Mother had it from Nell Brownshears and Nell she had it –

MILLOW: The brooms and the fire-irons, the weapons of war, you old whosit!

GRASSET: Here's your artillery.

TALMOUSE: Help, Colonel, help, help!

MILLOW: Here I come. Colonel Millow. Here I come. We'll sing a song to them and beat time to it.

JAPHET: Ow! Ow! He's cracked my knuckles!

GRASSET: Come here then, Japhey; you wounded soldier; I'll look at it.

MILLOW: (*Singing.*) 'King Charles he had a hundred knights –'

TALMOUSE: 'A hundred proud and lusty wights –'

MILLOW: 'That would not for a pagan fly –'

TALMOUSE: 'Though he was twenty cubits high –'

MILLOW / TALMOUSE: 'With a whackdee-crackdee-smackdee-hackdee-Foldee-oliday-ido!'

LOMBRICK / GRASSET: 'With a whackdee-crackdee-smackdee –'

(*The SOLDIERS have lately appeared at the windows cursing loudly. They now force MILLOW and TALMOUSE to drop their weapons.*)

LOMBRICK: (*Simultaneously.*) God help us, they're getting in!

JAPHET: (*Simultaneously.*) Let me get up to them.

GRASSET: (*Simultaneously.*) Stay where you are, Japhey, stay where you are!

TALMOUSE: (*Simultaneously.*) You Philistines you, you Philistines!

MILLOW: (*Simultaneously.*) Ah! Ah! Ah!

(*The SOLDIERS climb into the room.*)

1ST SOLDIER: Good morning, all.

2ND SOLDIER: Glad to see you, folks.

1ST SOLDIER: If you don't mind, you'll all stand over against that there wall where I can see you. No more hanky panky from nobody.

2ND SOLDIER: (*Unbarricading and unlocking the door.*) The lot of old riffraff. You'll cop it proper. You don't mess up good uniforms for nothing.

1ST SOLDIER: Not likely, you don't. You'd better give your 'eads a good scratch, mates; you won't 'ave 'em to scratch much longer.

(*Enter the CAPTAIN.*)

CAPTAIN: Unconditional surrender, I take it? Who's
 commanding these dogs of war?

MILLOW: Me, Captain, me.

CAPTAIN: You, is it? What's the matter with your brains?
 It's a fine mess you've got these people into,
 You old nuisance.

MILLOW: You can say old nuisance now,
 You can say it. I hadn't the forces, dear me no,
 I ought to have seen I hadn't the forces. Still,
 Even so, look at your own battalion;
 They're in a fine mess too. We handled them.

CAPTAIN: Resistance of law and order and obstructing
 The militia in carrying out their duties.
 You've let yourself in for something, you old ass.

NICOLETTE: Here I am, who seem to be the cause
 Of all this storm, like a toy Helen
 In a Halloween charade, without a word
 Of why. Why, Millow? And what, Captain?
 Who would imprison me? And what's my fault?
 Let's have some dialogue, man. I can hear
 Nothing but wooden swords.

CAPTAIN: I only know
 My orders, I'm afraid. And I was sent
 To arrest you.

MILLOW: I know why: ho, I know why!
 I'll write it down.

 (*He goes to a corner for paper and ink.*)

LOMBRICK: Here's a muck in a million. Sobbing cherubs,
 What's going to happen?

CAPTAIN: You'll know soon enough.
 You're all in a nice jam, I can tell you.

LOMBRICK: Sobbing
 Cherubs!

GRASSET: She's a lovely lady. I'd do more
 To 'elp her out of trouble.

TALMOUSE: Mr Millow
Mr Millow here's a wonderful man, *I tell you*.
If he's copping it I'm copping it. Yes,
Oh yes, I'm copping it.

NICOLETTE: Here are friendly people, Captain,
Who did what they could to help me. What shall I do
If they get punished for it?

CAPTAIN: Leave them to me.

MILLOW: (*Bringing his paper to NICOLETTE.*)
There's the answer for you.

NICOLETTE: (*When she has read.*) Yes; I see.
(*She crumples the paper. Enter the COUNT.*)

COUNT: Captain. There's a rather laughable story
That has come leaping down the corridors
Until it reached me. Now I think it goes
Like a kangaroo all round the streets. A story
Not very creditable to my army.
Who's the ringleader of this fantastic business?
Come on, who is it?

MILLOW: Me, you Lordship, me.

COUNT: Arrest him.

NICOLETTE: Must you do that because he tried
To help me?

COUNT: Take the girl.

TALMOUSE: And me, my Lord,
And me. I'm an old devil too.

SOLDIER: Get back.

NICOLETTE: My Lord, may I speak?

COUNT: For him?

NICOLETTE: For me.

COUNT: Go on.

NICOLETTE: If I'm a cloud that has come over you, like
gun-smoke,
Hiding your son, seeming even to darken
Beaucaire, as I think I seem to you, I know

You can do nothing more nor less than this.
You believe, and I think I believe it
With all my heart, if I should draw the blind
Down on my love for him, to give no word
Or look or a bare sigh even – in this city
So inwound with war we should still pass
Near in the street and remember; or at least
See something of ourselves in the other's window
Like Narcissus' shadow in the stream.
And the black breath of old wars and old fires
Would still float through the city and your brain.
I can see that's so, and I'll go quietly.
If you could think this unpracticable
But not mischief
Nor the sudden plunging of your trustworthy star
Nor dishonour, nor the self-will of a son,
But something clear and profitable that's matched
Against a greater profit, my heart would go
Quietly with me.
This thing is my acquaintance but your stranger.
I had no hand in making it, nor he
In making it; no fraction. It's as though
It is a thing that fledged upon the air
And dropped to us at random.
Yet I can count each lure that brought it down,
Each word of memory, each gesture's custom,
The bright memorials in him. It is this
That's on us and won't be whistled off,
Not mischief. But I know Beaucaire's content
And mine are unrelated, and I'll go
Wherever you will put me.
 Well! that's all, my Lord.
COUNT: You're a thoughtful girl. You understand me.
 I'll not waste words. We understand each other.
 The Captain will conduct you. Thank you, Captain.
 (*The CAPTAIN with NICOLETTE, the SOLDIERS with
 MILLOW, move towards the door. Enter AUCASSIN.*)

241

AUCASSIN: (*To NICOLETTE.*) Where are you going?

NICOLETTE: How did the fighting go?

AUCASSIN: Where are you going?

NICOLETTE: To a new lodging.

AUCASSIN: I think it's a prison. So the story goes.
Is it a prison?

NICOLETTE: I haven't heard the story.

AUCASSIN: I know it well. There was a man who had
The devil for his father –

NICOLETTE: Old wives' tales,
My Lord. They're told to children.

COUNT: Aucassin,
Get some rest.

AUCASSIN: Is that my father?

COUNT: What
Has happened? Has the fighting stung your eyes?

AUCASSIN: If you're my father you'll no doubt remember
Who's to be my wife.

COUNT: Now careful, son.

AUCASSIN: Or has the fighting stung your memory?

COUNT: Get to your room.

AUCASSIN: It has. It's lucky for you
I came back when I did. Forgetfulness
Might have tripped you up if I'd not come
To jog you. You remember, now I'm here,
So no harm's done.

COUNT: Take the prisoners on,
Captain.

AUCASSIN: (*Drawing his sword.*)
 So it must be a pricking conscience
After all to keep you straight. Don't travel, Captain;
Here's a six-foot drop.

NICOLETTE: No, Aucassin –
This is no good.

AUCASSIN: No other instrument
 Will play the tune my father understands,
 And I must be a David and whisk out
 The imp that's in him. Isn't that so, father?

COUNT: Put your sword up.

AUCASSIN: Send these men away.

COUNT: Look here, my boy, you're acting like a clown
 Who fights with a fierce nothing and gets floored
 By his own punches. I'm not out to hurt you
 But to help you – to give you time to think
 And look around so that you don't go jumping
 Out of your sweat into the nearest pool
 Without considering if it's going to drown you.
 If in a year, now, you should still decide –

AUCASSIN: Have you noticed, father, how things grow?
 How little stubborn berries apple up,
 And saplings go a progress into trees,
 And berry-boys, whom you can keep in feather
 By a vague promise for another day
 And teach good manners to their bare behinds,
 At last will grow to men? I know they will;
 I've been that slipshod way. But you still think
 I've cut my knee and howl at cowslip-time.
 Just rid your head of that and be a man
 Who knows his son's another.

COUNT: Very well.
 As a man who's hammered a city to a crown
 I'll see that no man melts that city down.
 I'll make that certain. In another year
 We'll talk again.

AUCASSIN: Right now is talking-time.
 You made a bargain with me, and then waited
 Till I was butchering across midnight in the north
 As I'd said I would, before you tried
 To make your best way out of it. But that
 Bargain holds. Too many men last night

Were sealed upon it to have it easily broken.
So scrap this business quickly.

COUNT: What are you men? Are you representative
Of my army and have to fume and tussle and storm
To get a girl out o' the kitchens? Are you frightened
Of one boy with a sword? What chance for Beaucaire
Against the enemy? Disarm the boy
And take the girl away.

AUCASSIN: Stand where you are.
You prince of double-crossers; you king-cheat!
For ten hours for the sake of this squint-eyed
Bargain, I've killed men I never knew
And heard how they screamed into dust. I'm their
Prosecuting counsel now as well
As mine. A ward of expecting skeletons
Are after the man who made them quick with rotting.
And I know him. He begot me too
But that time in a holiday-mood.
 You see?
A broken bargain doesn't clear away
With medicine like wind. Ratify now
And quickly.

NICOLETTE: Aucassin –

AUCASSIN: I'm waiting, father.

COUNT: For a day and a night you've gone without your sleep.
She shall go free. When you're yourself again
We'll meet and talk this over.

AUCASSIN: Do you think so?
If when I'm fighting for you you'll play tricks
What games when I'm asleep? We'll go to church
And set this right at matins.

COUNT: Take her away.

AUCASSIN: You devil!

(*He goes to strike his father and is disarmed.*)

COUNT: Take my son to the northern tower
With the other fellow. I shall come to him there.

AUCASSIN: So we come home again. So we come home
 Like a ferret from the burrow to go back
 Into the pocket. Goodbye, Nicolette.

NICOLETTE: Be good and laugh at this and get some sleep.

AUCASSIN: Do you curse the day you met me?

NICOLETTE: I shall put it
 Where it will multiply – on my left side, sir.

CAPTAIN: March.

(They go. The COUNT is left alone. He picks up Aucassin's sword which has fallen to the floor and runs his hand under the blade.)

(Curtain.)

Scene Two

(AUCASSIN's cell in the Northern Tower. AUCASSIN is standing on a stool with his arm through the bars of the window, trying to grasp something on the outside. A grinding of key in lock and enter MR NICHOLAS PERK with a jug of water and some books.)

AUCASSIN: Lend me your knife a moment, Jailer.

PERK: A knife? I'm afraid that would be contrary to the regulations. I'd like to help you, very much, but we must keep within the rules you know, and I understand that weapons mustn't be given to prisoners.

AUCASSIN: Who's that?

PERK: The Governor of the prison, sir.

AUCASSIN: Nonsense! – It's Mr Perk! I thought there weren't two with that voice. What in heaven's name are you doing in this place, sir?

PERK: Er… I retired from schoolmastering, my boy. Your father made me Governor of the prison. The old Governor you know was called up. Yes, it's quite a change after all these years, but I'm growing accustomed to it.

AUCASSIN: Mr Perk in charge of convicts! How does it feel, sir?

PERK: Much the same, much the same. I rather fancy they call me Old Nick just as you boys used to. I must say it's a little as though I was looking after the Lower Regions.

AUCASSIN: It must shake you up a bit to find an old pupil in them.

PERK: As a matter of fact, my boy, it's the greatest surprise to me that I didn't meet you all here. I could never see where else you'd end; no, not at all.

AUCASSIN: Look, sir, I wanted a knife to cut a branch of this apple-blossom. It'll bring Persephone down to your underworld.

PERK: Oh yes; well, what a pity the regulations forbid it. You'll have to try and wrench it off with your hands, I'm afraid.

AUCASSIN: That's not so easy through these bars.

PERK: Make the effort, my boy; yes, certainly. I remember you. 'Should think more kindly of obstacles' – that was you, I think I'm right in saying.

AUCASSIN: It was, sir. And 'Could do better'. That was me too.

PERK: You and the rest; and the rest. I've brought you some books to read to keep you quiet. The Bible; that's regulation reading. Virgil… You remember how we laboured at him together?

AUCASSIN: This is a good branchful if I could only get it off.

PERK: '*a Corydon, Corydon, quae te dementia cepit!*
semiputata tibi frondosa vitis in ulmo.
quin tu aliquid saltem potius, quorum indiget usus,
viminibus mollique paras detexere iunco?'

AUCASSIN: It's coming.

PERK: 'Oh Corydon, Corydon, what delirium
Possesses you? There on the leafy elm
Your vine's half pruned. Why not instead
Weave baskets for us with the reeds and withies?'

AUCASSIN: There! Half the blossoms are knocked off by the drinking water.

PERK: I daresay it would look very well standing in your
 drinking water.

AUCASSIN: Good. – Because it's a lie to say that I can find
 another Alexis; that's your answer, Thestylis. But thank you
 for your herbs, your garlic and wild thyme. How's that for a
 memory for the second eclogue?

PERK: My dear boy, I was only reading over a favourite passage.
 No doubt you'll remember in the class-room –

AUCASSIN: Thestylis bruises fragrant herbs together,
 Wild thyme and garlic for the weary reapers
 Imprisoned by the heat… You see I know it.
 We've got our sexes mixed. For Thestylis
 Read Alexis, for Alexis Thestylis
 The slave-girl. I see you know the way
 I came here.

PERK: Well, certain things I've heard,
 You know; I've heard a little of the trouble.
 We can have some good talks together, if you'd care to.
 Things will mend; yes, certainly.

AUCASSIN: Grass will grow over
 The filled-in trench. Grass will soon grow over.
 Or use beeswax for a mellow surface.
 Saffron for bruises. Poppy-tea for sleep.
 It's mending, mending, mending! – But I tell you
 All the stars have congealed into a sun
 That burns me up. This shadow that we stand in
 Is red-hot. I can't lie down in it
 Or pray and blow the candle out and sleep.
 My father dances in my head like air
 On the blazing stone. Grass will not grow over
 Where the sky's pitiless,
 Where old bones are unforgiving and young bones
 Are in the ditch. Grass won't soon grow over
 Where a heart's in flood. I tell you so, I tell you,
 I tell you…

PERK: Here, what's this, my boy? Now tears
 Won't do; tears won't do. Can you remember
 The last time that I found you like this? Dear me,
 Ten years ago or more; time does go by.
 A sum wouldn't add up.
 Well, here's a business!
 It added up, I fancy, in the end.
 We got it added up; yes, certainly.
AUCASSIN: My father
 Dances in my head.
PERK: I'm very fond
 Of paper-games. But all these wretched fellows
 In the cells don't quite catch on. They're very slow,
 They try my patience frequently. They're ninnies.
 If you felt so inclined now –
AUCASSIN: For how long
 Does he intend to keep me here? And how long
 Will he buckle Nicolette in heavy walls?
 I cast each rivet of that weight of armour
 And shaped her prison with a hammer of words.
 But my father put it on her. And I'm caught,
 Run into calms when all my sails are out
 To come to her. There's nothing to be done.
 If you could show me one way I could turn,
 One way, or any words that I could speak,
 Or how the east will ever fill again –
 If you could show me one way I could turn –
PERK: There isn't one. At least, not just at present;
 No, not at all. We must make the best we can
 Out of a bad business – goodness me,
 You mustn't give me the conundrums
 Or I shall be resigning. With some patience
 We'll come on top; yes, certainly. Shall I suggest
 To that old fellow Millow we might play
 A paper-game? At present he is aiming
 His boots at a pewter water-jug.

AUCASSIN: I'll play, sir.

PERK: That's good. I shall enjoy that very much.
 Good fellow. – Jailer!

JAILER: (*Offstage.*) Ugh?

PERK: Bring Mr Millow,
 Number Seven, up here. And Jailer – Jailer!
 Would you be good enough to bring some paper –
 Four pens and a bottle of ink when you come up?
 I think he heard me.

AUCASSIN: There's nowhere to go
 To lose a loss. Fields seemed unbridled once.
 They went hurdling and hedging to the sea.
 But if I escaped to them now, I shouldn't be out.
 The world has walls as thick as these walls are.
 Or else my head's my prison. Nicolette!
 What's all the endless tirade of creation,
 What's the sea's five-thousand fathoms,
 What's space that towers into incomprehension,
 That they should drain away as soon as water
 Scooped in my hand, at my five-feet of loss?
 I can't go on. She was proportioned to me.
 And I can't match with any other thing
 Or walk, or feel, alone. I can't go on.

PERK: You can; you'll find a way.

 (*Enter JAILER with MILLOW.*)

JAILER: Pens, ink, paper, and Number Seven.

PERK: Thank you, Jailer.

MILLOW: What's the trouble, Governor? Is it a Court Martial?

PERK: No, no, no. Quite unofficial, Number Seven. We thought
 perhaps you'd care to join us in a four-handed paper-game.

MILLOW: A paper-game, sir? I'd like to remind you that I'm
 a political prisoner of a dangerous type, Mr Governor. You
 should have me in chains. I won't be treated like this!

PERK: *Esprit de corps*, now, Number Seven. We all have to give up
 something for the good of the whole. Let's all pull up round
 the table. Jailer, we shall need you in this.

JAILER: Ugh.

MILLOW: If I thought I was going to be imprisoned in a
kindergarten I'd have died like a Roman on my own sword.

PERK: Sit down, sit down. Now you each have a piece of paper
and a pen. You can write, can't you, Jailer?

JAILER: Ugh.

PERK: Very well. Now we each write down the first line of a
piece of poetry – something we've made up ourselves – but
the last word of that line we write a little below the rest.
Then we fold the paper over, just leaving the last word visible,
and hand it to our neighbour, who writes a second line to
rhyme with it. Then he folds *that* over, leaving the last word
visible and hands it on again. When it comes back to the
writer of the first line he unfolds the paper and reads it. Have
we got that quite clear?

MILLOW: Poetry? Now that's talking, Mr Governor. I've been a
poet in my time.

PERK: May I make a suggestion, Jailer? – if you held the pen the
other way round. That's it. Shall we start?

(*They set to work. A whistle from outside the window. They're all
too intent to hear it. The whistle comes again, and JAPHET comes
into view on the branch of the apple tree.*)

MILLOW: How do you spell mobilisation?

PERK: M-o-b-i-l-i-s-a-t-i-o-n.

MILLOW: M-o-b-o… I'll put something else.

(*Pause.*)

AUCASSIN: Right.

MILLOW: There.

PERK: Come along, Jailer. We're all ready.

(*Pause. JAPHET gives another whistle.*)

Here we have the first one complete. Let me see. (*Reads.*)

'The moon above Enymion paused and leant

Like a stout war-horse who for the fray pants.

And down into the valley slowly went –'

Er… 'Her old gent.' – I think that's what's written here. This is yours, I fancy, Jailer. What is it?

JAILER: That's writing.

PERK: Yes, but what does it mean?

JAILER: It's me name. 'Arold Gent. That's 'ow they told me you wrote it. 'Arold Gent.

(*JAPHET gives a piercing whistle and draws their attention to the window.*)

PERK: What in the world is this going on? Now then: good gracious me: what are you doing up there, boy?

JAPHET: Please, Mister, can I speak to Mr Millow, Mister?

PERK: I should certainly think not. You've no business up there at all in the first place, I should say. And in the second, it's not possible for me to give you permission to speak to prisoners. It's not in my province.

JAPHET: I've got to speak to 'im, Mister. It's death and destruction.

PERK: Then you must approach him through the proper channels, my boy, not up a tree. I rather fancy there's a form you should fill in. If you'll give me your name and address I'll look it up and send it to you.

JAPHET: I've got to speak to 'im, straight I have. It's the enemy, Mister.

PERK: Come, come, what about the enemy?

JAPHET: I've got to tell him about Miss Nicolette, Mister.

AUCASSIN: What's that?

PERK: (*To AUCASSIN.*) That's all right, my boy. I'm dealing with this, thank you.

AUCASSIN: (*To JAPHET.*) Listen – who sent you? What trouble is there? Where's Miss Nicolette?

PERK: Get back to your place, sir!

AUCASSIN: No, sir. My place is right against the news. (*To JAPHET.*) Come on, what is it?

JAPHET: They said I'd got to tell Mr Millow.

AUCASSIN: Millow, come here.

MILLOW: Yes, sir. Here I come.

PERK: Sit down, both of you. Do you hear me?

AUCASSIN: Now then. Tell Mr Millow what you've come for.

PERK: I shall have to report this, I'm afraid. I don't want to be
 unkind but this vexes me very much.

JAPHET: It was the enemy, Mr Millow. They've broke through
 the defence at the tower where the lady was.

AUCASSIN: Was?

MILLOW: What's happened? What's happened?

JAPHET: They said, Tell 'im they've broke through and Miss
 Nicolette's been taken prison, tell 'im.

AUCASSIN: I must get out. You understand that, sir?
 I must get out of here. Your regulations
 Must go into the paper-basket. Minutes
 Can do a century's mischief if we stand
 And scratch our heads. Come with me, Millow;
 There's work for you.

MILLOW: For me? Did you hear that Japhet?
 Tell them Mr Millow has the matter in hand.
 Mr Millow will see to it. We'll think up some strategy.

JAPHET: (*Going.*) Yes, Mr Millow.

AUCASSIN: Come on.

PERK: Now wait, my boy.
 We can't do everything at once. We'd better
 Sit down and see how matters can be worked…
 Dear oh dear; I'm sorry about this. – Jailer!

 (*The JAILER stands in front of the door with his knife out to
 forestall AUCASSIN.*)

AUCASSIN: So that's the attitude you're going to take?
 What in God's name's the use of this? Think, man,
 Think. The south tower's fallen. And how far
 Is south from north? Scarcely farther
 Than life from death, and that's only a step.
 What's the point of keeping us here? It's war
 And what chance have we now if I'm in here

Like a baby in a pen? I've got to fight
And quickly. If you can't see another reason
Your own safety balances on this.
Be sane.

PERK: I understood your attitude
Was rather that this war didn't concern you
To any degree. So I was led to believe.

AUCASSIN: Not concern me, sir? Why, you'll tell me then
I'm not concerned with my own breathing.
This war's part of my body's argument
Like breath and blood since that boy's story.
You heard him. Nicolette's a prisoner.
Have you got ears true and ready enough
To hear the bass under that easy phrase?
You should; it cracks my eardrums. Nicolette's
A prisoner; a prisoner, did you hear?
A prisoner, a prisoner, a prisoner!
Let that poison worm in or rush you, as long
As you rock with some understanding in the end.
Nicolette's a prisoner!

PERK: Listen, boy.
I'm in a position of trust. My goodness me!
What would you think of me if I betrayed it?
I'll send a note to your father right away
And see what that does. That's the best way out.

(*AUCASSIN hurls himself at the JAILER who throws him off.*)

MILLOW: Look out – his knife, my Lord!

PERK: You silly young ass!
That's no good, my boy; no earthly good.
If you get damaged, which you most certainly will
If you do that again, you'll find yourself
In hospital, and under a double lock –
Your damage and the door-bolt. A bad business.

AUCASSIN: I see… I see…
The shutters are up, Millow. We can't buy.

MILLOW: Lie low, lie low.

AUCASSIN: (*Quietly to MILLOW.*) I knew better manners
 At school. They worked.

PERK: The old man's plotting, Jailer.
 Perhaps you'd better give him those chains he wanted.
 No, not now. We'll see if he gives us trouble.

AUCASSIN: Do you remember Clements Major, sir?

PERK: Yes, very well.

AUCASSIN: He got a wound last night.

PERK: Oh dear, I'm sorry.

AUCASSIN: (*Sitting at the table and toying with the ink-pot.*)
 We used to sit together
 In the front row and get you onto talking
 About the fish you caught down in the mill-pond
 And where you'd been for your holidays. The lesson
 Would get the go-by!

PERK: You were the worst offender
 I don't doubt. No chance these days of fishing –
 I could play a very pleasant world on that slender line
 In those days. Almost two years since I was down there.
 Last time was a cloudy Sunday, I remember,
 And puffs of light rain. There was a handsome trout
 In the pool under the bridge: a monstrous fellow
 With a breast of brick-dust,
 Curving and sliding in his element
 With no decision but a lively instinct
 For food and safety. Where I stood above him
 My shadow scared him, so I climbed a fence
 Into some dancing dervishes of nettles.

AUCASSIN: (*Putting his hand up.*) Sir!

PERK: What is it?

AUCASSIN: I've knocked the ink-pot over.
 Sorry, sir. May I go and wash my hands?

PERK: Yes all right. Don't be long.

AUCASSIN: Thank you, sir.

 (*He gets outside and runs.*)

JAILER: Here, he's gorn orf like a streak of greasy lightnin'.

PERK: Oh! Oh, well perhaps you'd better fetch him.
 We can't run any risks.

JAILER: I'll ketch the beauty.

 (*Exit JAILER.*)

PERK: For the moment I'd rather forgotten the circumstances,
 But I think he's a trustworthy boy.

MILLOW: I think he is.
 Dear Lord, I hope he is. Please God, I hope
 He won't forget me.

PERK: Are you a fisherman?

MILLOW: No, sir; no, sir. I'm an army man by nature.
 There, I've got my fingers in the ink.
 I'd better go and wash them.

PERK: No, I think not.
 One at a time. And anyway you can't;
 The Jailer's locked us in.

MILLOW: Dear Lord, dear Lord,
 I can't believe he would have gone without me.

PERK: Gone? I forbade him to go. He's washing his hands.
 I can hear the water running away.

MILLOW: Oh well,
 I hope you can. I'll walk about a bit.
 It keeps me from worrying.

PERK: The cardinal cure
 For that is playing your fish.

MILLOW: Take my advice
 And start in fishing now, Mr Governor.
 You've plenty of worry coming to you soon
 I shouldn't wonder.

PERK: There: they're coming now.
 They're on the stairs.

MILLOW: He hasn't forgotten me,
 The darling fellow!

PERK: We haven't read the rest

Of the rhymes. That ought to take his mind away
From his sad news, poor boy.

(*AUCASSIN unlocks the door and throws the JAILER into the room, bound with a rope. AUCASSIN has the JAILER's knife in his belt and a sword in his hand.*)

What's this, boy? Insubordination?

MILLOW: Ah!
We're off, we're off!

AUCASSIN: I'm sorry to trick you, sir;
Time's got me on the hip. We had to hurry.
This wasn't any negligence of yours;
No one shall ever think it; but a desperate
Story that ran you down. And if I can
I'll bring you new days with the trout.
Millow, the day's down on us – come on.

JAILER: He 'id and ketched me in the rear.

AUCASSIN: The door
Will be locked but send the rope down for the key.

MILLOW: A weapon, a weapon!

AUCASSIN: Take the knife. Goodbye, sir.

MILLOW: Drop your line down for the key-fish, sir;
It'll take your mind off worries, so they tell me.

(*Exit AUCASSIN and MILLOW.*)

PERK: Rather unsporting of that boy. But still
I might have done it once myself.

(*He begins to untie the rope.*)

 Well, Jailer,
Here's a pickle. Did you yell?

JAILER: I said
''Ere! Wot the –!'

PERK: And I thought it was the water
Running away… I hope that boy comes through
All right; I only hope that he's successful.
Really, these are the most confounded knots.

(*Curtain on Act Two.*)

ACT THREE

Scene One

(A farm in the hills, that evening. WILLIAM BIGHT, an old farmer, and his WIFE are getting the last of the sun.)

MRS BIGHT: *(Calling indoors.)* Take a look at the stew, Mary; we're
 afore'and.

GIRL'S VOICE: *(Off.)* Yes, ma'am.

BIGHT: They'll not be long, no, not them lads.
 If it were us now when we were daisy-hearts
 We'd harrow and graff until the dregs o'day,
 Bain't that so, mother? And try to finish un
 By a farthing of starlight. Fifty year ago
 We were spring-chickens proper, proper daisies.
 But them lads of ourn, what goes for they?
 Drop it and run when the chill comes on the sky
 Says they.
 When the sweat stops runnin' over your backside
 Day's done, says they. You're nowt but two-footed bed-sores
 Both on you, says I. God bless them for good boys.

MRS BIGHT: Supper at the appointed time, I say,
 So good meat doesn't go to spoil.

BIGHT: Yes, but if crops and cattle go to spoil
 Where's your good meat then? A healthy appetite's
 Wedded and bedded to a healthy conscience
 And a healthy conscience comes of zeal, mother.
 The earth knows purty right, I reckon. Look
 At her budding and flowering now and bearing fruit
 And the sun rising by the clock like a proper man.
 And them owdacious comets, now, careering
 Faster nor martins to the midgey water.
 In all my borns I ain't never been beazled wi' staring
 And staring. Stares whiles you can, I says;
 The zeal of the earth goos dupping along, I says,
 So stare whiles you can. And so I stares.

MRS BIGHT: I've been gooing to tell you, father-lad,
 I've been regretting our peter-grievous natures.
 We were a pair of chuckle-heads in thinking
 The Lord had spent us up, the day we lost
 The poor old farm. I reckon after all
 He'd got a deedy eye to the boys here in the hills.
 A workaday spring He saw they had
 Sowing barley in clay, paring their choosen hop-roots,
 Trenching and fencing. But the dears, He says,
 Where's my daffydilly? Where's the garden?
 So He shuts up our workdays like an old book, father,
 And ordains that you'll keep a watchful eye on them
 And I'll set flowers out for their summer, like.
 And so I 'ave done; a purty gay-ground for them
 To smell the winders; you know I love them things.
 Honey, lavender and penny-royal
 And sweet-johns and a load of butter-candles
 And featherfew and bay and Indian-eye
 And campion; and sweet-peas that seem to tug
 At their stalks to be after them talkative bees
 That tell 'em what the world is; and moth-mullein
 With its steeple of old sunshine. I've just set them
 For the lads, when the house was done; and they'll come
 growing
 When the world's done for some of us. That supper
 Won't be worth the eating by the time they want it.
BIGHT: That's Henry whistling Piecrust, so the sheep
 Be up. The trouble they had them hens, you'd think
 Them boys had never seed a farm, the flappetting
 And squawking getting them in. No hen never got
 Me throwing my hat at un.
 There goos the cows in now, churning up mist
 White as their milk. We'd best be getting in
 Mother; you'll catch a cold.
MRS BIGHT: Here's Thomas now.
 Henry's always behind, always the lapsy un.

BIGHT: Ah, he's a wily un; more lapsy
 Less to do, like. He knows a thing or two
 But he won't never be the farmer I were
 Not if he takes a race-horse to it.

 (*Enter THOMAS, their younger son.*)

MRS BIGHT: Thomas,
 Your supper's spoiling.

THOMAS: Henry's just coming.
 There be the leeks you wanted, mother.

BIGHT: Son,
 You should bring a branch in when you come,
 A do-a-little for your mother's fire.

THOMAS: I'd plumb forgotten that, father – shows you now
 How long it is since I were a nipper to 'ave
 Forgot to bring the wood home.

BIGHT: That's it surely,
 You need your old father here to recollect you
 The sense he taught you once't.

MRS BIGHT: Come on in
 And have your supper.

THOMAS: Just let me wash myself.

MRS BIGHT: Come in, father, and we'll dish it up
 Whiles he washes hisself.

BIGHT: Whistle your brother, Thomas.
 Tell him his mother's maundring for her meat.

 (*Exit BIGHT and MRS BIGHT.*)

THOMAS: (*Calling offstage while he goes to the pump to wash.*)
 Henry – They've got the supper waiting, man.
 Leave Molly Moo to say her prayers to herself.

 (*Singing as he washes:*)

 'Crowing day has gone to roost
 Spin a penny and spin a penny
 'Twill crow again as once it used
 And a holiday comes tomorrow.
 The foxy dark begins to prowl

 Spin a penny and spin a penny
 And onto the branches of the sky
 With a piece of silver in his eye
 Up flies the moony owl
 And a holiday comes tomorrow!'
(*Enter HENRY BIGHT.*)

HENRY: We must see to the fences in Little Egypt tomorrow.
 Tantrum and Belle went roaming.

THOMAS: Did they that?
 We'll have them lost in Piper's Wood like Bess were
 And squeezed dry by them pixies now. We'll see to it.

HENRY: Let's have the soap. This water comes out cold
 As winter.

THOMAS: What's old Cobbler barking for?

HENRY: Moon's rising maybe.

THOMAS: A man's crossing the field;
 Not a hand neither; nobody as we know.

HENRY: What's he want?

THOMAS: P'raps he'll say what he wants.

HENRY: He's a city gent. (*Calling:*) Maybe you'll shut that gate
 Thank 'ee.

THOMAS: What's he wanting with us, Henry?

HENRY: P'raps he'll tell us what he wants.
 (*Enter GASTON FLOIRE.*)

FLOIRE: Good evening;
 I'm sorry to intrude. My name is Floire,
 Gaston Floire.

THOMAS: Evening.

HENRY: What's he want?

FLOIRE: I want some help from you, Mr – Sorry,
 I'm afraid your name's escaped me.

THOMAS: Bight's the name, sir.

FLOIRE: Bight? –
 Any relation of the old man Bight
 Who had the mill down in the valley?

THOMAS: Sons, sir.
 He's living up here now, is him and mother.

FLOIRE: Gaston's luck! Then you already know
 Half my story. The truth of the matter's this:
 The enemy have gained a partial victory
 Over Beaucaire – that is, one tower's been captured –

THOMAS: There you are. We said maybe it were a war.

FLOIRE: Maybe it was a war? Well, of course it is.
 Didn't you know Beaucaire has been besieged
 For the past year? Now boys, you can't tell me
 You didn't *know* about this war.

HENRY: We thought it were.
 We saw 'twere trouble and so we marketed
 On t'other side of the hill.

FLOIRE: But darn it, boys,
 Your father's farm started the whole affair.
 It was his mill that drove the fatal wheel
 For hundreds of chaps who meant to die in bed;
 And now they go about the air like chaff,
 So much waste matter. Well, I never did.
 And you didn't know it!

THOMAS: Father's farm it were then
 That made the trouble? Did you hear that, Henry?
 That'll make him laugh. Why, sir, our farm up here
 Be many times as large as dad's old mill.
 If they started in about us, now, we should have
 The whole world topsy-turvy.

HENRY: Yes and all.
 Father will crow at that. What's the trouble then?

FLOIRE: I'll tell you the whole story later on.
 I want to strike a bargain with you chaps.
 It's on the level. Give me a job as farm hand
 For tonight, or perhaps for tonight and another day.
 I'll pay you for it.

THOMAS: We don't need a man, sir.

HENRY: No, we don't need un.

FLOIRE: Shall we say, five florins?

THOMAS: Henry, did you hear what the gentleman said?
 He wants to pay for sweating.

HENRY: That's not human.
 Don't have no truck with un.

FLOIRE: Now listen, boys;
 It's a long story but the main point's this:
 A lady was in prison in the tower
 When the enemy captured it. Instead of waiting
 To become their prisoner, she escaped. I know
 Because I was on the spot. Well, that's my job –
 I happen to be a minstrel, Gaston Floire,
 You may have heard of me. I saw her go.
 Here's a romance story, I said to myself;
 And being fed with war-news till I retched
 I nipped away and followed her. Now, boys,
 She's coming here. She's heading up this way,
 So don't let's argue. Just be dandy-boys
 And fit me with a rig-out. Don't you see,
 I've got to get her story! – Here's five florins.

THOMAS: What do you say to that, Henry?

HENRY: Well then,
 Can you hedge and ditch?

FLOIRE: No, but that's neither here
 Nor there; all that I want –

HENRY: Can you milk a cow?

FLOIRE: Look here, let's get it straight; that's not my line.
 I can't do anyting at all except
 Imitate a goat: *Ma-a-a.*

HENRY: That don't happen to be a goat at all.
 That be a sheep with liver-rot.

FLOIRE: She'll come
 Before you fix me up; time's getting on.
 (*Enter BIGHT and MRS BIGHT.*)

MRS BIGHT: Thomas now, your super's getting cold –
 Oh, I beg pardon, sir; – I didn't know

The gentleman was here.

THOMAS: This here be mother.

HENRY: He's brought us some laughable news, father then.
 The gurt boffle they're making at the city
 Be all come out of your old farm, he says.

FLOIRE: That's quite right, sir. A really slap-up war
 Came out of your eviction.

BIGHT: Well, that place
 Were allus packled with mischief, were that farm.
 We found the soil sprang troubles easy there,
 Eh, mother?

MRS BIGHT: We did that. But fancy now,
 The gentleman said they were fighting over it
 Like cockses, father.

BIGHT: Come along inside, sir;
 Evening's time for yarning now. You've got
 A tale or two, I daresay. Come on in.

THOMAS: Yes, sir; we'll find a coat for you as well.
 Come inside.

 (*Exeunt BIGHT, THOMAS and FLOIRE.*)

MRS BIGHT: He's left the gate wide, pest him.
 I'll go and shutten.

HENRY: He shutten once't; I tolden.
 I'll shutten, mother.

MRS BIGHT: Go and get your supper.
 It's waited for you both. I've had my bit,
 I couldn't wait no longer. Get on in.

 (*HENRY goes into the house, MRS BIGHT to shut gate. Enter
 NICOLETTE from another way. She goes to the door and hesitates;
 then she sees MRS BIGHT returning. Enter MRS BIGHT.*)

 Good evening. Can I help you?

NICOLETTE: May I rest here?

MRS BIGHT: You look jawled out, you do.
 Have you come many miles?

NICOLETTE: Up from Beaucaire.

MRS BIGHT: Why, missy – from Beaucaire! It's a rookery
 Of towers and chimneys so they say. I've heard
 The trouble, at night sometimes, like cartwheels grumbling
 Over Kingdom's Hill. I've said to father
 'It's not all honey and blesses in that city'.
 Nor bain't it, you poor lady. How did you come 'ere?

NICOLETTE: Through chinks, like a deserting mouse; and then
 Up the hillside, like a cuckoo
 When he rests on every gorsebush in his way
 To cry 'Oh dear'.

MRS BIGHT: You little traveller,
 Why, you're tired to death. Come in the house now
 And get some food and sleep; we've got 'em both.

NICOLETTE: If I shan't be in the way, I'd rather
 Sit here a little while. I've had a diet
 Of four walls for too long, and here there's not
 A fence between you and your neighbour's Plough
 Up in the sky there. Please, I'll sit and breathe.

MRS BIGHT: So you shall, so you shall sit and breathe.
 That there Plough was idle before history
 I reckon, and all them yellow cornheads set about
 Bain't ripe for cutting yet. Maybe that's why
 There be leisure in heaven as they tell us.

NICOLETTE: This is good. – The moon has come up searching
 For the drowned earth. It's dragged the mist and fished
 The landscape up, and only left reflections.
 No roots left! Tomorrow we must plant
 The world all over again.

MRS BIGHT: Where do you go
 Tomorrow, miss?

NICOLETTE: I must be off tonight.
 I'm on my way to the coast.

MRS BIGHT: You can't do that,
 Missy; you can't go walking on tonight.
 There be no good road there, only puckling woods
 And pits that have been left so long, the bushes

Hide 'em, and they say the fairises
Play Old Harry there at nights. Don't venture.
There's a bed here for you, and in the morning
One of my boys will see you on your way.
I wouldn't have you go for the world's sake;
I'd never rest again.

NICOLETTE: I think it's better
To get a little farther while I can carry
The moon in my hand for a hurricane-lamp. It isn't
Dark yet, and I can get a few miles over.
When the moon sets I can find some place to sleep in.
Don't be afraid; by practice I've developed
A way to reckon with strange country.

MRS BIGHT: Miss,
I'll never let you. What be a few hours?

NICOLETTE: Well, an hour in winter-time's enough to melt
A continent of snow; an hour in summer's
Enough to dry a dewpond; and in autumn
To throw out all the leaves like torn-up letters.
And an hour in spring's enough to make me wish
The road would double back to where I've come from.
That's what hours are.

MRS BIGHT: But you wouldn't go and walk
Back to the city when you've got your friends
Down at the seaside where there's piece and quiet.
Tomorrow you can dup off nice and early –
I'll cut you sandwiches; and by the evening
You'll be all gansing-gay.

NICOLETTE: That isn't safe.
I've cut my thoughts into the proper shape
To please the future best, and that's this way
To the coast. Between now and tomorrow morning
My heart may well have mounted like a beggar
On a wish's back, and then it would be a gallop
Off again to the ragged place I've come from.

MRS BIGHT: Is your mother in that city?

NICOLETTE: Nor my father.

MRS BIGHT: No, they're waiting at the seaside for you.

NICOLETTE: They're further off than that. Over the sea.

MRS BIGHT: Oh, my hob-lamb, that's more danger for you.
 I knew a sailor once. He told us tales.
 The bellow of the cows at calving time
 He said were nowt but the whistle of a cricket
 To a sea that were in spate. I wish you hadn't
 To go there. Han't you got an aunt, perhaps,
 Or uncle nearer by?

NICOLETTE: Not even a small one.

MRS BIGHT: Eh, you purty soul, what's in that city?
 What turns you there? I bain't so half-baptised
 That I don't know. Your heart be down along there.

NICOLETTE: I've brought it with me.

MRS BIGHT: That's too heavy luggage
 To go so far with, all across that ocean.
 Put it down here for a time.

NICOLETTE: No, it would hear
 Old cries. It couldn't sleep.

MRS BIGHT: You little lady;
 Come now.

NICOLETTE: Send me on my way again.

MRS BIGHT: What drove you out of that city? – you're so tired
 Climbing them hills – what made you happen along?

NICOLETTE: I won't come to any harm. Don't worry
 Over me any more. I'll get to the sea
 By noon tomorrow.

MRS BIGHT: Oh dear, I could wrap you up
 In my apron like a half-drownded kitten
 And carry you to comfort, that I could.

NICOLETTE: Send me away – scold me for trespassing…
 I've come into your apron.

MRS BIGHT: Missy dear,
 Don't mind, now; there, my cherry;

Let your sorrows run loose; they'll find their own
Pasture to sustain 'em, I've had sorrow
Sometimes now, pulling down my feet
Like January butter; but it dries.
I know the way it comes; I know the way.
Thomas, when he were a baby, when I sang him
'Little Ghostesses' would say sing it again,
And when I'd sung it he'd say sing it again.

(*Sings:*)

Three little ghosteses
Sitting on posteses
Eating hot buttered toasteses.
Greasing their fisteses
Up to their wristeses
Ugh! Ugh! Dirty little bisteses.

That's my best pretty. You shall see, you'll see.
Running tears can make a way for us
Like water-courses. When they're dried again
We can walk in their bed. Them be doctor tears
And a young blessing. When you're old they come
More slow and difficult, like walking does.

NICOLETTE: They're finished now. You see? These little last ones
Trailing down my cheek have given up
The race; they know it's over! – What a visitor
To bring you at the end of a working day.
But now I feel as though my brain had sat
On your seat here and rested.
That was a torrent of sleep and now I'm up
And about again.

(*Enter THOMAS and FLOIRE.*)

THOMAS: (*Singing as he comes out of the house.*)
When crazy winter drives the trees
 And don't know where to take 'em,
We're needing fires to warm our knees
 And settle down to make 'em –
Oh. I didn't know there was visitors, mother.

MRS BIGHT: My son Thomas.

NICOLETTE: Good evening, Mr Thomas.

THOMAS: Evening, Miss. (*To FLOIRE.*) Is this your lady then?

MRS BIGHT: Whatever's the gentleman doing in them clothes
 now?

THOMAS: We've taken him on as a hand, mother, that's why.

MRS BIGHT: A hand? That's no good for a gentleman
 To be a hand.

FLOIRE: My father was a scholar
 Certainly; he taught me how to read;
 But my mother brought me up as a hand, yes, ma'am.
 Is the lady in difficulties?

MRS BIGHT: The lady's travelling
 And came in here to rest herself.

FLOIRE: Now listen,
 The lady can't be travelling like this,
 With no company and no luggage and so late
 In the evening, without being in difficulties.
 It isn't possible.

MRS BIGHT: Look after your business.

FLOIRE: That's so, isn't it, lady? I've the world
 Pretty much at my finger-tips. – You see, ma'am,
 Trouble is my business. Come now, lady,
 What's your story. Possibly I can guess it.
 Let's put it that you're running from Beaucaire.

NICOLETTE: And then put it away.

FLOIRE: Did I get that right?
 Now why should a young lady run away
 Into the blue? Perhaps because the war
 Shooed her away. But then it takes some courage
 To escape past the enemy and into
 A friendless country. Well, then, for some reason
 She felt that if she stayed she'd be a danger
 To someone she was fond of – how is that?
 Maybe she felt –

MRS BIGHT: You keep yourself far off
 Young man out of things that don't concern you.
 I know your kind. You're like them minstrel fellows
 Who come flocking like crows to any mortal field
 That says No Trespassing. I've seen 'em do it.
 Things that are kind and tender they'll nose out
 And squawk away with; they'll make sweet things sickly
 And tears into tittle-tattle; yes
 They will. And tear out bits of the quiet plumage
 Of men's hearts to make their own peacock's tails of.
 Well, there's no murders nor suicides nor sinnings
 Here, so back yourself out.

FLOIRE: All right; don't bite me.
 If I can't try –

MRS BIGHT: Don't take no notice of him.
 The pesterer!

NICOLETTE: I've got to make my way
 Before this moon goes.

MRS BIGHT: No, miss, I can't let you
 Wander alone; you mustn't make me, dearie.
 I'd never sleep.

THOMAS: Where be she making for?

MRS BIGHT: Down to the coast.

FLOIRE: I'll see her safely there.
 I've a sense of direction like a cat
 Making for an old home. She'll be all right.

MRS BIGHT: I wouldn't trust you. Thomas boy, you go
 Along with both of them. Henry will manage.
 Father and I'll set to till you get back.
 (Calls.) Father! – We'll tell him how the lady's put.

NICOLETTE: Please, I can go alone – I know the way
 Brambles and shadows can be dealt with.
 You'll make me feel my little breathing-space
 Has set the whole farm by the ears; so let me
 Thank you and go.

MRS BIGHT: Don't say such things.
 Thomas needs a holiday. A good night's walking
 Will set him up.

THOMAS: That's right.

NICOLETTE: No, it's absurd.
 You'll make me say I'll wait until tomorrow
 And that's a contrary wind I want to miss.

FLOIRE: Tomorrow's as dangerous, just as dangerous.
 There's no road from here to the coast, and it's damn easy
 To get yourself caught up like wool in the sheep-tracks
 And at last rot on a thorn-bush. Don't forget it.
 Now I'm a walking compass, guaranteed
 To bring you to your proper destination
 With no bone out of place; and so the sooner
 We're off, the sooner they will have me back
 And the better for the farm. Just get that right
 And let's have no more back-chat, lady-bird.

MRS BIGHT: If there's any argifying, miss,
 On the way there, you take my Thomas' word
 Not that young fellow's. Thomas was born and bred
 A country lad, and knows his north from south
 Like a proper chap.
 (*Enter BIGHT and HENRY.*)
 Father, I've told young Thomas
 To go along with the gentleman and show
 This lady to the sea. She wants to be there
 By morning. – Father and me will knuckle to
 Till Tom be got back, Henry; won't we, father?

BIGHT: And if we do, mother, and if we do
 He'll see what farming was when farming was.

FLOIRE: If farming was.

MRS BIGHT: I'll go and get some food
 To keep you franzy.
 (*Exit MRS BIGHT.*)

NICOLETTE: This is all too good
 To give me. It makes me feel a little girl

 Again, not able to find a word to say
 On an overwhelming birthday.

THOMAS: Bain't no trouble.

BIGHT: I've walked at night when I were a slippy boy:
 Come out of the winder. Days my nose were down
 To labouring, but nights, they were a chance
 For hobby-travels, to see ghostes rising
 And cub-foxes tumbling. I seed the foxes
 But ghostes were too crafty on their toes.
 But you look out. These parts be fairy country
 They say. And you've got the lady moon to fetch 'em.
 In deep down hollows they'll be riding round,
 Little snippets with muscles like a man
 But quick like bees, and singing, very like.
 All of 'em born out of this 'ere soil
 By the heat of the moon there, so they say. And why
 Not, I say? We bain't so plaguey easy
 To understand ourselves, and bain't tremendous
 Neither. To something bigger nor ourselves
 It might be we were fairies. Here we be
 Pottering and peeping on a mighty world
 And in the end, why sure enough we vanish.
 So you go careful in them chancey hills
 And listen out. If you should see a bat
 Fly straight instead of staggering, you'll know
 They'se somewhere close. And happen you should catch one
 I've heard say that his heart will hammer so
 He'll burst like a stick bursting in flames.
 So keep an eary for flimsies.

THOMAS: We will, father.
 Do you mind how Bess were lost at milking-time
 And came back home from Piper's Wood bone-dry?

BIGHT: I've knowed Ned Hawkins up at the next farm
 Since times he were a teether and I tell 'ee
 I'd be surprised at nowt.

 (*Enter MRS BIGHT.*)

MRS BIGHT: Here's just a something
 To keep you bobbish. 'Twill do till breakfast-time.
 Here, put it in your pocket, Thomas lad,
 And keep your hands off till you really want it.

NICOLETTE: I'd have been livelier climbing up the hill
 If I could have guessed what waited up on top.
 Thank you for it.

FLOIRE: Try and have a guess
 What's at the end of the next part of the trek
 Before we start. Maybe we'll travel lighter.

NICOLETTE: I can't see so far.

FLOIRE: I'd make a shot
 In the dark.

MRS BIGHT: You have adone with guessing and enquiring,
 And keep your nose free to smell the path out;
 That be your share of the matter, letbehowtwill.
 She've a lamentable jaunce ahead
 So lead her nice and smooth.

FLOIRE: Believe me, ma'am,
 I'll lead her like a guardian angel, up
 And over to the best place for her good.
 There'll be no accidents or misadventures
 Or data for bad dreams. You say no more.
 I may be left-handed professionally perhaps
 But I only use my right hand among friends.
 Don't be so hard on me. I know I like
 The world for making troubles for itself –
 I don't deny I make a song about it.
 My feeling is that if it's going to go
 To all that trouble it might just as well
 Have something to show for its pains. On the other hand,
 When I'm in charge I beckon down a windfall
 And exit smiling. And I guarantee
 This lady will be safer than new houses.

MRS BIGHT: Oh well, I hope so.

 (*Curtain.*)

Scene Two

(The same as Act One; the next morning. The bells are ringing. The population, singing and shouting, are streaming towards the market-square. A BEGGAR selling rough-and-ready flags is standing on the steps.)

BEGGAR: Flags one penny each! Only a penny!
 Flags for the glorious victory. Buy a flag
 To welcome 'ome the 'andsome conquerors!
 Flags pennyeach! – 'Ere, lady, buy a lovely flag
 To celebrate the gorgeous victory. A penny
 Only a penny, lady,
 And this 'ere shirt cost me 'alf-a-quid
 When it was new. It's giving it away.

GIRL: I'll have one.

BEGGAR: Thank you, lady; thank you, lady.
 God bless you. And God bless your hubby
 For an 'ero. God bless all the h'honourable 'eroes
 Of this gorgeous victory. God bless
 Lord H'Aucassin the blessed 'ero
 For leading of 'em into bloody battle.
 God bless the 'ole blinking city. Thank you, lady.

GIRL: Why don't you go down to the market-place?
 That's where the excitement's going to be. You'll sell
 More flags down there, Lord Aucassin's
 Going to come riding in at the head of the men
 In grand style. My brother was fighting with him;
 He's only fifteen but he's as good a soldier
 As you'd see in a lifetime. You won't do anything here.
 Take my tip and get down to the market-place.

BEGGAR: 'Tain't my pitch, lady, but I'll chance it.
 Thank you, lady. – Buy yourself a flag!
 Flags to welcome 'eroes! Penny each!
 Penny a flag to show your patriotism.
 Flags for 'eroes! Flags for victory!
 Only a penny. Thank you, sir. A penny!

Only a penny! Last lot to be 'ad.
Gorgeous flags for a gorgeous victory!
(*He disappears in the crowd. Enter the COUNT and COUNTESS, the BISHOP, GENERAL BOULGARS and OFFICIALS of Beaucaire.*)

COUNTESS: (*To the BISHOP.*)
Look what excitement! The population is ringing
Like the bells – the market-square is swaying with them
And look at them streaming up the side-streets
And pressed back again – like dancing bell-ropes
Jerking on the one note of their hearts,
This splendid victory!
I could cry, I could cry as easily as anything.
That exaltation of face, look, my Lord!
I have always found a crowd of happy people
Unbearably exciting. Listen to them –
That murmuration of greedy starling-hearts
Snatching these crumbs of peace we've thrown to them. –
It's too soon to go down: they're pouring in
From the four corners of the city.
And to think my son put heart into the men
And urged them to this triumph – well,
My cup is overflowing. What a ride
For him through the gates, to find this congregation
With such an anthem in their eyes. They've brought
Every coloured thing their hands could light on
To make the dried-up city flower again.

BISHOP: Yes, they'll have a welcome, these good fellows;
It's brewing up for them; we'll see, we'll see.
Myself I should flinch at it; it's quite an ordeal.
They're coming out of chaos into bedlam
Let loose. I for one have grown impatient
To see the lazy tournament
In vogue again and a nice prosperity.
And those poor fellows will need sheets and pillows
And a key against night-terrors for a little.

COUNTESS: The excitement will act like a tonic for them.

It has for me – the shouts and the songs. And then
To know my son's found his real self at last:
The soldier that we always knew him to be
Under his wayward opinions; the splendid leader
And friend of all his people. That is peace,
Real peace for me.

COUNT: (*To BOULGARS.*) Come down a moment, General.
There's something I have to say to you, my friend.
This isn't unblemished victory, for you.

BOULGARS: No, my Lord.

COUNT: I know it and I'm sorry.

BOULGARS: May I speak my mind, sir?

COUNT: Yes, go on.

BOULGARS: There was a quandary you put me in
In yesterday's business.

COUNT: Well, Boulgars, go on.

BOULGARS: You said, you remember, that we neither knew
Nicolette's parentage. I knew, my Lord;
Not when we captured her at Belforado;
But since we brought her here often enough
She's talked about her life before we brought her.
They are the oldest blood known to her country
And run through all the history and legend
Like the threads that bind an old and crusted book.
Further than this, she told me that her mother
Was dead and life not altogether happy.
And so we kept her here. I should have told you
Of this, my Lord, only it seemed to me
That in the circumstances you might think
I was attempting to circumvent your orders
Or even, my Lord, encouraging a marriage
With your son. I thought an opportunity
To speak might present itself when I had done
What you wished. But that hasn't been so,
Opportunity's gone. I was too late for it.
I thought that you should know this, sir.

COUNT: Too late
 For me to know it. Yesterday is out
 Of our province or I should make some alteration.
 I am sorry, Boulgars; believe me, I am sorry
 For this. – We must go down.

COUNTESS: They're shouting for us.
 There's been nothing like this since our wedding day.

 (*Exeunt. Enter from another way AUCASSIN with MILLOW.*)

MILLOW: On my heart, I'll forgive you anything, sir – you've brought me fame, and if we can't ride in the procession it's a pity but we can't expect everything.

AUCASSIN: Go on, man; run round to the gates before it's too late. There wasn't any need to have slid away because I did.

MILLOW: No sir; oh no; I'm your man; you've made me. What a fight, what an unforgettable holocaust! I've sweated off the years in gallons. Yes, sir. – I shall go into my grave backwards, on all fours, like a barking dog into its kennel. But not yet by any means. My body's still putting out shoots. My doctor says it's lumbago but I tell him it's growing pains. – I've only two regrets. One is that that fraud of a minstrel wasn't there – after all these years waiting for my opportunity and when it comes, no publicity! I knew that man didn't know his job. And the second is that I can't get a smile out of you, when I thought we should ride back like Charlemagne after Pampeluna leaning back and bellowing all the old songs: they say the saliva trickled down his beard but he didn't stop once to wipe it off.

AUCASSIN: I'm sorry, Millow. I should be singing too
 If I'd found what we went out hunting for
 In that wild wood. But I can only cry
 My tally-ho: Where's Nicolette?
 Yesterday at sunset we had the soldiers
 Remembering two-pence-coloured battle-stories
 And singing songs. And brandy kept us warm
 And our high spirits were unstoppered.
 For a slap on the back we'd have marched against Michael

And all his angels. And so tally-ho!
The wild woods were round us. And by dawn
The bells were knocking our dead towers awake
And a deputation of dead hearts
Was knocking at heaven's gate.
By dawn I'd sent a thousand women searching
For what I'd stolen from them, but my pockets
Were empty. By noon with pen and ink
We'll make an armistice and then a peace.
Tick tock. We'll keep anniversaries.
We'll tie two sticks together for a cross
And a knot in our handkerchief. We'll pray, we'll pray!
Where's Nicolette? Where is she, Millow? Tell me.
Where could she get to in a world that tips
Over as easily as a cup? I tipped it
Over. I just put my hand out, Millow;
It was done in a minute, I just put my hand out.
And time set in like a black frost. – That minute
Has found its end. Nothing can drag it any
Further. They're dead men, and Nicolette
Has gone.

MILLOW: I've read of heroes, dear me yes,
Halfway through the night, but never of one
Who came home again like this. Listen, my Lord,
Listen to a fellow who had to kick his heels
For half a century before the gods
Found him. Get your breath. There's more to do.
We'll have you a sand-boy yet.

AUCASSIN: After a time
I'll find myself king of some castle.
I'll collect it tower by tower like beer-mats
Or old china, and enjoy the view.
Yes, I'll be a sand-boy, Millow. I'll pin my faith
To the world's furniture
And grow hilarious on gewgaws.
My mother had decently concealed her room,
Walls and all, and made her ceiling quaint

With plaster stars. An excellent thing.
The sky's altogether too haphazard; much
Too wild to entertain. Why, I have seen it
Spit its stars into the inky gutter
Twelve times in an evening. So we'll have
Propriety from now on, Millow. Yes,
We'll be circumspect. Acquaintances
But none of your bosom friends. No friends. I know them.
They'll flick their mortal fingers and be off
Without a smile. And none of your beauties of nature
Either, that make you tie your duty up
To a green stem, that bends even under
A dropping of dew. I've been burned once.

MILLOW: I know,
It's the devil of a world. As luck would have it
Today my horse has galloped home, and yours
It seems to me came a cropper at the last fence.
Dear me, I'd like to help you. It's the devil
Of a world, the very devil. Would you come
And have a drink with me, sir? and that might give us
An idea or two how we should go on.
I've got a mouth like charity.

AUCASSIN: Two nights
And a day saw us through this business.
It leaves us time on our hands.

MILLOW: I've thought of that, sir.
Days will be pretty thin things after this.
I shall be back in the blessed kitchens again
With an unreceptive audience and a thirst for news.

AUCASSIN: Nicolette, Nicolette. I'd come, if I knew how.

MILLOW: A change of shirt and we'll both be off, sir.
We'll find her. The world, they tell me, is nothing at all
To the size of the sun. And I keep that off
With a rhubarb leaf, so what's our difficulty?

AUCASSIN: We cut up the world pretty fine last night and found
Nothing but blood.

(*Enter the COUNT, COUNTESS, the BISHOP and GENERAL
BOULGARS.*)

COUNTESS: He's here! My darling boy,
Where did you get to? – Everyone was waiting
To welcome you. Have you been hurt?

AUCASSIN: No, mother.

COUNT: I sent a rider with a message for you
That we'd be waiting at the gates.

COUNTESS: And when
The men rode in without you, oh, my dearest,
Our hearts turned over. All the waving hats
And coloured streamers faltered and fell down
As though a wind had suddenly stopped blowing.
And then the intake of consternation!
The thunder of cheering trickled back like a wave
Down the beach; and then a second wave
Leapt over it – the frantic shouting for you –
Where's Lord Aucassin? and Where's our little Lord?
They were almost as sick at heart as we were,
Your poor tired boy. You've had a terrible time.
We can hardly hold our pride for you, my darling,
And were longing to give you a really rousing
Welcome home. But never mind; a little later on
You can come out and show yourself.

AUCASSIN: Yes, mother.

COUNT: That was a pity, lad. It should have been
A memorable moment for you. And for them.
Never disappoint the people, boy;
These affairs are mortar to the bricks
Of government. But let me tell you now
Before these few, as I should like to say it
Before every man left breathing, that this city
Owes its happiness to you, its freedom
To you, its peace to you and all its coming
Prosperity to you. I shall remember
How you stood up and made disheartened men

Into a headlong wheel of victory; and how
I heard the news when I was standing by
Up to the heart in nightmare. When you see me
Put down my books and seem to sleep, you'll know
The vein of gold I'm working.

AUCASSIN: Thank you, father.

BISHOP: My Lord, this has been something to call good
However it may seem to you in this
Stale moment after. Here is peace now.

AUCASSIN: Thank you.

BOULGARS: Yes, you've brought safety at last, my Lord.
A better piece of soldiering I never
Hope to hear of, even though you stole
A march on my generalship. You're a usurper.
It was magnificently done.

AUCASSIN: I think,
General, we're facing the same way. The sun's
Behind both of us and throws our shadow
From here to the horizon.

BOULGARS: Yes, my Lord,
I think so.

AUCASSIN: Old Millow here is wise.
He says that there's to be no sitting down.
And I believe him. By evening, shadows are longer.
And so I'll travel my shadow till I find
Its seabeard where Nicolette is lost.
Here's peace for you, father; I might as well
Have paid it sooner. Now I have to make
A second throw to keep myself in pocket.
You've done some perfect business for me, Millow,
And got me to my feet. Look after yourself
Now, and tell the people last night's story.
You've got an audience waiting for you there
That Homer would be proud of.

MILLOW: Yes, my Lord.
I'll tell 'em. They'll soon see who ought to be

The minstrel. Oh my word! – God bless you, sir.

(*Exit MILLOW.*)

AUCASSIN: There's immortality! – I'll be back later,
Father, whenever my luck arranges for it.

COUNTESS: Dear boy, you can't go riding off like this
In the middle of the festivities, without
Food or sleep. This is just foolishness.
Tomorrow you can go, and you'll be fresh
And ready for anything. But now it's madness.
Two days and nights you've had no sleep at all.
You'll kill yourself.

AUCASSIN: Why, you can sleep for me
And eat for me, just as you did before
I pulled a breath. Sleep, eat and pray this time
And I may breathe again, in a slung world
Halfway to heaven. Or if not –. Remember
Sleep and eat. For while there's still a world
For her to walk on, I shall find her.
How long I shall ride, or how often there will seem
Not a leaf of hope in the hills, is neither here
Nor there. This is a planet that is blest
With miles that are measurable, and I'll endure them.
You can tell yourself now as you see me starting off
That I'll top up this victory with another
More after my own heart. So keep your spirits
And watch for me. – But what's the latest news
Of you and me, father? Will you see me up
Into the saddle?

COUNT: If this weren't your story
I'd ride with you, boy. But as it is
I'll issue a new currency of prayers
To have you both back here again before
Spring ducks under the first rose.

(*Enter FLOIRE.*)

AUCASSIN: Did you hear that? It's the first holiday omen.
Has our quarrel blown down in the night?

It has! From now on I'll acknowledge
Magic in April. You can be witness, father,
That you've fastened spurs on me, like wings
On my heels. Now I can understand the bucking
And rearing in the bulb and root
When they snuff resurrection in their air.
I'll be petal-hardy and bite up
Into the sun. Can I have Black Cherry?
She'll reach for the world's end with every arrow
Of her sinews and outdistance all her whinneys
Of fear. She was bred for this.

COUNT: Look after her.
She'll make the best of a day that any can,
And climb surer.

FLOIRE: Pardon me, my Lords –
Gaston Floire, minstrel – I've acquired some news
You might be glad of.

COUNT: What? Who is this fellow?

FLOIRE: Gaston Floire, minstrel, in at the birth,
In at the death, my Lord;
Floire's news is good news;
No news is bad management.

COUNT: All information must come through the proper channels.

FLOIRE: But, my Lord, I'm a proper channel all right.
This is the brightest news I've ever provided –
A real piece of creative work, my Lord.

COUNT: Lord Bishop, General, come with us; we'll see him
Safely mounted. To me this is a ride
That will set Beaucaire at rest or have her down.
Come on.

FLOIRE: But look, my Lord –! Lord Aucassin,
Here's something you should know – it's what you want.

AUCASSIN: You heard my father. Send it the right way.
He'll hear you.

FLOIRE: So he might. But where will you be?
This is your pie, my Lord, if I may say so;

And you'll be riding on a damn fool's errand
Half down the earth.

AUCASSIN: What do you mean?

FLOIRE: I've news
Of a lady.

AUCASSIN: Father, I'll come on after you.

(*Exeunt COUNT, COUNTESS, BISHOP and BOULGARS.*)

Now, what's your story?

FLOIRE: Well, sir, yesterday
When the most formidable attack in living memory
Resulted in the terrible destruction
Of the south tower –

AUCASSIN: Have you seen her; yes or no?

FLOIRE: I followed the lady after she had made
An astonishing escape –

AUCASSIN: Where did she make for?

FLOIRE: In an interview that I was lucky enough
To get with her, she said that she intended
To reach the coast by morning.

AUCASSIN: At what point?
Come on, man; news should travel faster than this.

FLOIRE: I interviewed her at a little farm
Up in the hills, belonging to the Bights –
Sons of the Bights that had the farm and mill
That cradled all this trouble –

(*Enter NICOLETTE, seen by AUCASSIN, unseen by FLOIRE.*)

Myself and one of the sons said that we'd show her
The way there; but I knew if ever woman
Was mistaken, she was – it wasn't the right way
To give me a good story. So the road
I pitched on swung itself about, and fell
By starlight into the valley. There we heard
The battle, like giant drums and beaten trays
To bring that swarm of stars down. And the lady
Guessed –

AUCASSIN: And what did you say?

NICOLETTE: I said 'Not here'.

FLOIRE: I can see that my lovely story's pirated
 Already. We minstrels ought to be protected.

AUCASSIN: But at dawn when that fierce swarm of stars was down
 And victory cried and laughed in the sudden silence
 Like the one survivor, you came here.

NICOLETTE: I came
 To find you. But I still shall say 'Not here'.

AUCASSIN: Nicolette, my father's waiting for me,
 Now at this moment, to ride out and find you.
 I'm already booted and blessed and welcomed home
 With you beside me.

NICOLETTE: Then you can shut the gates.
 My world has crept here after me.

AUCASSIN: I'll lock them,
 And the key can go over the mill. The rest of spring
 Can come into the open and be easy.
 There's nothing to hide from.

FLOIRE: Here's the whole town dancing!
 The last time we had them doing this
 Was on St Martin's day, two years ago.
 Come up and watch them, –
 That's my sprigs of joy!
 Get your feet to the world and settle it down.
 The worms have been making it tricky with their casts.
 Drive your war-horse into the spring field!
 For him there's daisy-diet; and for me
 The silly season. And for you
 There's business as usual. Ah, my ups-and-downs,
 My little crazies, carry today too far –
 Tomorrow it'll not be far enough.
 Tomorrow it'll tread on your toes. But cock your ears
 For me; I'll give you a world to pass the time with.
 I'll sing for you as long as my breath lasts –
 Bigger and better stories! Dance away!

And when you've danced your feet completely sore
I'll tell you how we won the latest war!

(*The curtain falls.*)